# IN
# A SEA
# OF DREAMS

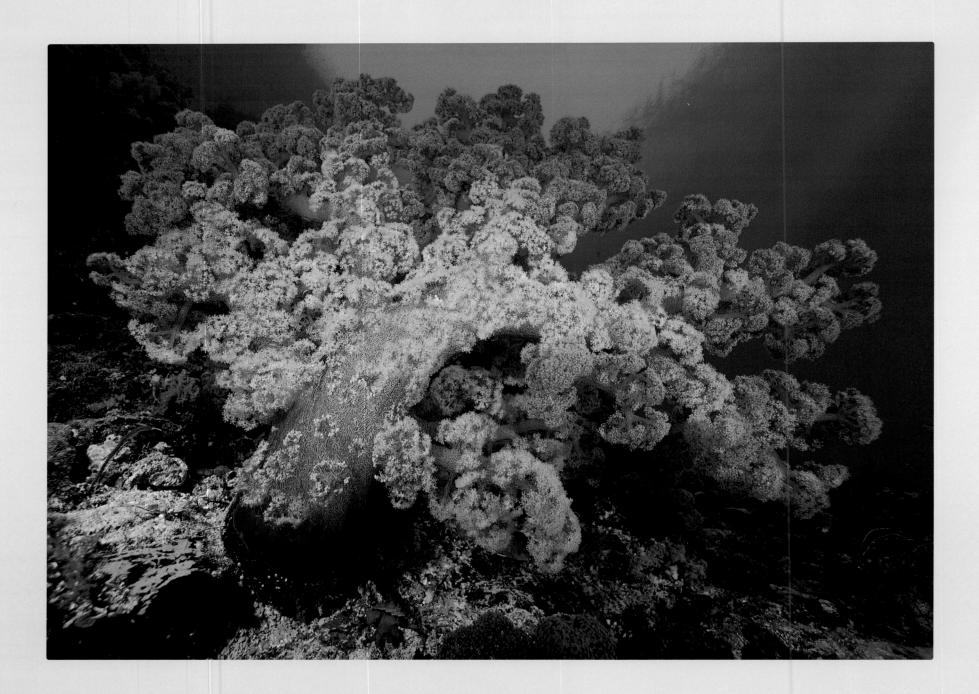

THE OCEAN REALM COLLECTION

# In A Sea Of Dreams

CHRISTOPHER NEWBERT

BIRGITTE WILMS

*In A Sea Of Dreams*
Published and distributed by
FOURTH DAY PUBLISHING, INC.
*Post Office Box 6768*
*4067 Broadway*
*San Antonio, Texas*
*210-824-8099*
*210-820-3522 fax*

FOURTH DAY PUBLISHING, INC.

Library of Congress Catalog Card Number
94-61043
ISBN: 0-9642736-5-9

Printed and bound in the United States of America.

First Edition.

Inquiries regarding the photographs
may be directed to:

Christopher Newbert
Birgitte Wilms
*Post Office Box 2011*
*Basalt, Colorado 81621*
*303-927-9789*
*303-927-9708 fax*

All of the photographs in this book have
been taken underwater, in the wild,
of animals in their natural state.
The pictures are from the following locations:
Cocos Island, Florida, the Galapagos Islands,
the Hawaiian Islands,
Papua New Guinea, the Red Sea,
and the Solomon Islands.

Profits from the sale of *In A Sea Of Dreams* are
donated to OCEANICA, a non-profit organization
dedicated to the conservation of marine ecosystems,
the protection of marine biodiversity,
and the promotion of an environmentally
sustainable stewardship of oceanic resources.

It is the sincerest hope of the authors and the publisher that
*In A Sea Of Dreams* will inspire a new awareness for the beauty
and frailty of all things oceanic.

In memory of my sister Marcia.
You are deeply missed and always in our hearts.
*CN*

To my parents, Erik and Anni, and to my brother Per.
Thank you for encouraging me to follow my dreams.
I er altid i mine tanker.
*BW*

As I once became part of them,
all these creatures of the sea are now a part of me,
in my mind, in my soul, in my dreams.

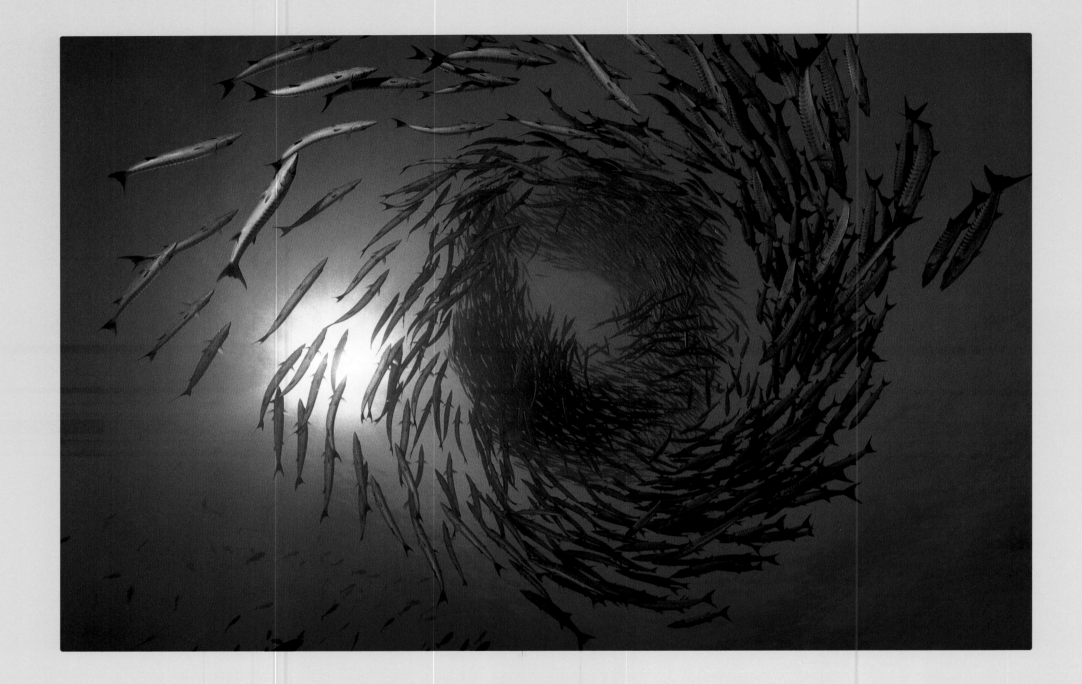

*Barracuda School*

*Tridacna Clam Mantle Detail*

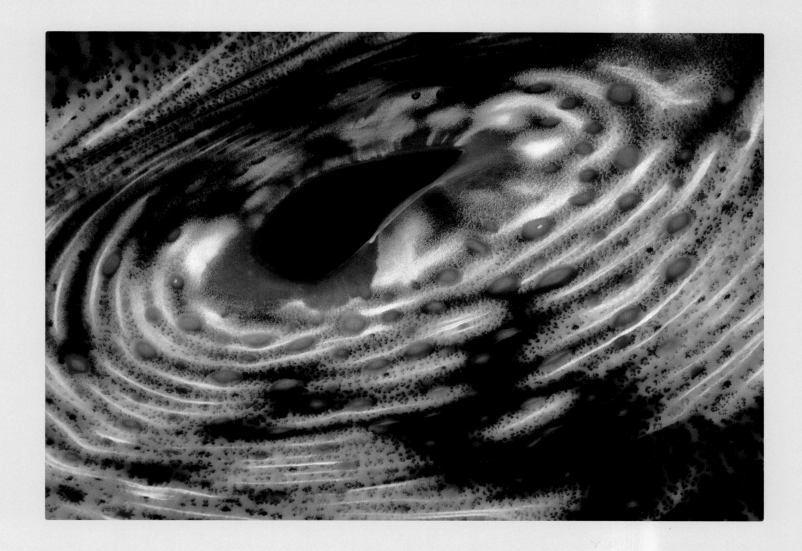

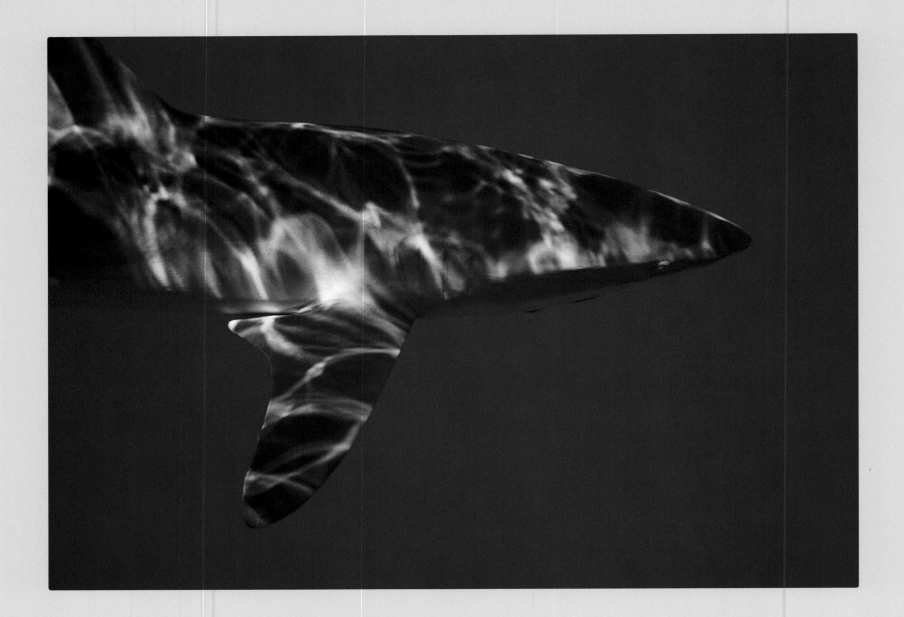

*Galapagos Shark*

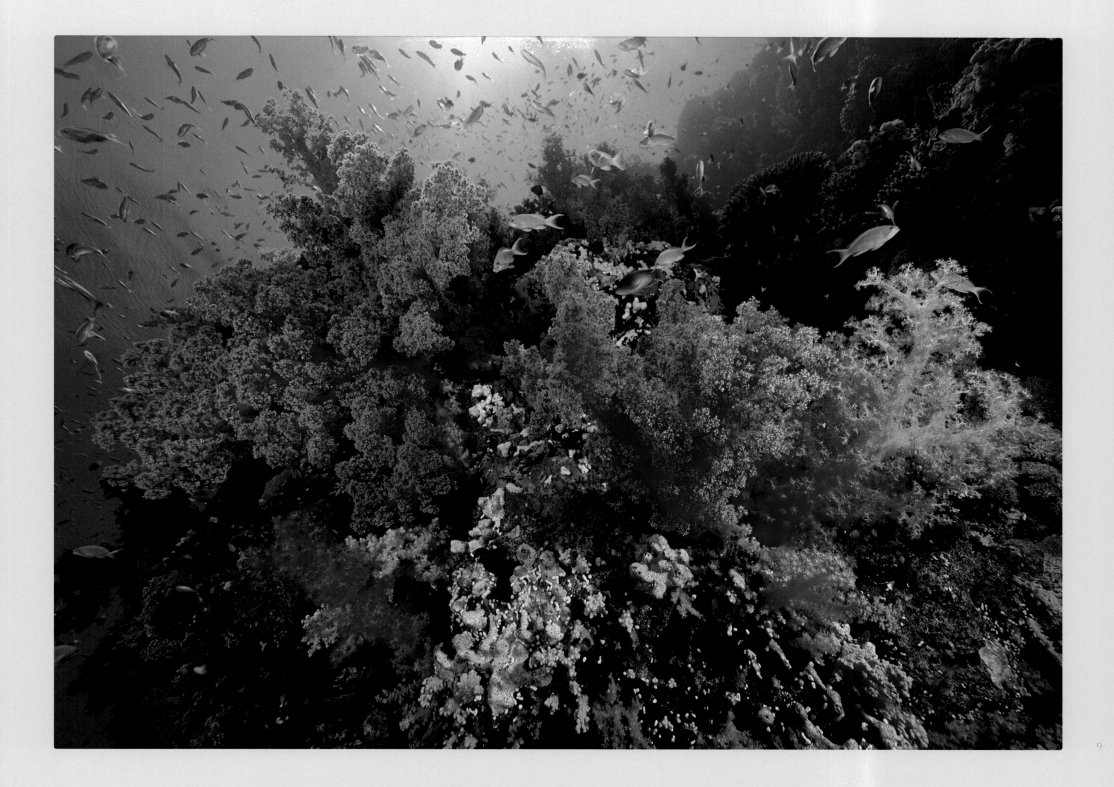

*Reef Scenic*

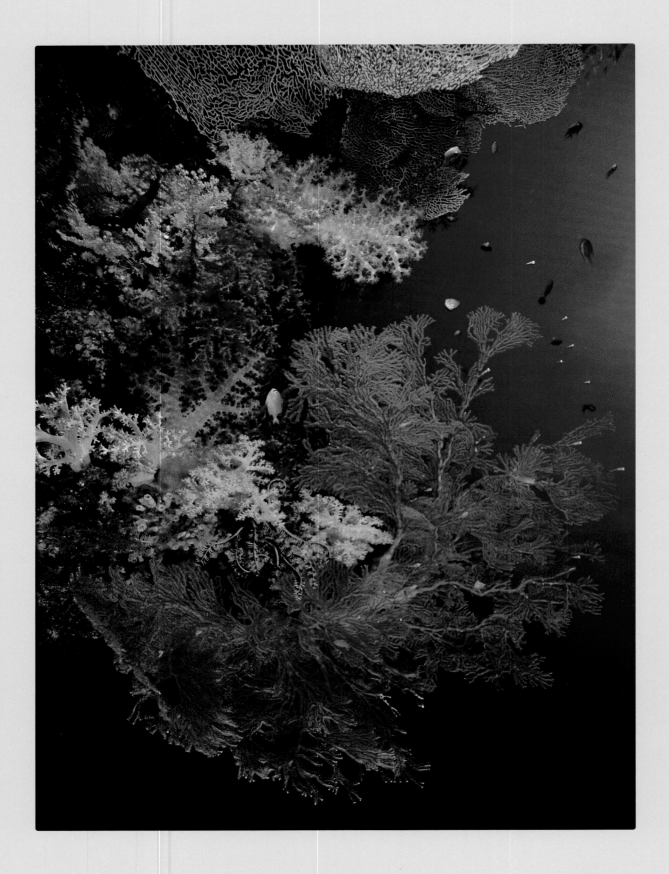

*Soft Coral and Sea Fan*

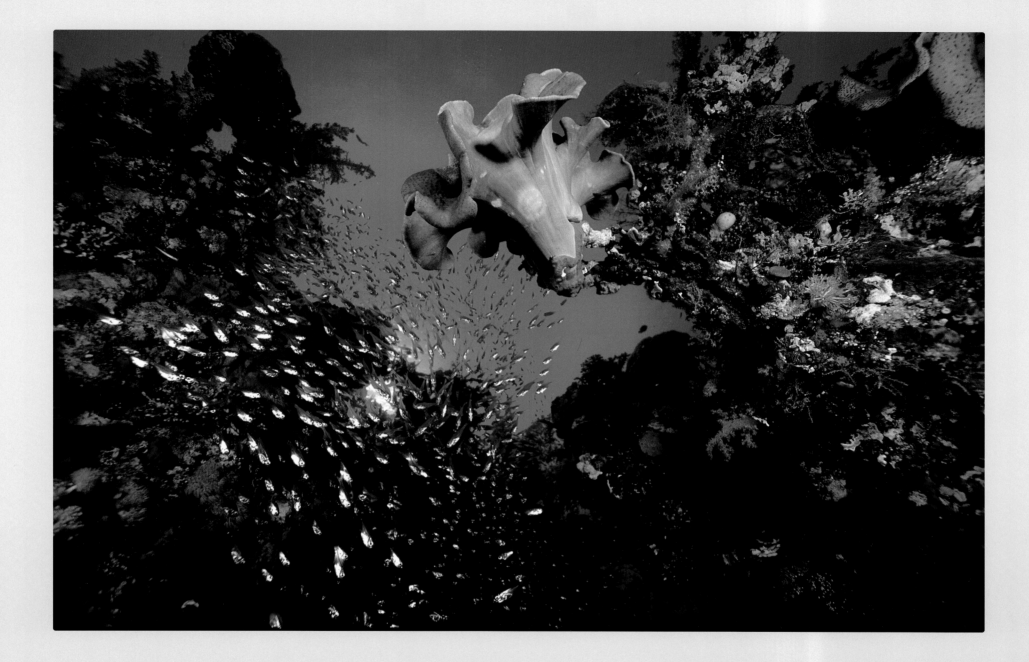

*Leather Coral with Glassfish*

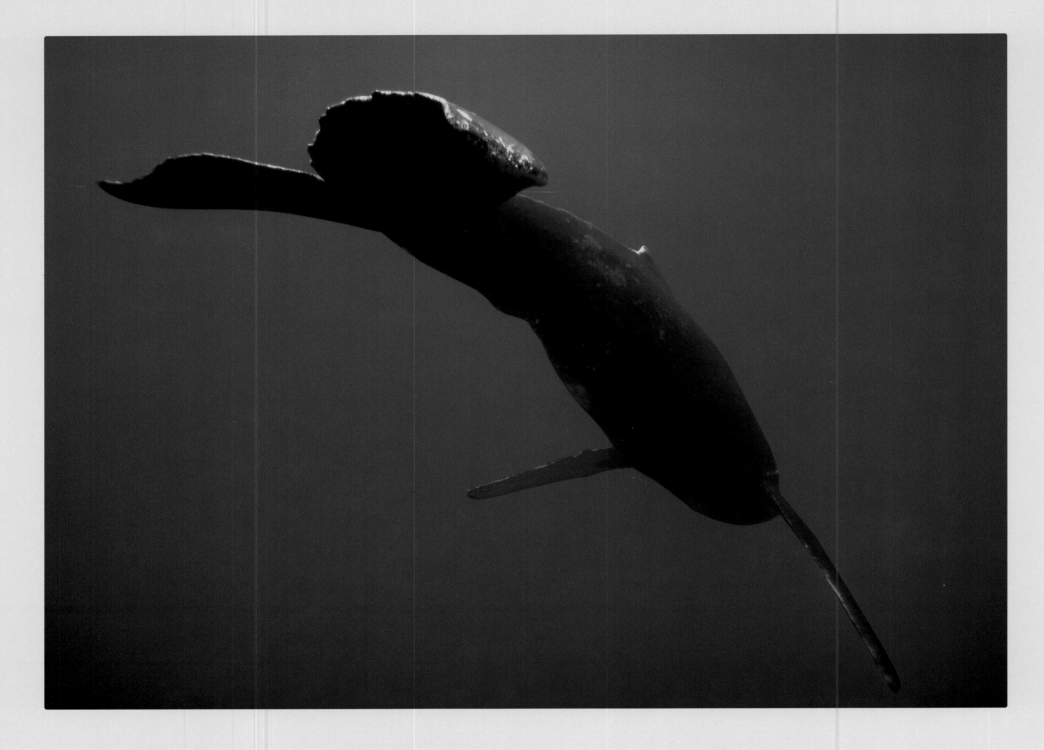

*Humpback Whale*

*I* have always dreamed of the sea.
When I was a young boy, I had a small fresh water aquarium,
a simple fish tank that held a handful of neon tetras,
some angelfish,
plus an assortment of aquatic weeds.
And in this aquarium I had carefully placed a miniature ceramic diver.
An old style hard hat diver he was,
with an air hose that ran from an electric pump
on my desk into the diver's helmet.
I recall that he was posed in front of a tiny treasure chest
brimming with gold and jewels and wonder.
Air bubbled endlessly from my diver through the depths
of my little ocean, and the sound was reassuring,
as rhythmic and calming
as a mother's heartbeat to a child in the womb.

I would sometimes sit for hours on end, staring through
the glass windows of my aquarium.
As my angelfish would glide before me, lacy filaments would trail
from its fins tracing delicate, beckoning arcs,
reaching out to me, encircling my imagination,
and drawing me into their world of mystery and magic.
I was enthralled by the vibrant colors of the neon tetras,
hypnotized by the fluid movement of these animals
through their weightless universe.
Each night I would fall asleep to the sound of that tranquil heartbeat,
for my little tank held more than fish and plants and a toy diver.
That aquarium had become the vessel of my dreams.

Within a few short years my fish tank was gone,
but my undersea fantasies remained. I would sit
on a boat dock in a certain cove of a New Hampshire
lake where we visited each summer,
staring into the empty, green-brown water below, my eyes straining
for a glimpse of a fish I had once found there.
With mask, snorkel, and fins, I searched eagerly, and
though I never found the fish,
oh, the wonders
that appeared through the window of my mask!

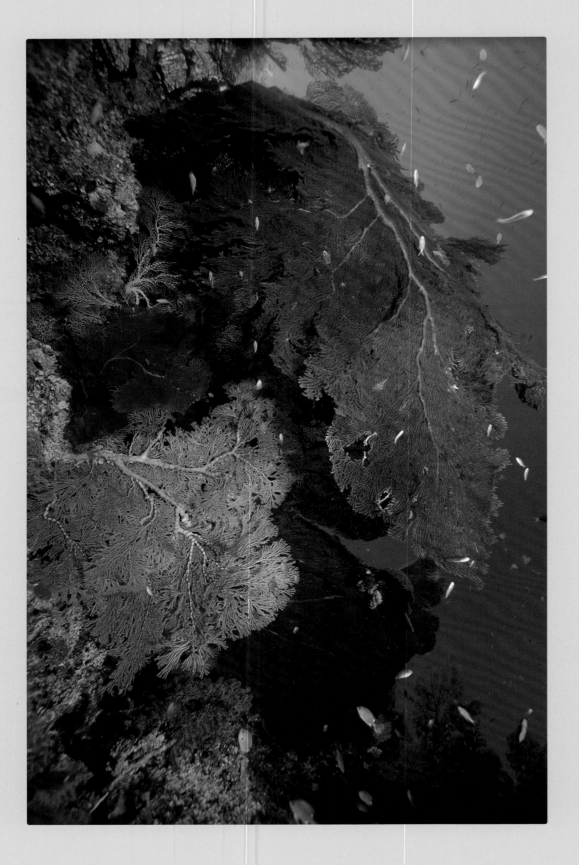

So I learned to scuba in the chilled waters near my family home
in Massachusetts, making my first dive in a local pond.
Excitement rippled through me when I discovered
its most prominent feature: a sunken tree stump,
about twelve feet deep, near the pond's center.
A face mask offers a limited view underwater,
but in the company of dreams,
it can be a gift filled with visions.

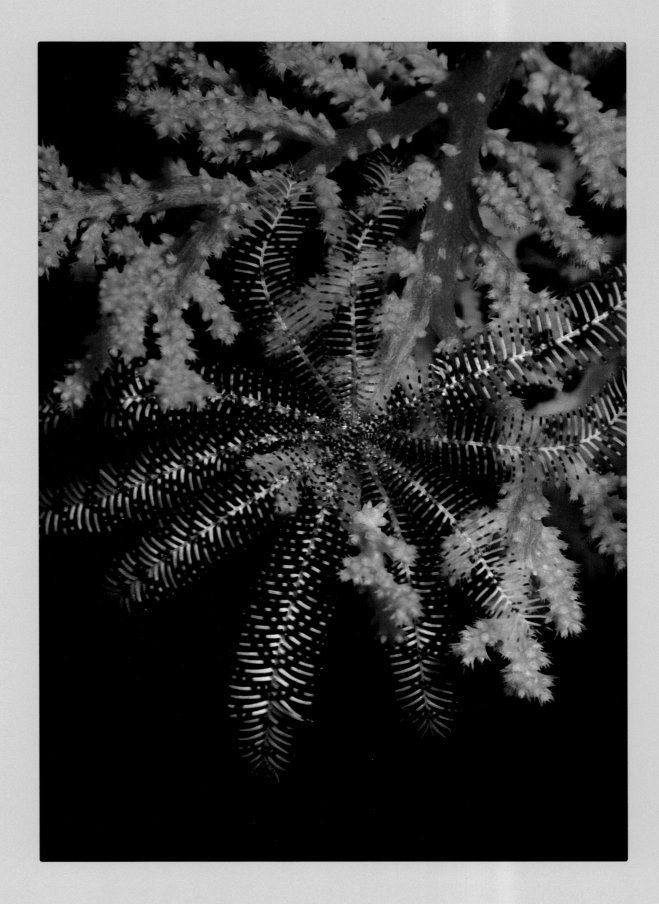

15

*Crinoid on Soft Coral*

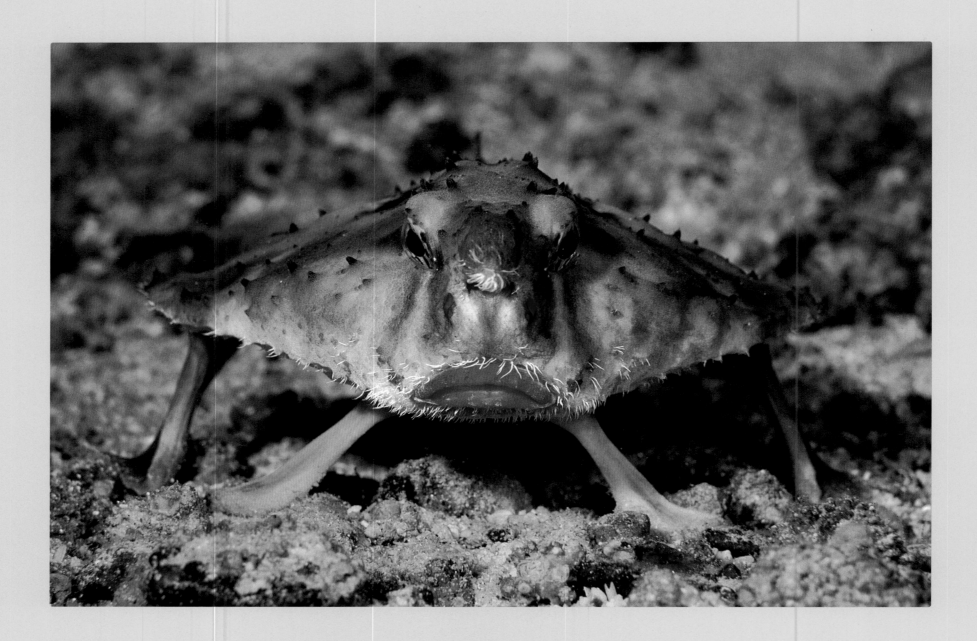

*Rosy-lipped Batfish*

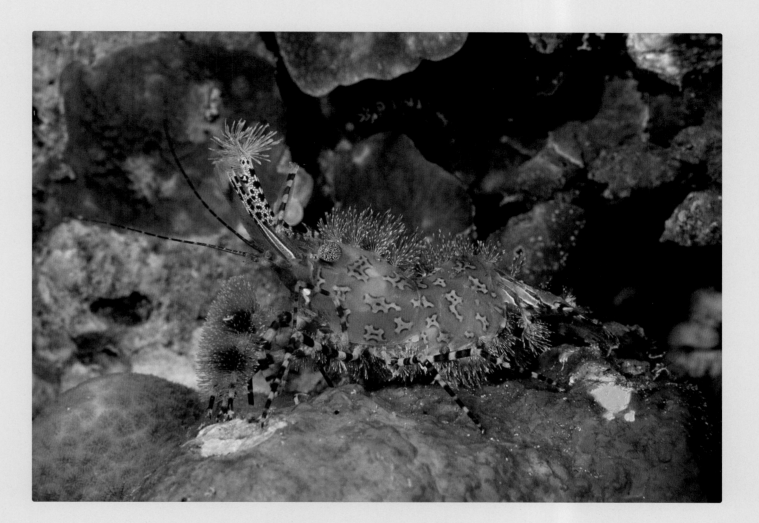

I still remember vividly the general contents of the recurring dream of my youth.
It would always be a strange marriage of the familiar elements of my life
and those fantasies I held of the sea.
Great manta rays floated among the tree tops of my neighborhood.
Our front yard was a field of waving sea fans, and schools of fish would gather in the street.
A shark once chased me through my house, but I escaped through the porch,
only to have the shark tear through the screendoor after me.
I learned early on that screendoors make poor shark cages.
Strangely absent in these recurring visions was any specific sense of water,
for somehow in my dreams
air and water were inseparable, a common fabric
on which my fantasies were brightly embroidered.

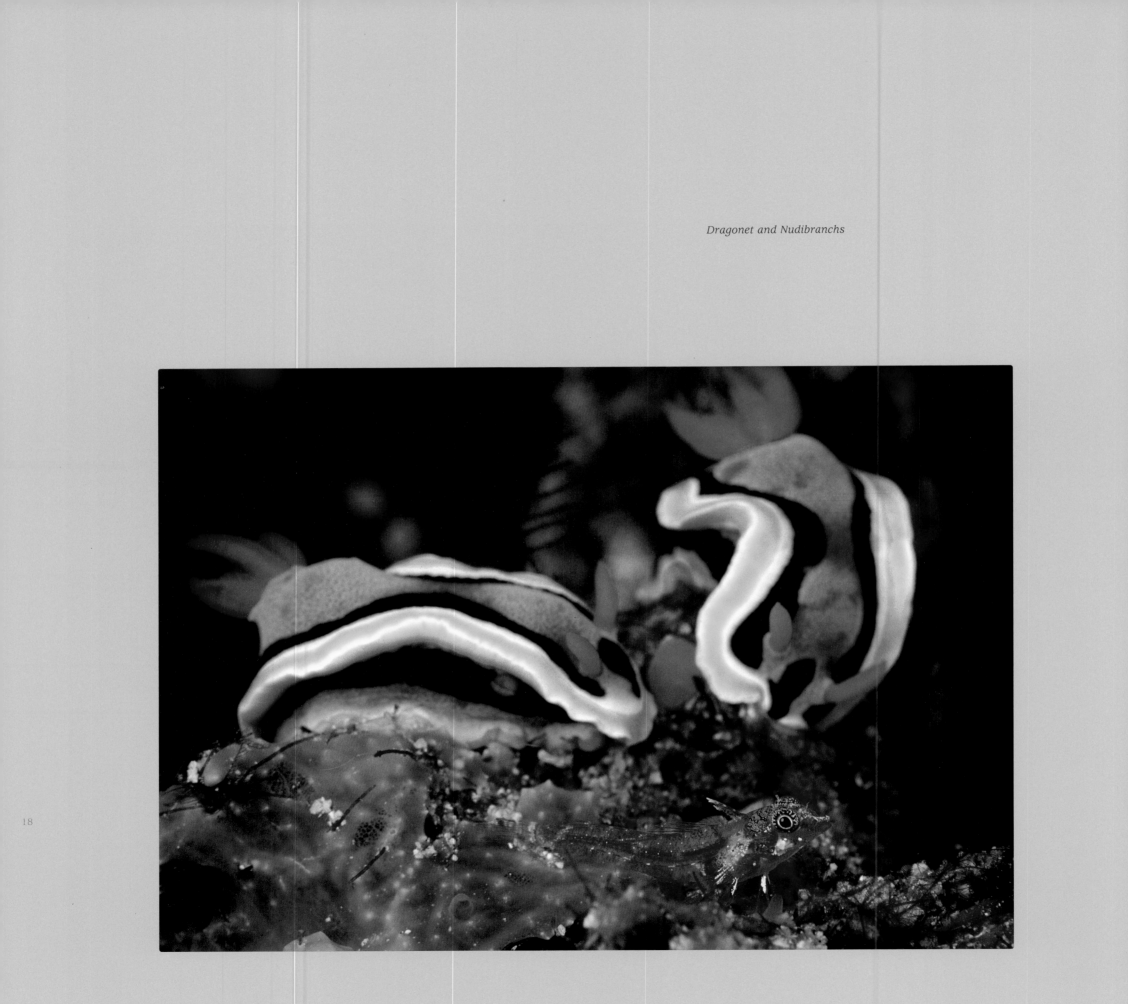

In time, I followed my sea dreams throughout the world
and became the diver of my childhood aquarium.
The bubbles from my own breathing are now that rhythmic heartbeat soothing me
when I'm suspended in nature's womb.
I stare endlessly at the natural treasure opened before me: the jeweled reefs of the Red Sea;
the silver reflections off a dolphin's fin in the Galapagos Islands;
the sapphire blue of the Solomon Sea;
the golden luster of a soft coral garden in Papua New Guinea.
I envision hidden treasures as well, those mysteries of nature so jealously guarded by the sea.
The sonorous tones of a singing humpback whale;
the common currency of simple plankton exchanging
carbon dioxide for a wealth of oxygen breathed back into our atmosphere;
the dark beauty of violent predation; the tiara lacework of tiny coral polyps patiently building
earth's largest living structures.
Yet for all its richness, here is a treasure easily lost,
one fragile as a dream.

Now I live high in the mountains.
Throughout my adult life I have always lived on a mountain,
and for many years that mountain was a volcano surrounded
by the sea in Hawaii.
I could look out my window each day and watch the distant ocean in all her moods.
Often I would be at work in my darkroom,
conjuring from photographic paper and chemicals marine life captured in light.
Stepping outside to view the finished print,
I would hold the sea creature to the sun,
the ocean shimmering miles below me, and sometimes think of cultures
whose people have believed
that a photographer steals their spirit by taking their picture.

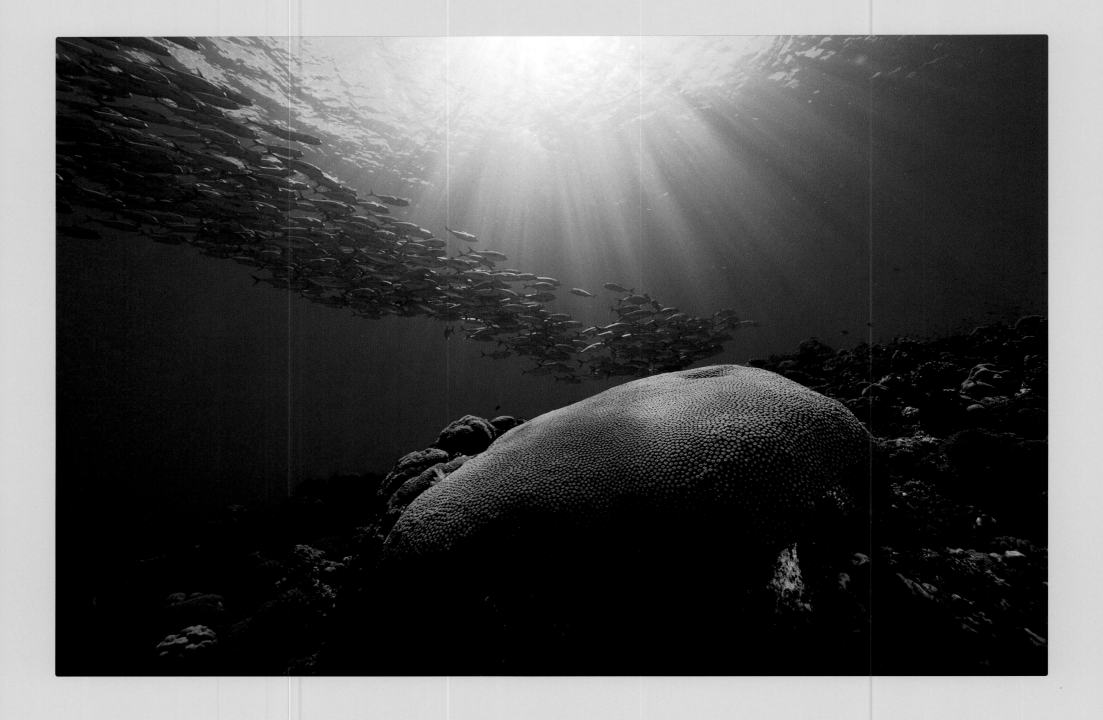

*School of Fusiliers*

*Sea Cave*

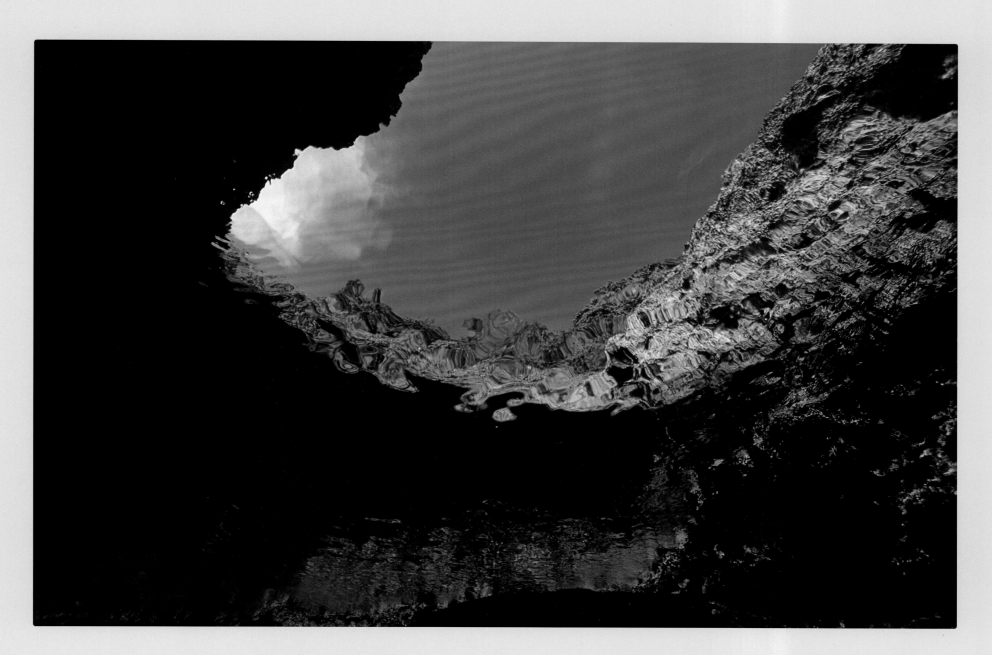

They hide their faces in the presence of a lens to guard their souls.
Looking at my sea life photographs, I would then wonder if I was such a thief,
for the image of their beauty was here with me on the mountain.
I don't think of myself as a spirit robber,
for in making their photographs, I brought to these beings a flash of light,
one richer in spectrum than any they had known.
Their special likenesses were recorded on film only by the unique quality of light each creature reflected.
And that, I came to realize, is how all of us are perceived by the world around us, by the energy we give back.
Their images, formed of this light they returned, might carry their spirit
to a world so often blind to the lessons of nature,
to a world so much in need of dreams.

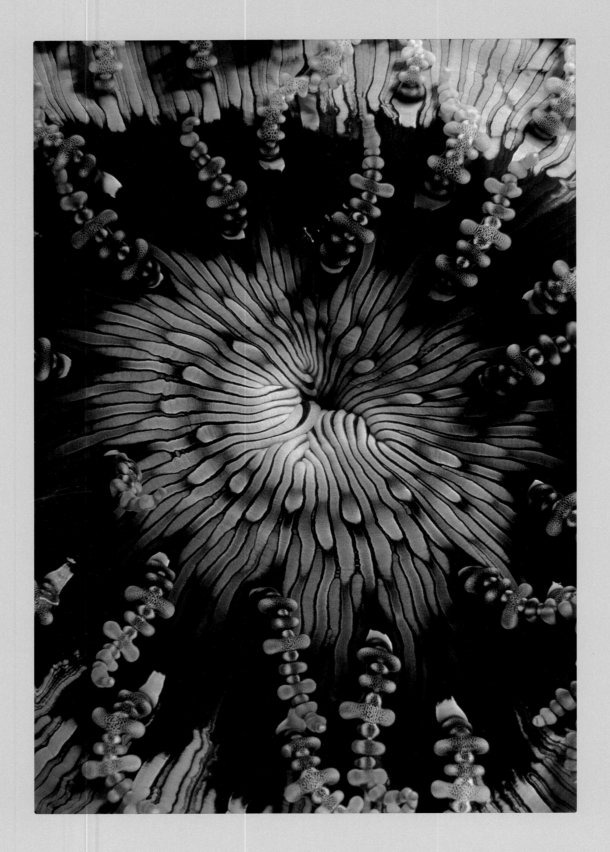

*Beaded Sea Anemone*

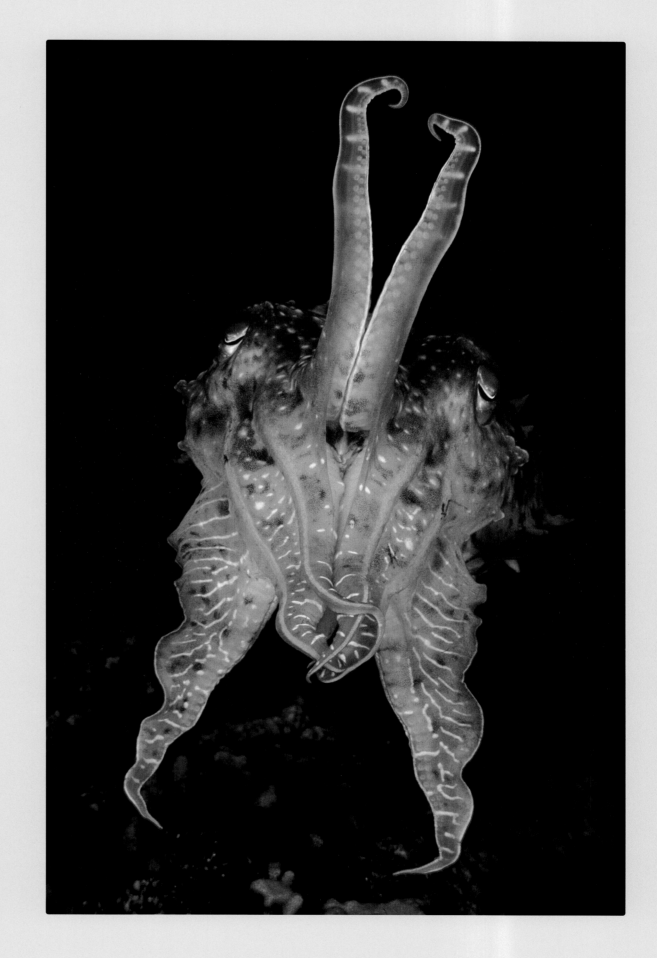

*Cuttlefish*

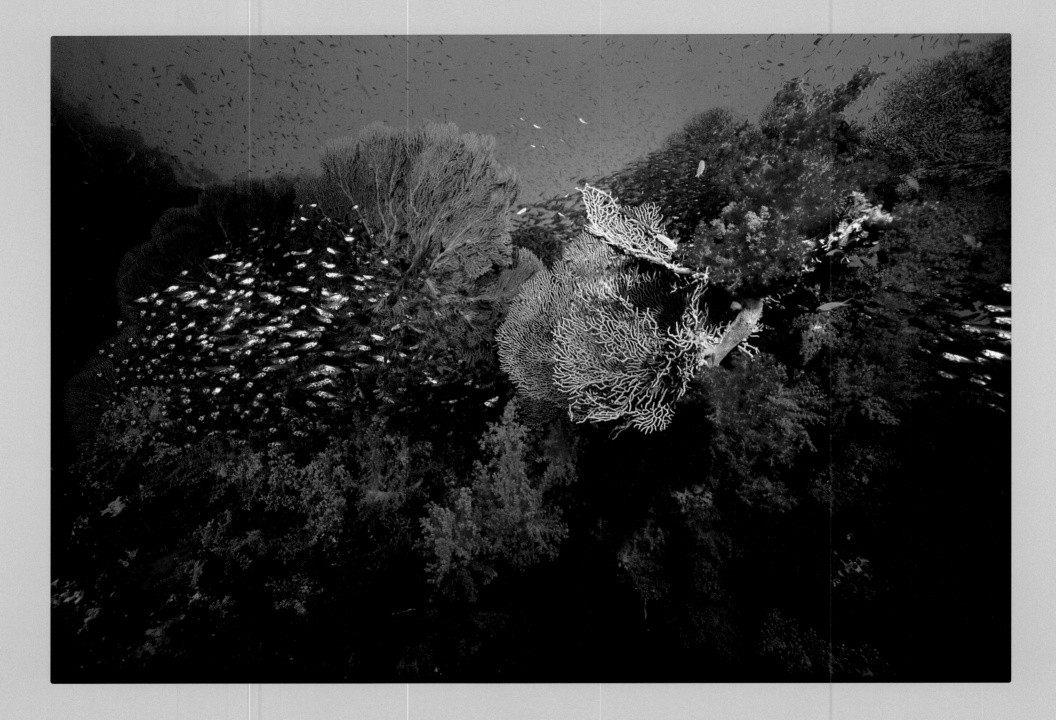

*Red Sea Reef Scenic*

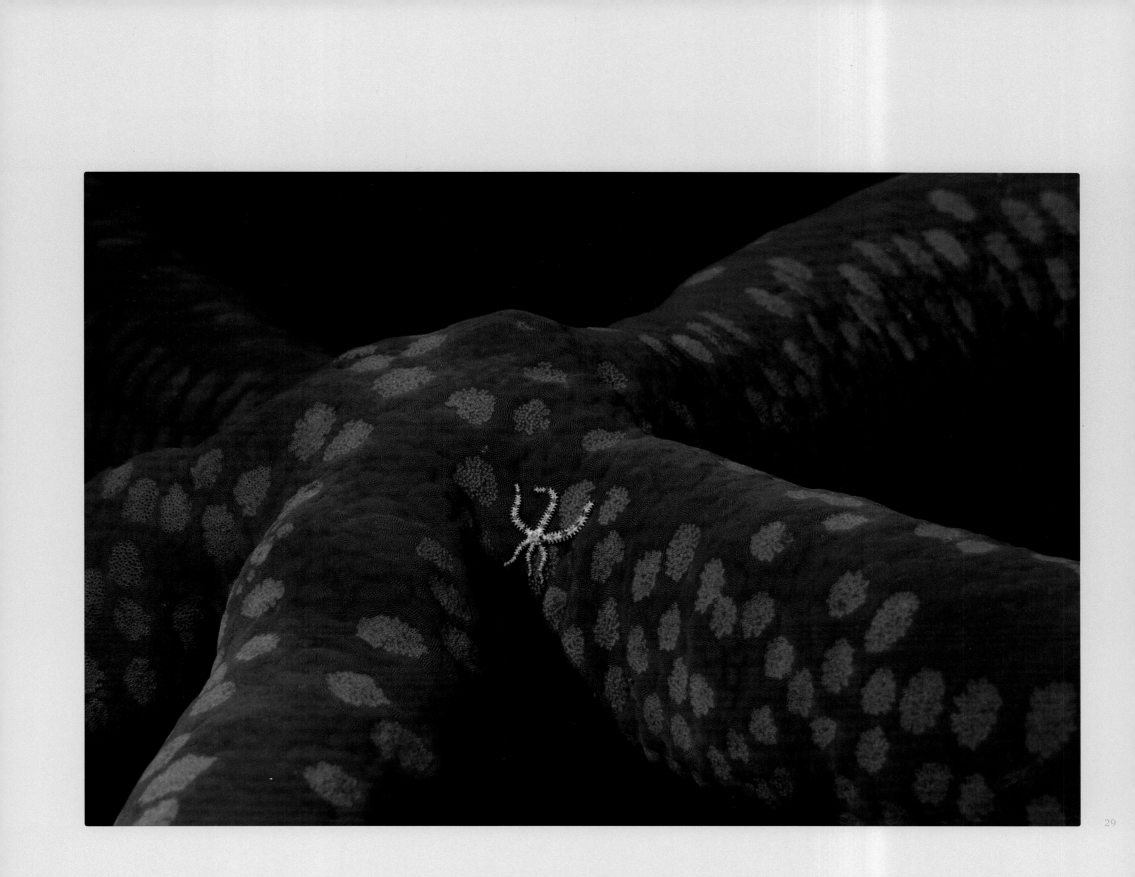

29

*Juvenile Brittle Starfish on Sea Star*

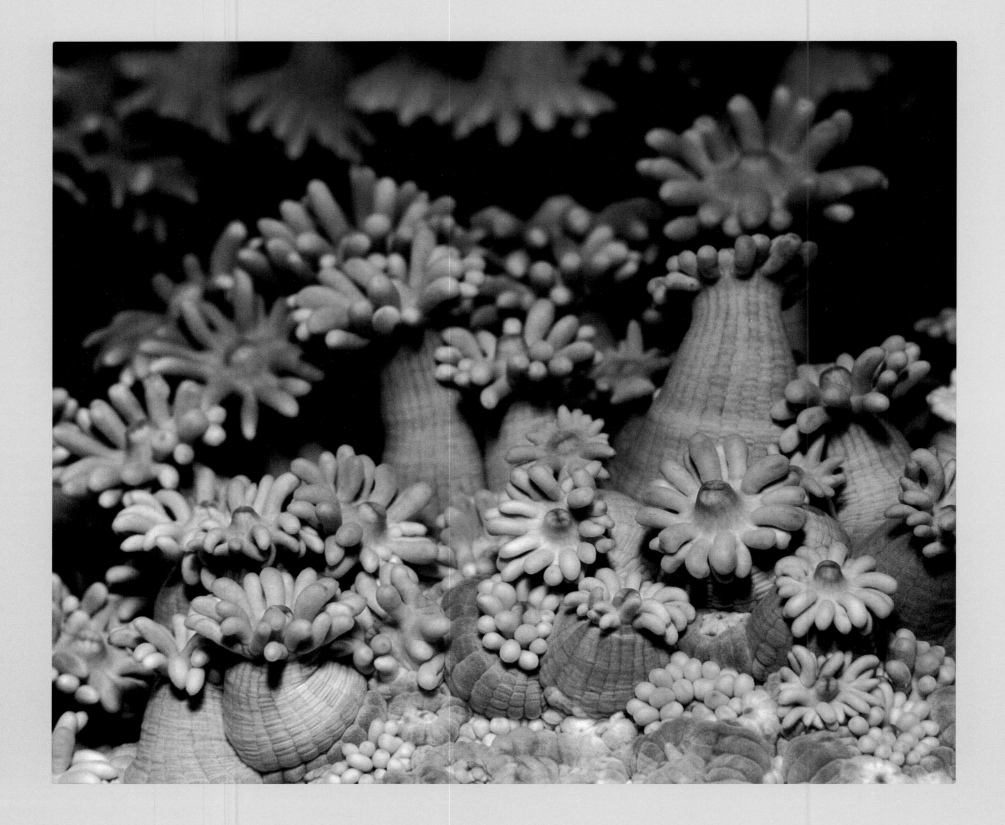

*Hot Lips Daisy Coral*

Still growing from this prehistoric sea floor,
    the mountain I watch daily is home to its own thriving, evolving community of life.
    Wind, rain, expanding ice, roots of trees and grasses and plants, hooves of deer and elk and horses,
    paws of mountain lions, bear, and coyote, the feet of humans and the tracks of our machines–
    all will inevitably conspire to break this mountain down, to make it, too, vanish.
    In time, slowly,
    but most surely,
    water will return this mountain to the sea.
    Through our windows I catch but the briefest glimpses of this process
    which illuminates our place in the continuum of life.

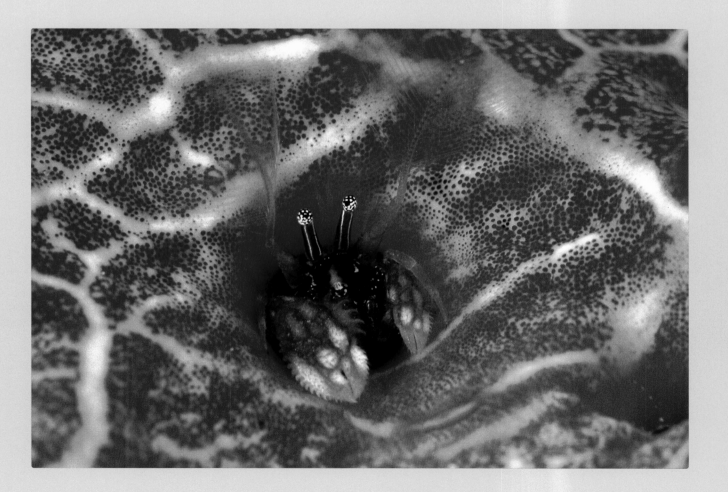

*Hermit Crab*

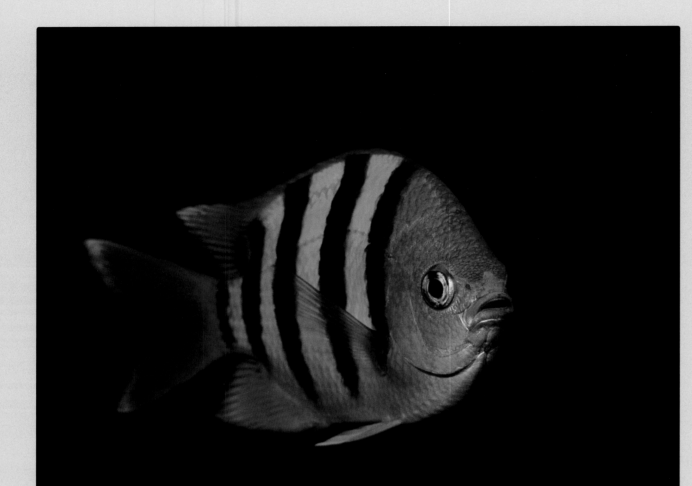

*Sergeant Major*

Different windows join many worlds, and in a unique way dreams, too, are windows,
giving us a view into our inner landscapes.
Beneath us now lay ancestral remains of the marine life whose photographic images decorate our walls.
When the sun is right, reflections from these prints are mirrored on our windows.
During these moments, as we look out upon the vanished sea around us, a menagerie of ocean life swims through our view,
across the vast white canvas of the snow-capped mountain.
In this synthesis of light, two worlds are momentarily merged, land and sea reunited.
The ancient blends with the present, while dreams intermingle with reality.
All has become one, wedded in this moment to its source,
as together we drift in a sea of dreams.

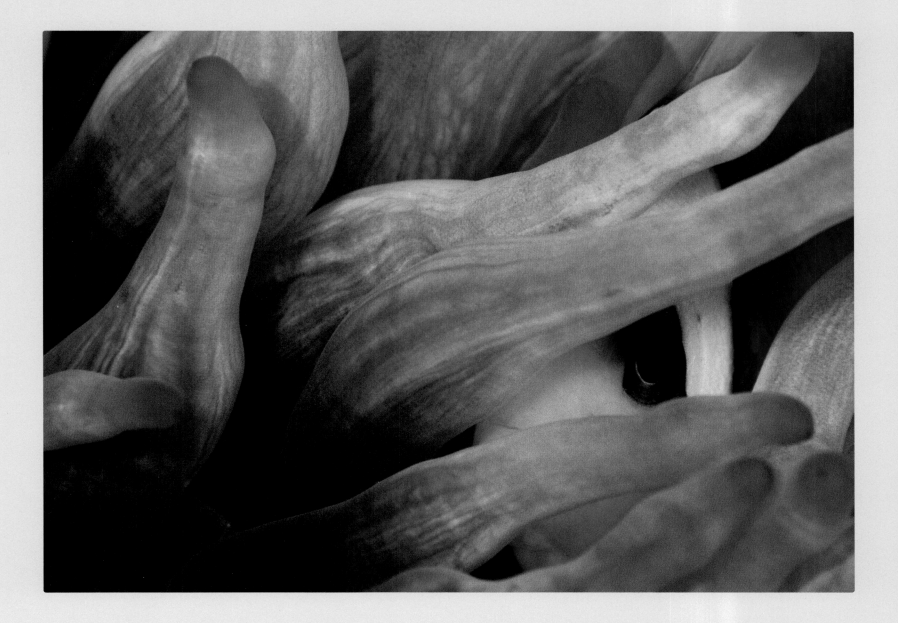

33

*Sleeping Anemonefish*

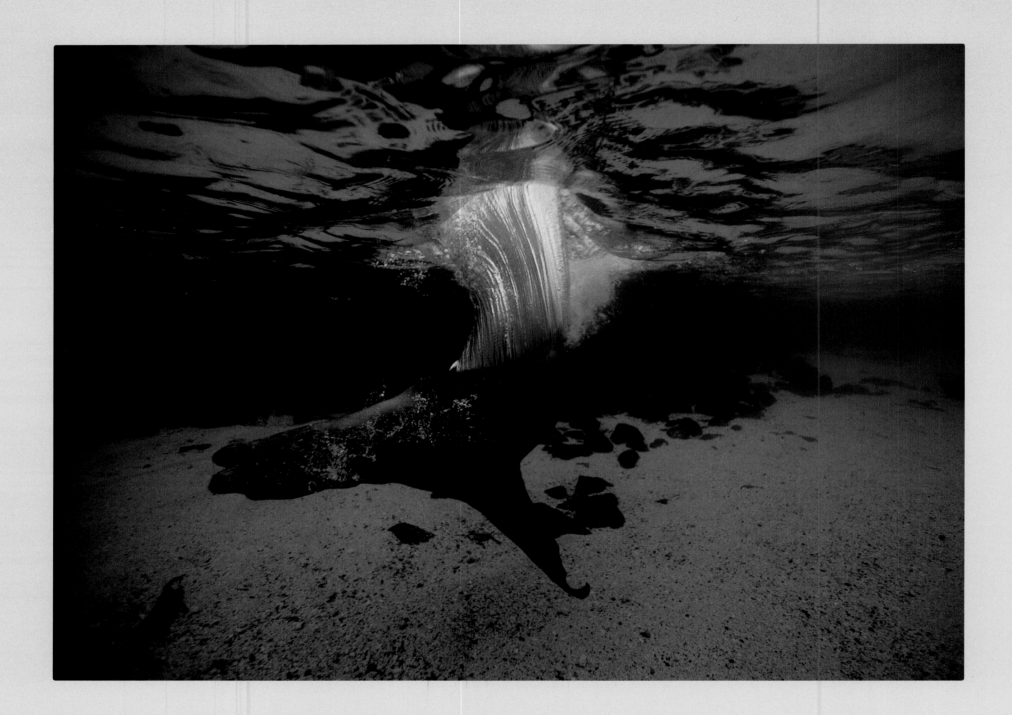

*Sea Lion*

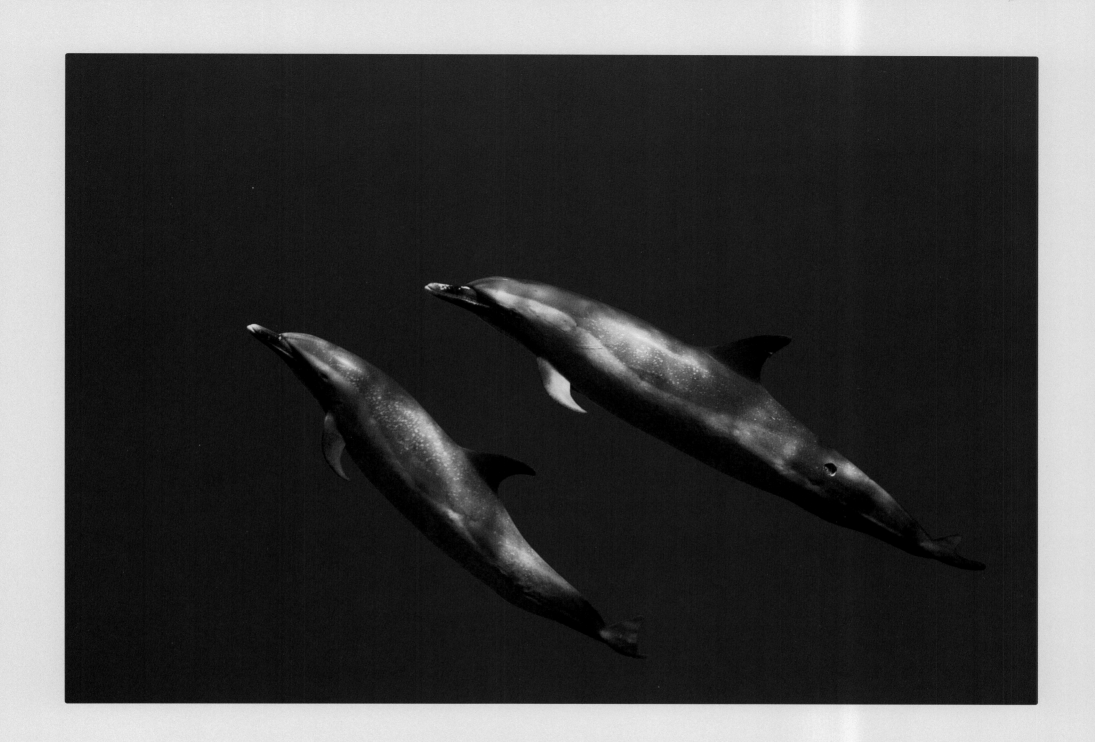

*Pacific Spotted Dolphins*

*P*uffy charcoal clouds all around us hung low and heavy on the horizon,
drifting like schools of jellyfish gathered by an early morning tide.
Tendrils of distant rain showers fell gently from their bellies,
slender tentacles reaching to the sea below.
Here and there laser beams of light from the rising sun
melted the somber grey overcast.
A sea of blue
poured through every fresh opening,
soon flooding the sky above.
In the distance the jellyfish began a slow retreat as the new day gradually came to life.
Mountainous islands cloaked in thick coats of jungle
rose sporadically through the dissipating mist,
oases of green in high relief
punctuating an endless plain of featureless blue ocean.

Fed daily by the jellyfish clouds,
the trees and vines and ferns and flowers had woven
a ragged green carpet covering an ancient floor of coral reef,
each species struggling for dominance,
reaching upward for the sun.
Or they had surrendered, adapting to a life in the shade,
thriving in the cooler underbelly of the jungle canopy.
Along with birds and reptiles, insects and snails, a handful of smaller mammals
such as possums, giant rats, and flying foxes
found life agreeable in this chaotic jungle foliage.
Especially the birds, it would seem.
The elegant hues of the eclectic parrots,
the flowing pure white plumage of the cockatoos,
the moody herons stalking their prey,
the cacophony of nonstop singing,
chirps and whistles from the rainbow lorikeets.
The birds are splashes of dancing color and vibrant energy
on a lethargic canvas of green.

Surrounding each island, resting just beneath the surface
yet falling off hundreds of feet into the deep blue,
lies a magnificent network of coral reefs so luxuriant in color,
so diverse in flora and fauna, so intricate in architecture
that the singular beauty of the islands themselves pales in comparison.
Largely unexplored, such reefs harbor life forms
never before seen, species yet to be named.
More than this, they nourish a spirit of exploration,
leading to unexamined places within our world,
sometimes within ourselves.
These special reefs hold our dreams of discovery.

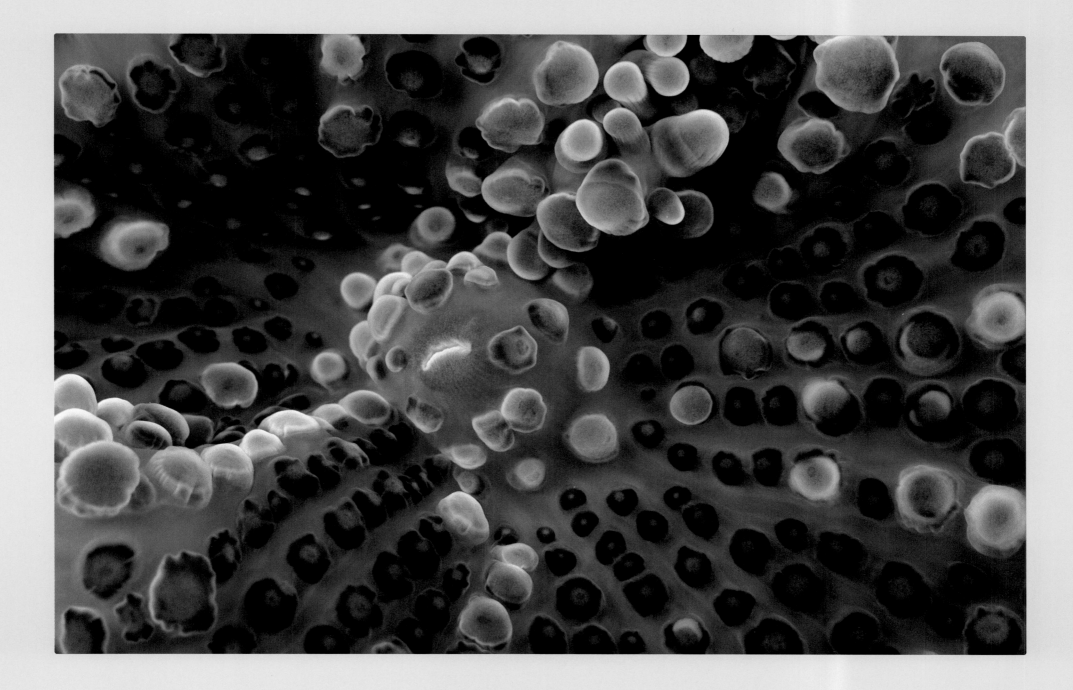

*Corallimorpharid Detail*

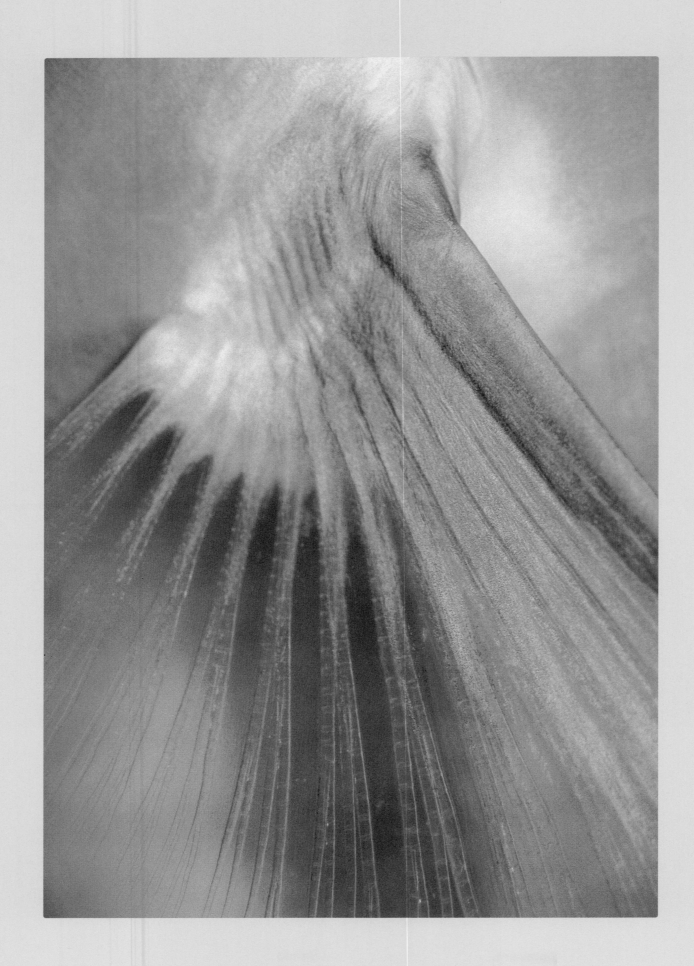

*Parrotfish Pectoral Fin*

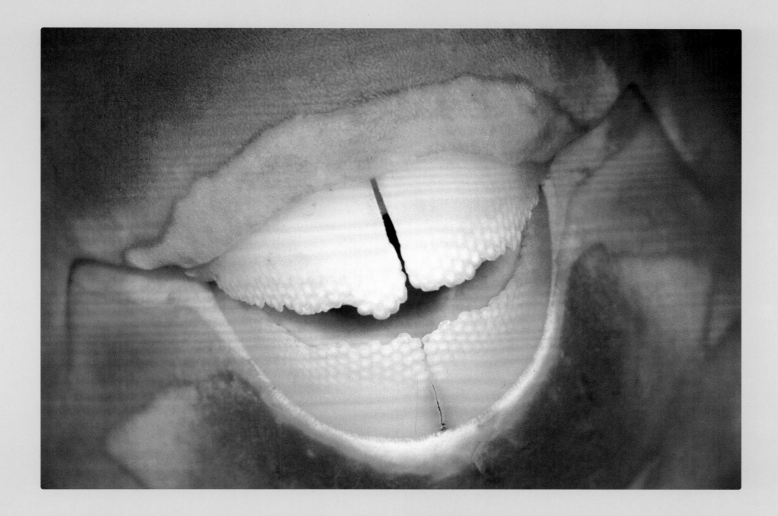

*Parrotfish Mouth*

*Triggerfish Fin Detail*

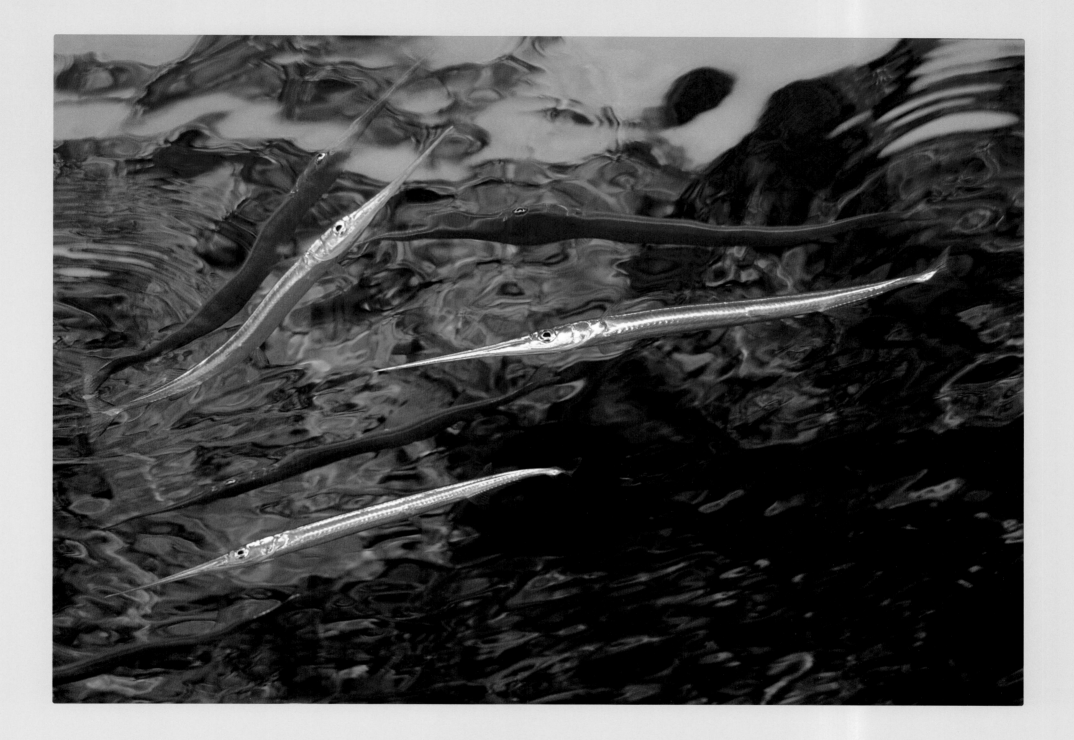

*Needlefish*

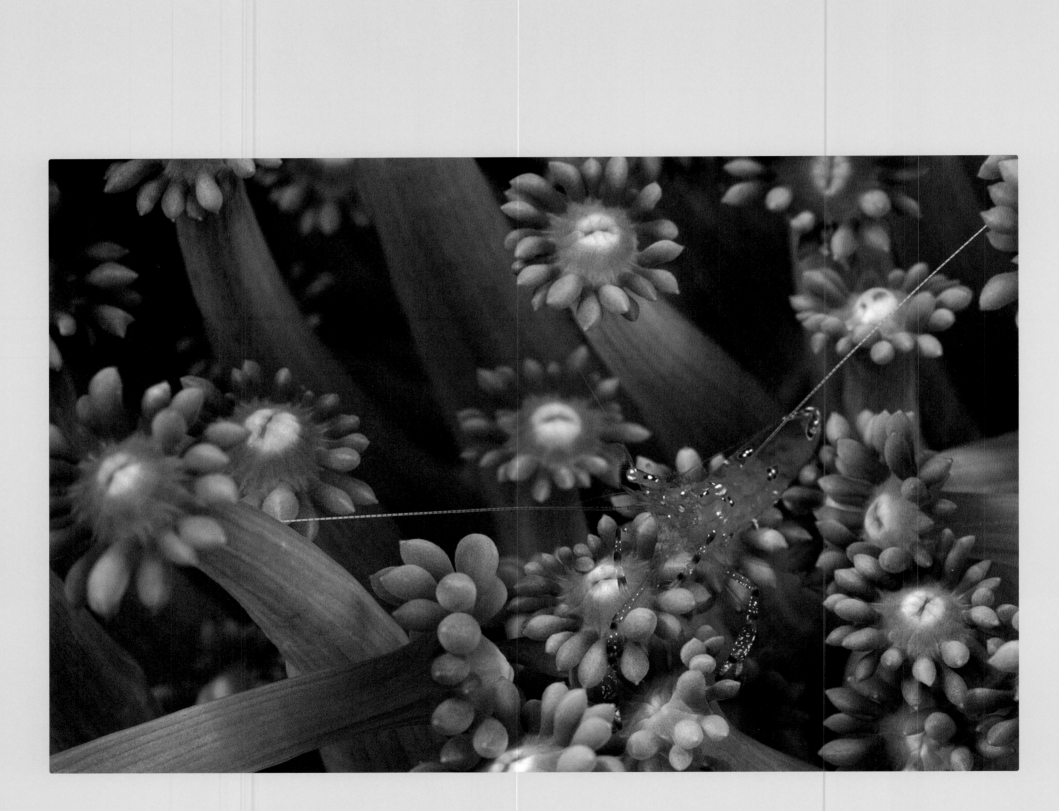

42

*Shrimp on Daisy Coral*

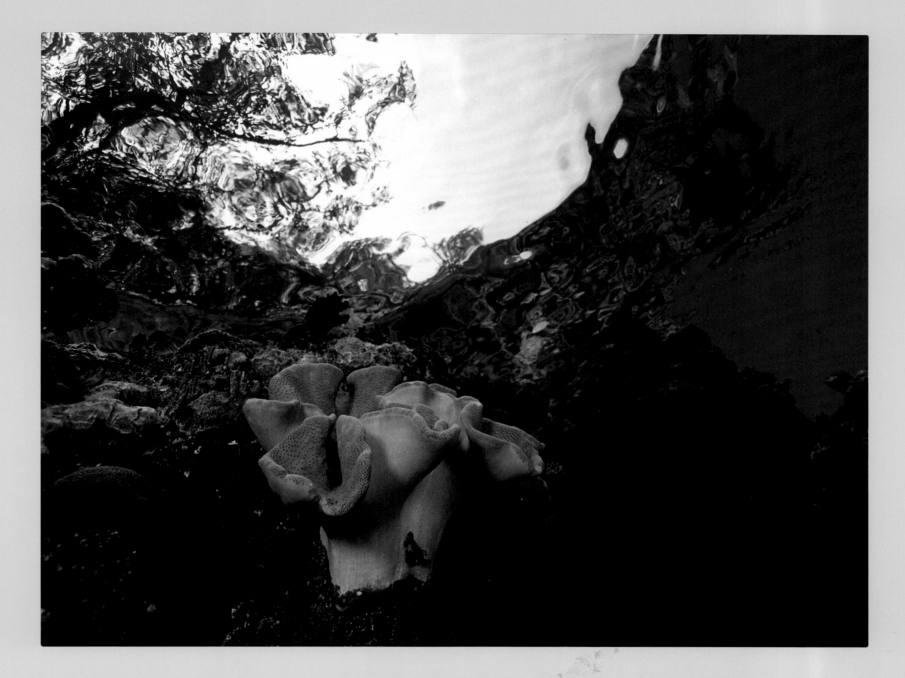

*Leather Coral*

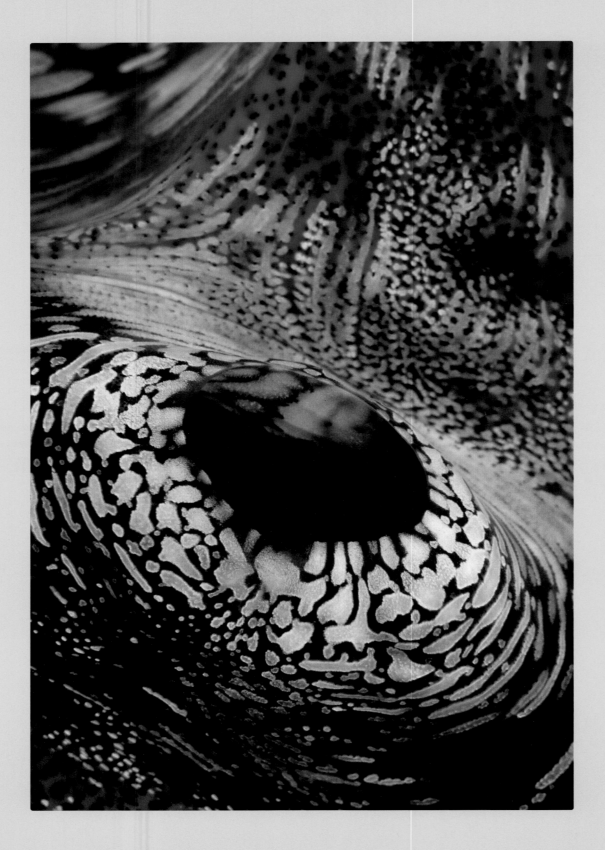

*Tridacna Clam Siphon*

44

As the awakening tide flowed easily
through the reef passage,
I was carried like a lover's dream
on a spring breeze, weightless,
exuberant, and free,
over ravines
and larger canyons
etching the face
of the tangled coral slopes,
leading to a steep undersea drop-off.

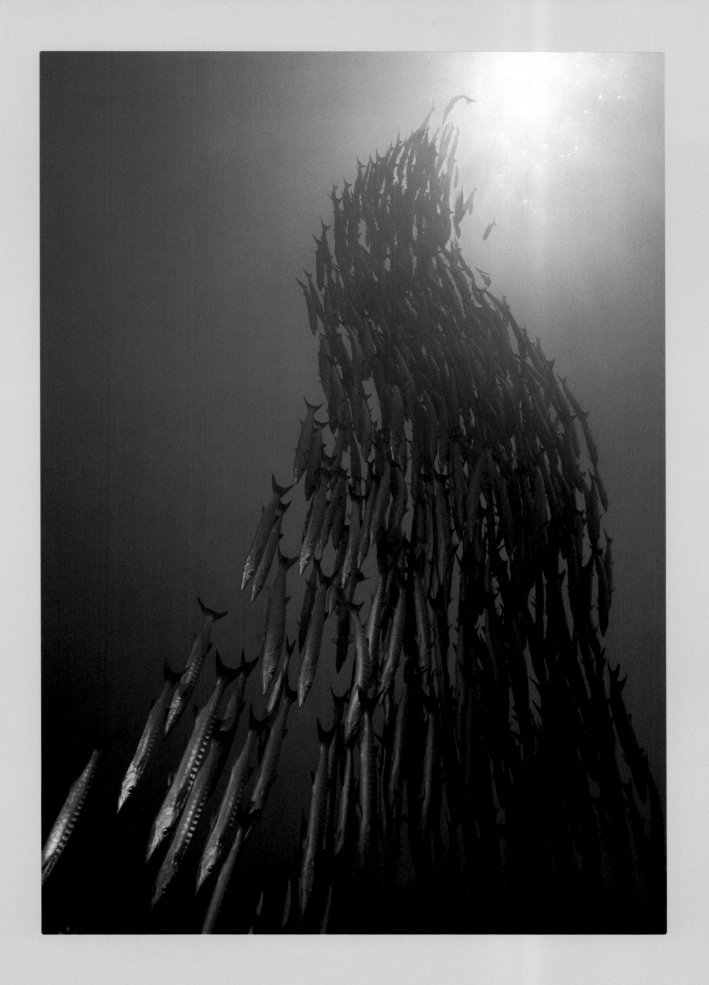

*School of Barracuda*

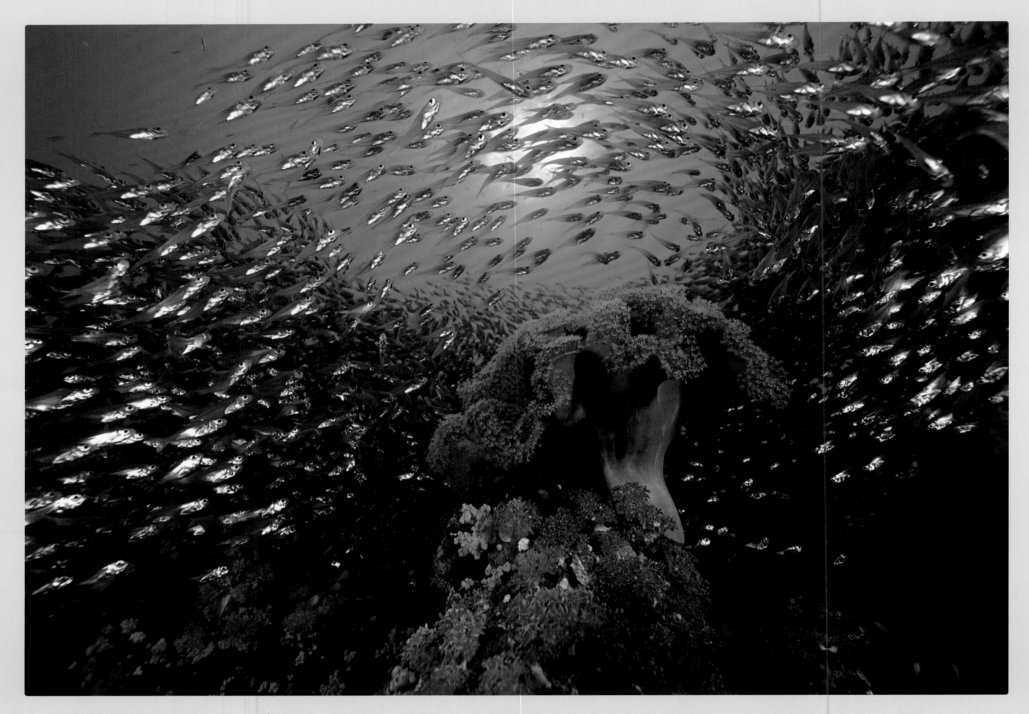

*Leather Coral and Glassfish*

Laden with fresh nutrients, the current tempted small,
plankton-eating fish by the tens of thousands from their protective cover in the coral.
I watched several varieties of anthias, largely purple, yellow, pink, and orange, fill the ocean
with their vivid sunrise colors as they ventured well off the reef to feed.
Though gathered in immense numbers, they were not organized in any apparent schooling formation.
With twitching, sporadic movements they lunged at nondescript bits of passing plankton,
creating a festival of colorful confusion above the bustling coral reef.

Magnificent square-spot anthias vied with purple queen basslets in a pompous rivalry marked by neon excess.
Like many other fish, the males of these species began life as females.
In the absence of a male among a particular bevy, the dominant female will reverse sex.
By maintaining cohesive groupings in this fashion with a male always present among many females,
they eliminate the need to stray too far from their familiar reef area during the course of reproduction,
and thus their exposure to danger is minimized.
But when it comes to feeding,
competition for the existing food draws them higher into the water column,
farther away from the safety of their protective coral home.
So there they were, countless morsels of hot pink and purple
dancing high above the protection of the reef,
appearing oblivious to any potential danger and paying
no attention to me as I sailed through this swirl of multicolored confetti.

Surrounding the anthias, many thousands of tiny silversides frantically nipped at any passing nutriments.
Hawkfish everywhere, some large, some small, variously striped, speckled or checkered,
long-nosed or short, all watched hungrily, waiting for some food to drift their way.
But lacking the air-filled swim bladders which give other fish neutral buoyancy and the ability
to swim effortlessly, the heavy hawkfishes sat instead,
resting on gorgonian sea fans, rocks, or various hard corals,
greatly minimizing their peril from predators as they remained partially hidden in this coral thicket.
All about them
a staggering variety of butterflyfish, angelfish,
wrasses, parrotfish, surgeonfish, blennies, and gobies hopped,
swam, perched, and lurched,
taking maximum advantage of the food flowing in with the tide.
Large herds of enormous bumphead parrotfish grazed nearby,
biting off big chunks of coral with their powerful beaks. It was not the stony coral they found
nutritious, but the mixture of algae, waxes, and soft polyps contained in each hard coral cell which
nourished these robust fish. And with their distinctly fused teeth,
nature had given these creatures a unique tool to quarry her lavish coral gardens.

As they would swim off, silty curtains of finely crushed excreted coral trailed behind them,
clouding the water for a time until the current carried the newly formed sand away.
This sand would fall like a light rain,
finding pockets and plateaus in the reef on which to settle.
Eventually overflowing these smaller pools,
the coral sand would trickle like small mountain creeks down the sides of embankments,
then join wider streams which fed large sand rivers,
coming to rest at last on broad sandy deltas.
The flows were sand clocks marking the passing ages in a timeless world.
This once-digested coral was now home for an intriguing menagerie of subterranean aquatic creatures,
small tunneling shrimp, burrowing fish of all descriptions, urchins, luminescent anemones,
feather tube worms with bright plumed headdresses, and curvaceous, gleaming shells.
As deceptive to the casual eye as a vast terrestrial desert, these undersea sandy plains were brimming with life.

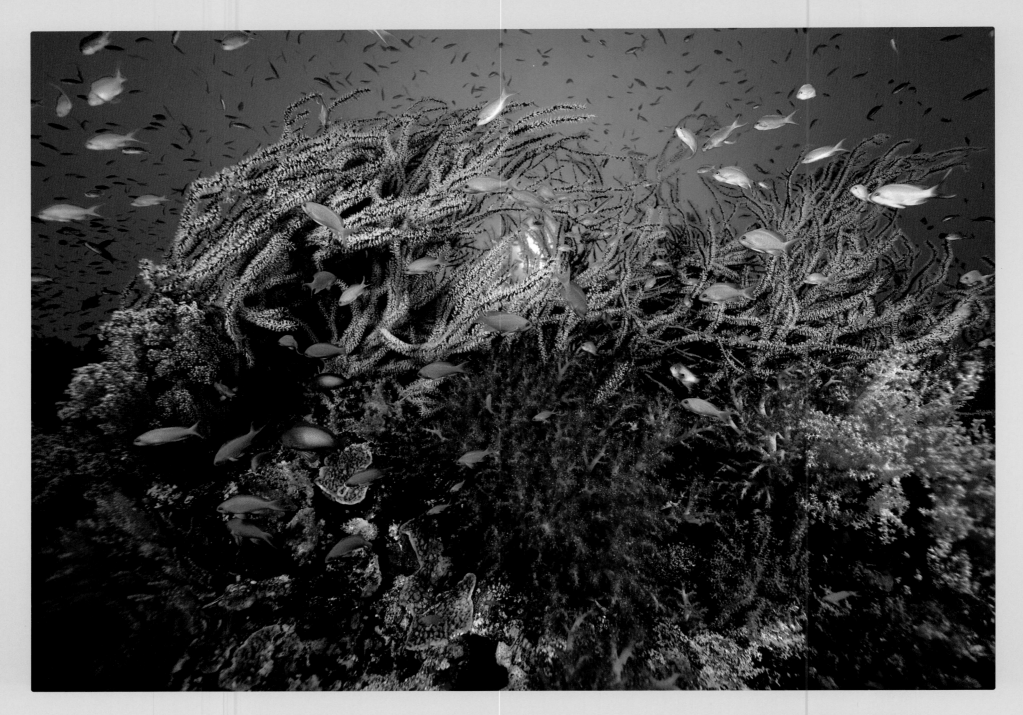

*Sea Whips and Pseudanthias*

A tremendous report thundered from somewhere below.  Two huge bumphead parrotfish retreated,
circled wide, then turned and swam full speed at each other toward a massive head-on collision.
Another explosive boom reverberated across the reef as they hit once again.
Was this some territorial battle perhaps,
the fight for male dominance of a harem?
Was this the purpose of the large bulbous knot on their forehead,
or merely how they got that way?

*Stargazer*

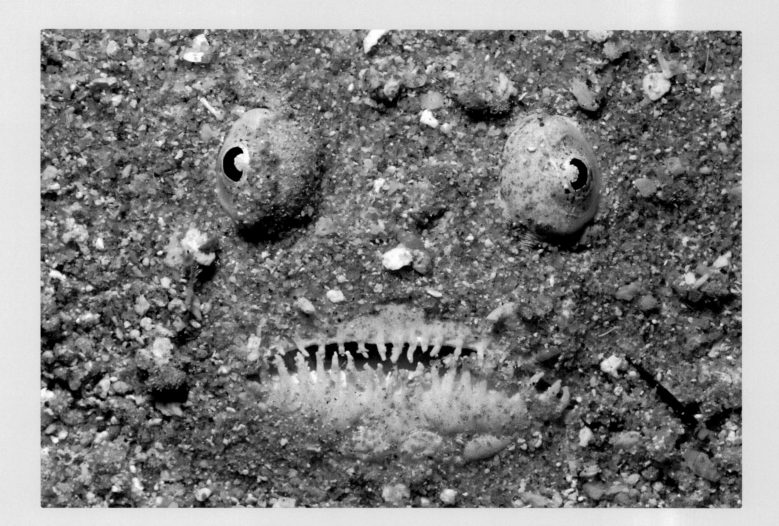

Their beak-like mouths made the fish look all the more preposterous,
but the euphoric effect of nitrogen at depth made such foolish
speculation somehow plausible to me.
Again they crashed mightily,
and I winced at the impact,
but no particular attention was paid to the parrotfish by others on the reef,
as activity surrounding me continued at a frenetic pace.

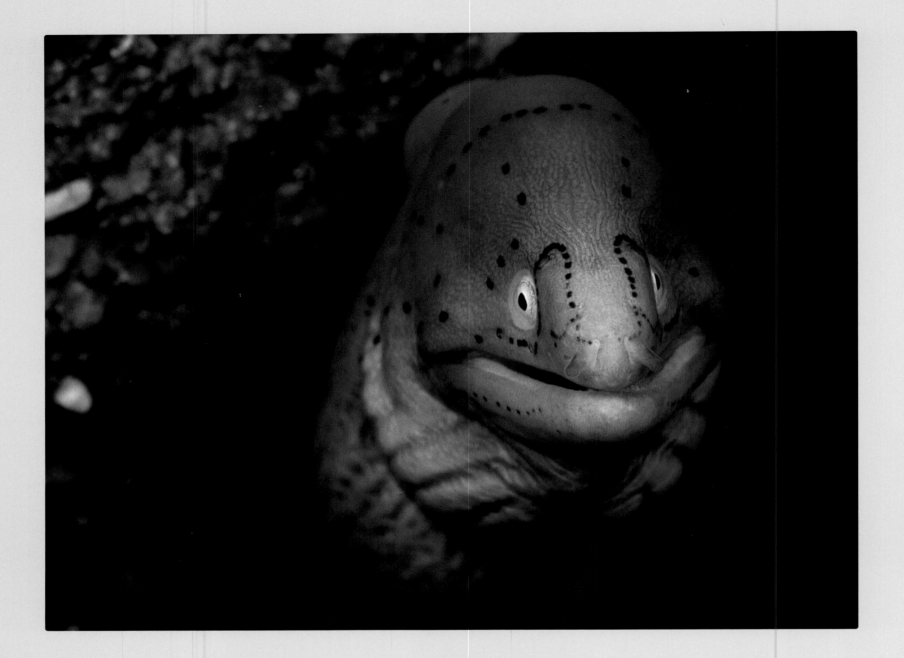

*Grey Moray Eel*

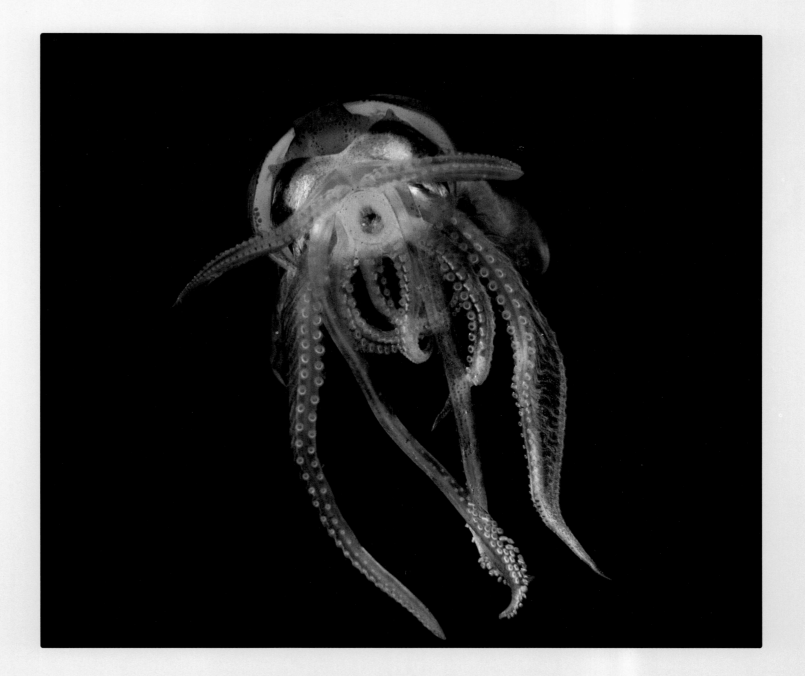

*Pelagic Squid*

By the hundreds, tiny hermit crabs with brightly decorated claws and hairy bodies
peered out from vacated serpulid worm holes in the coral.
Bulging from the ends of protruding stalks, their eyes were striped or speckled
and waved about erratically, one independent of the other.
I wondered if my underwater strobes with their large spherical ports,
attached to the ends of long strobe arms,
might appear like huge stalked eyes to them,
and I, the hermit crab from hell.

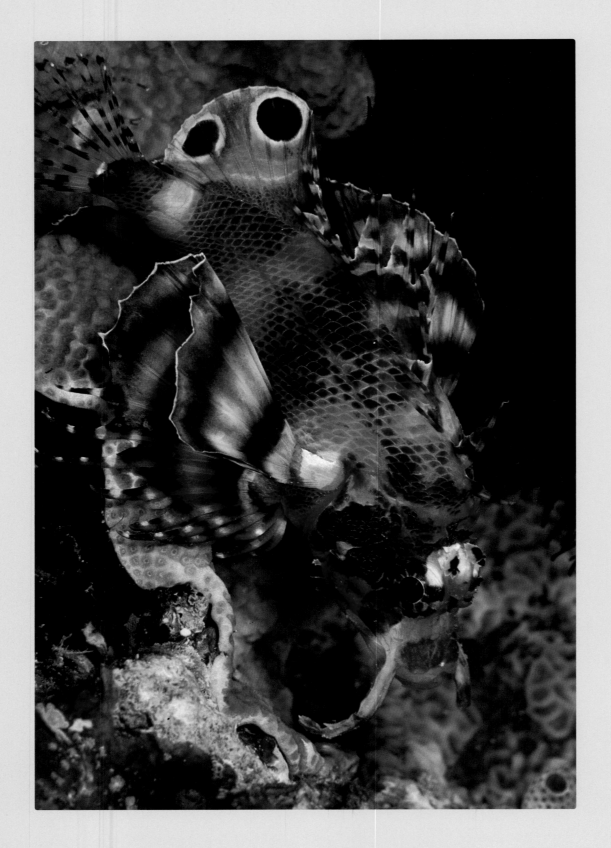

*Oscellated Lionfish*

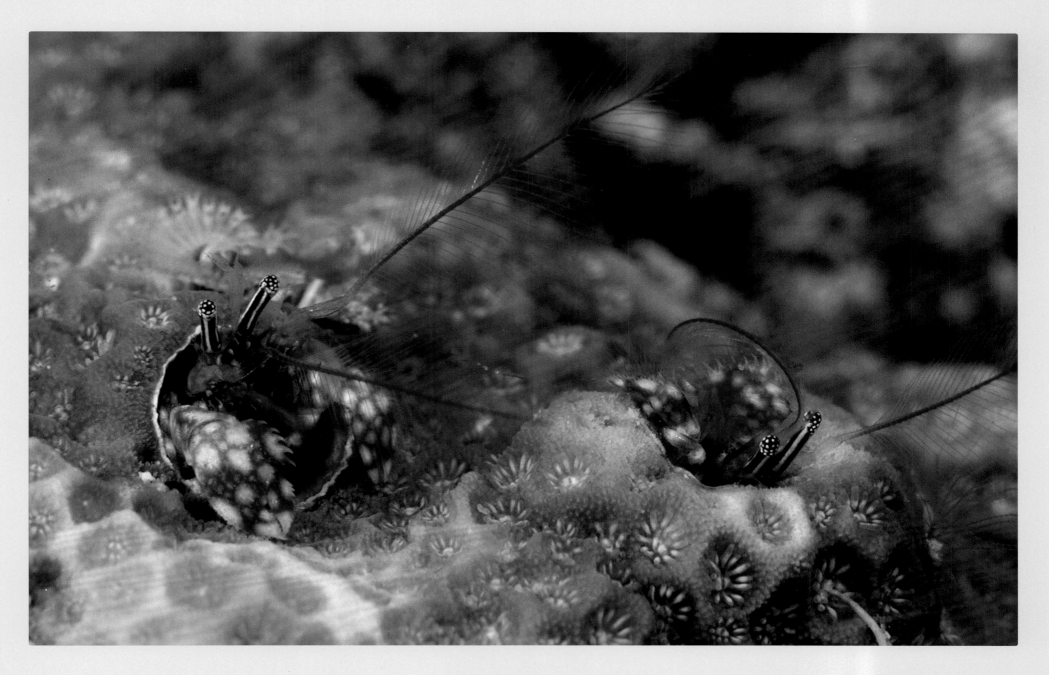

*Hermit Crabs*

Their long, feather-like antennae rotated this way and that,
arrayed like countless little fishing nets across the surface of the coral,
capturing the passing bounty.
Popping in and out of their holes as if on springs,
they were a miniature madcap colony of crazed crustaceans.

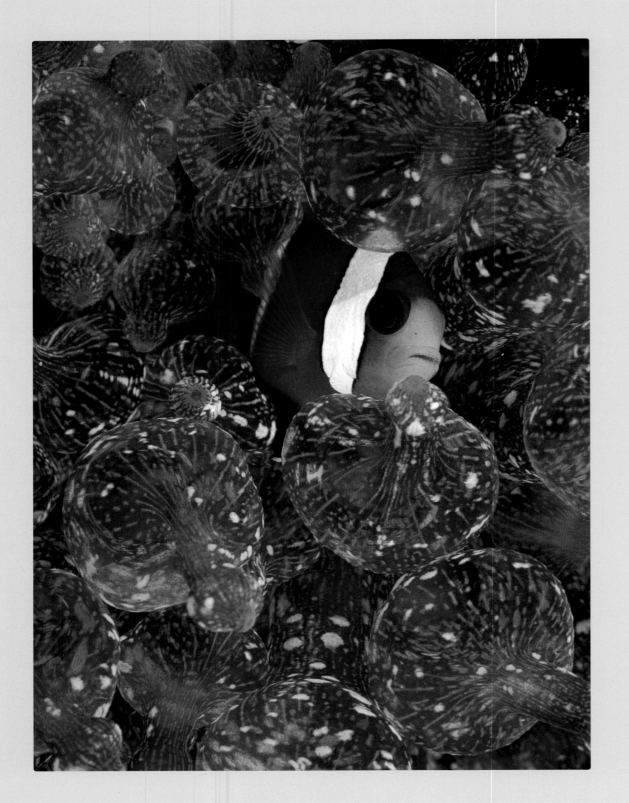

54

Nudibranchs of many dozen varieties
      foraged for food, courted mates,
         or were laying their chiffon ribbons of eggs
   on rocks, on top of sea squirts,
            or on any smooth surface they might find.
The reef was a gallery of these shell-less mollusks,
               gaily colored and delicate of design,
            each species
      more beautifully rendered than the one before.
I longed to frame them all in my lens,
      to paint each individual with the light from my strobe,
         to possess on film the spirit of beauty
            which had created such masterpieces.

Soft corals bloomed luxuriantly,
      unfurling their water-filled limbs,
         exposing their hungry polyps
            to the food-laden current.
   Fully extended, they formed a lush carpet
      of reds, purples, yellows, and pinks,
         muted peaceful and pastel
            by the sea-filtered sunlight.

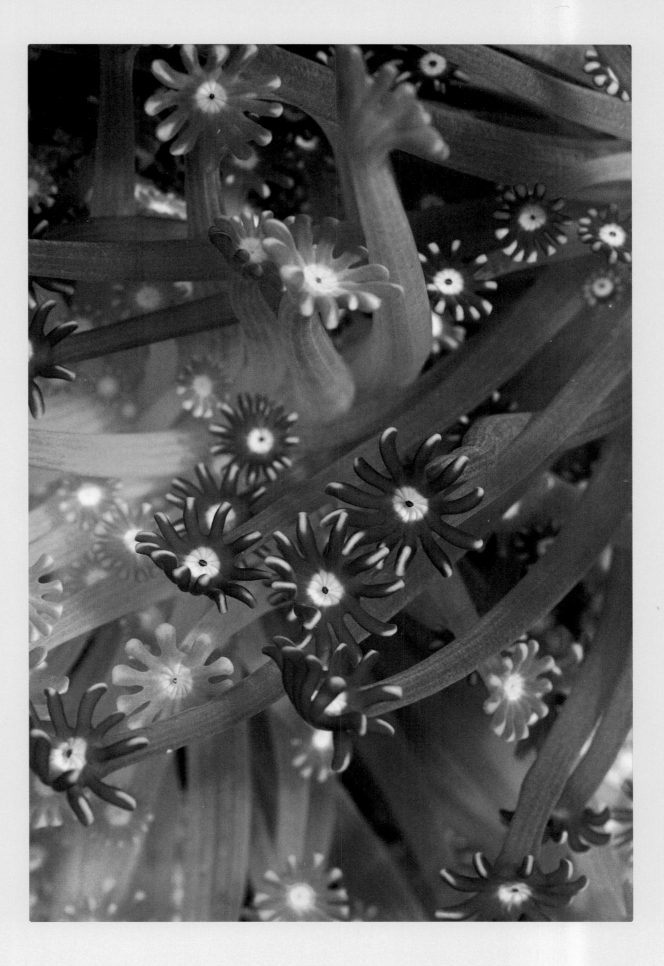

*Coral Polyps*

55

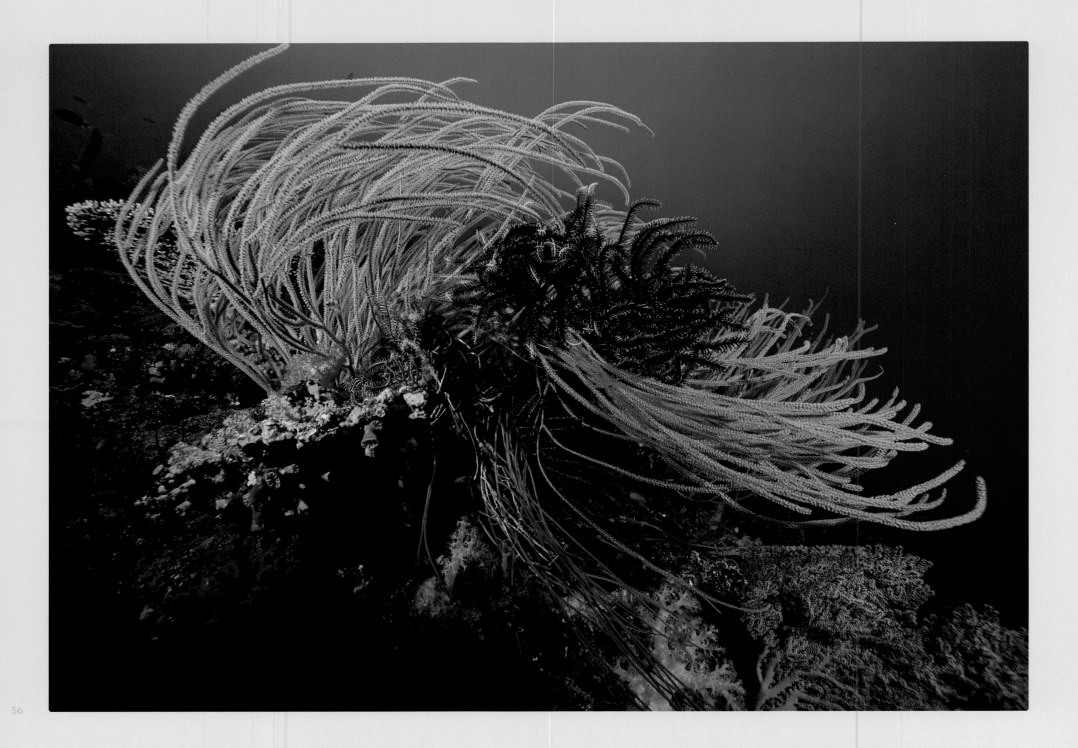

*Sea Whips*

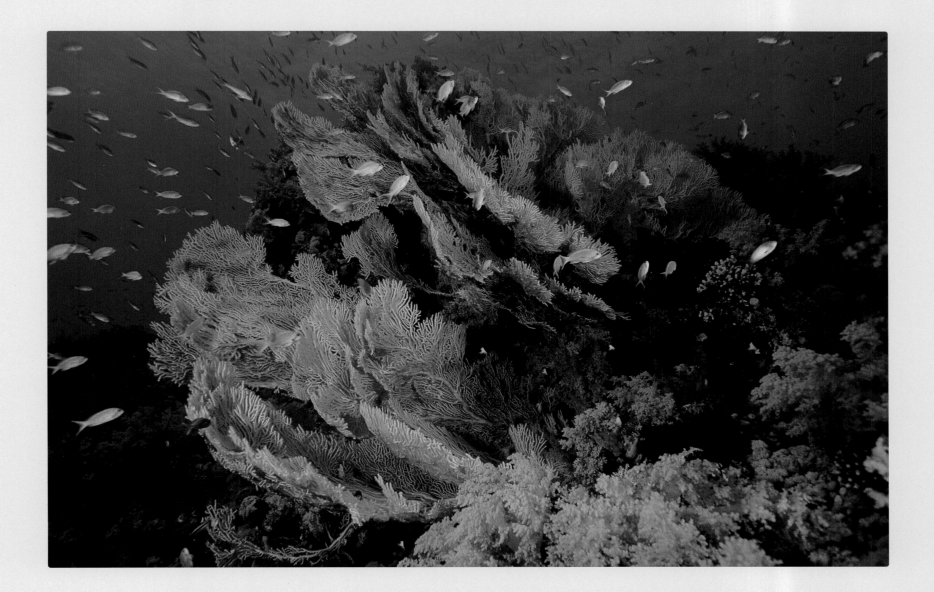

Tiny camouflaged gobies scurried up and down the crimson branches of fifteen foot wide gorgonian sea fans,
scavenging bits of plankton captured by the fans' polyps.
Row upon row of such massive, swaying fans lined these plunging undersea walls,
perpendicular to the current to better maximize their feeding efficiency.
Each fan was formed of thousands and thousands of minute, flower-like polyps.
Every polyp, a separate and unique animal unto itself,
developed and grew in cooperation with its neighbor,
creating flexible colonial structures both intricate and huge.
Buoyed by the water,
they would achieve improbable formations
impossible to duplicate on land.

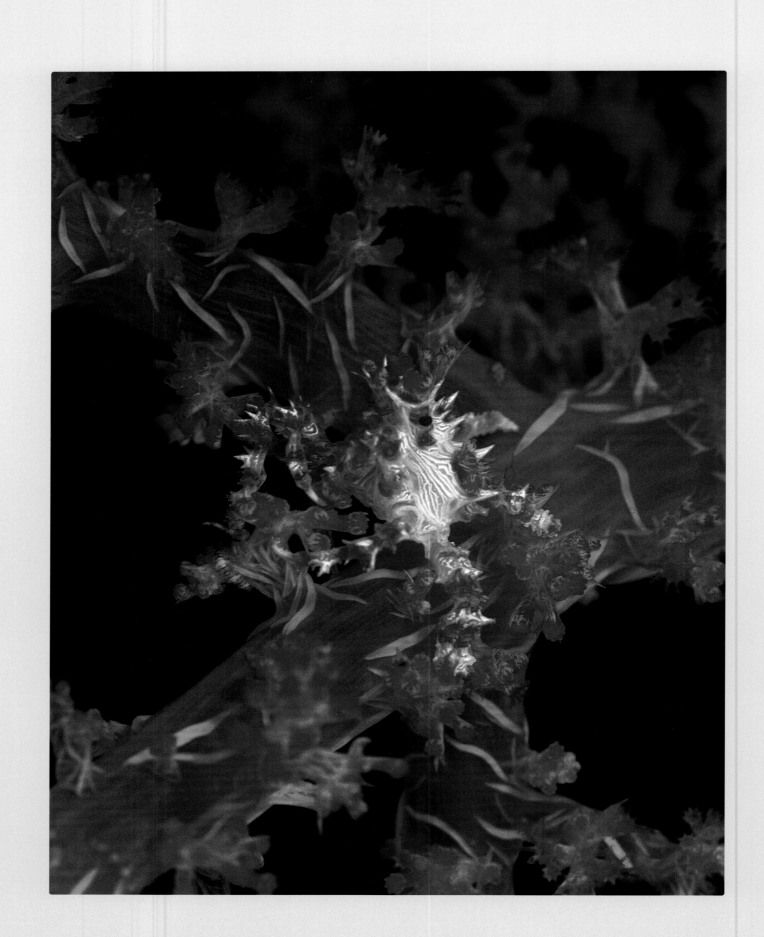

*Decorator Crab on Soft Coral*

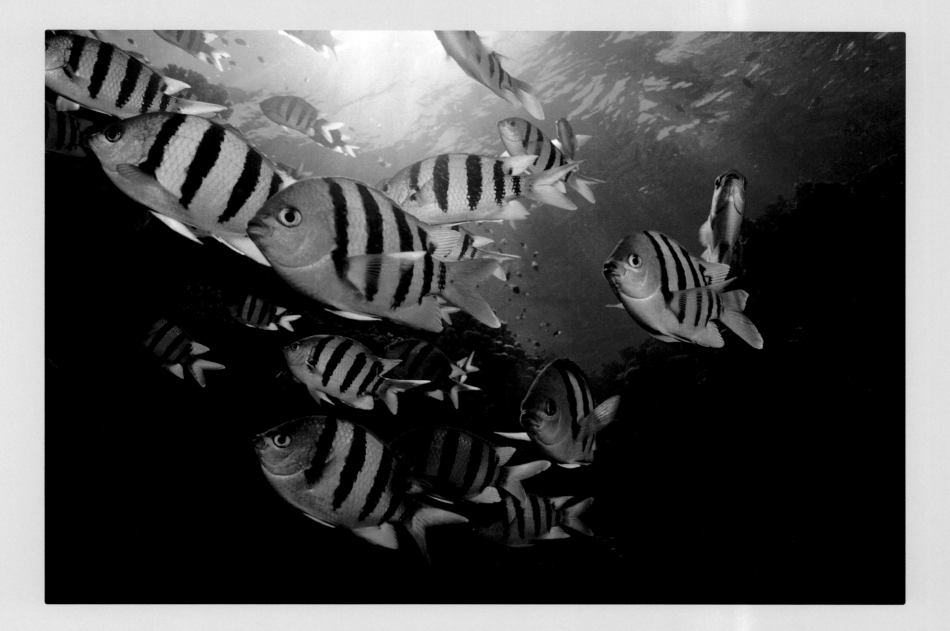

*Sergeant Majors*

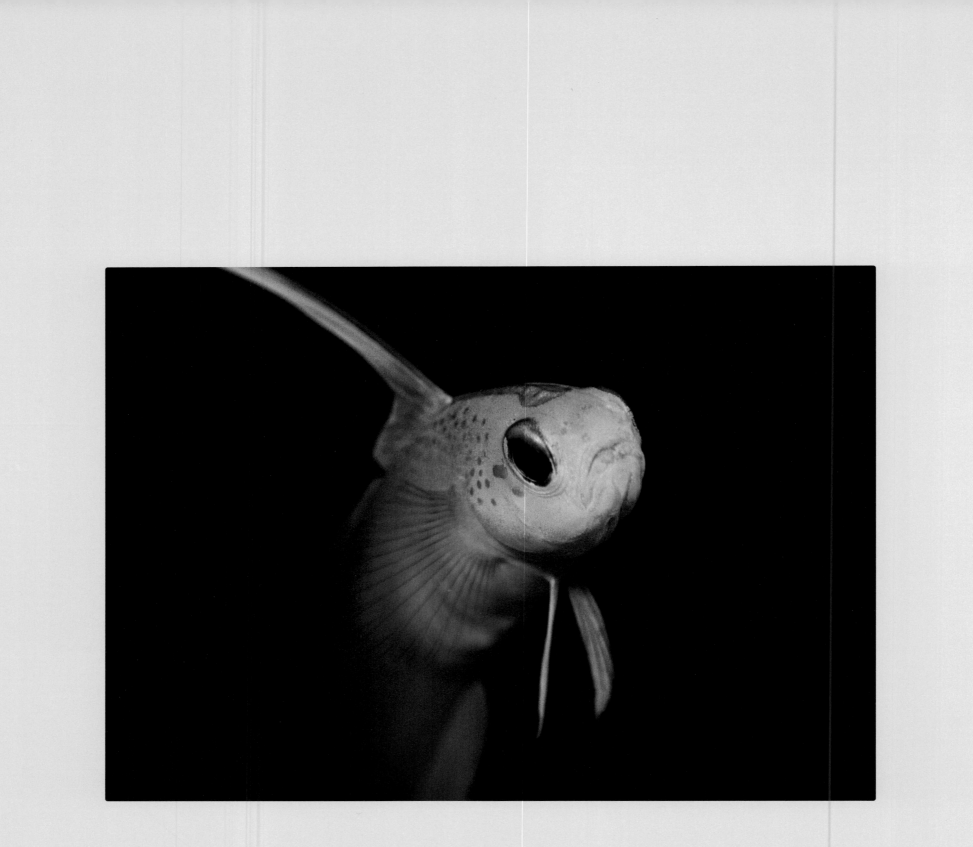

*Fire Goby*

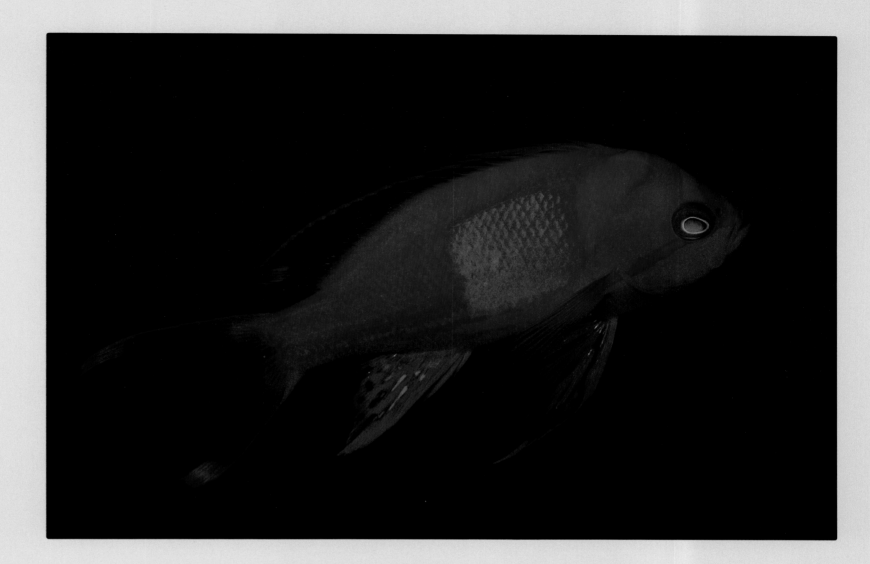

*Squarespot Basslet*

On these elegant coral arabesques many other creatures commonly made their home.
Many of the fans wore a flowered collar of crinoids, black, silver, golden yellow, and scarlet.
They would cluster along outer edges of these gorgonia
where their gently waving pinnate arms could reap a more fruitful yield of planktonic riches.
And each crinoid was itself home to a variety of ever smaller sea beings,
shrimp living on their arms, crabs hiding among their feet,
or clingfish resting near their mouths.
The layers of life seemed to go on forever,
each species more surreal than the next.

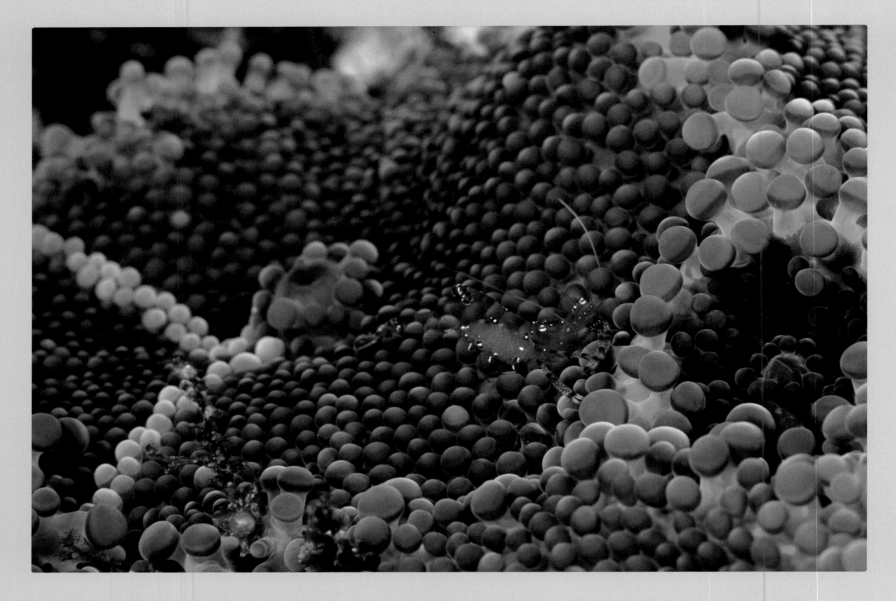

*Shrimp on Corallimorpharid*

Through the magnifying lens of my camera, I was drawn ever deeper into an intoxicating world of fantasy
and splendid mystery.  My lens was a kaleidoscope where familiar perspectives distorted,
and unexpected, dazzling colors burst into my eyes.
The known dissolved into magnificent dreamscapes
populated by wondrous creatures from some imaginary fable.

Sponges, feather worms, ascidians, and anemones
formed a collage of dizzying shape and hue.
All the while at my back, thick curtains of radiant blue fusiliers hung in the open water
directly off the lip of the drop off, flashing in the sunlight like blinking stars.
But it was those millions of baitfish which became such an inviting lure.

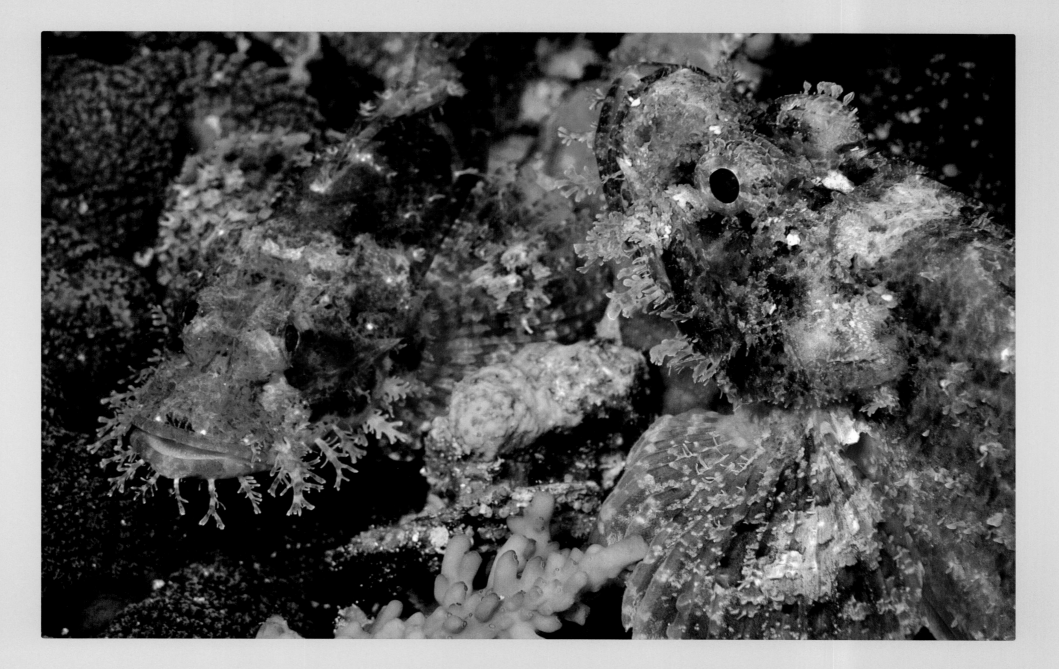

*Scorpionfish*

And so the predators were drawn.
While plankton might be sufficient for many smaller fish,
the jack is an accomplished hunter, thriving on more challenging prey.
Combining lightning speed and agility with a voracious appetite,
they closed in from the deep, casting hungry eyes at the smorgasbord before them.
Many different species were among them, for over two dozen types of jacks are found in these waters.
The striking diamond trevally, long dorsal filaments trailing like traces of light, glided by in no particular hurry,
but with a sure sense of authority. Then several giant ulua shot past,
steering an erratic course through the heavy traffic, cruising the open water above the reef.
The largest member of this family, they can attain weights of up to one hundred fifty pounds of solid muscle, teeth, and hunger.
One could imagine the fearsome sight they would present to anything smaller in their path,
for their mouths were slightly agape and menacing, their stare cold and intent.

A huge cascade of big-eyed jacks fanned across the blue-water background,
luminescing as their smooth silver scales caught the sun when they turned on their sides,
reflecting that wayward starlight back to the sky, eighty feet above.
Thousands of rainbow runners swam by in an endless procession.
Their elongated blue-grey bodies with forked yellow tails and horizontal blue stripes glowed against the indigo depths.
Some were badly scarred and several had fresh wounds from recent maulings. In the rather straightforward economy of this natural world, it
is simply eat or be eaten. These survivors had found a middle ground of sorts,
at least temporarily, but any weakness resulting from such wounds
would seal their fate before another day would pass.

In roving packs of a dozen or more,
large dog-tooth tuna ruled silently with their thundering power.
Indeed, wherever they swam, lesser fish
gave them a generous berth.
The entire reef lay exposed to the will of these powerful eating machines,
capable of such stunning acceleration and violent strikes.
The planktivores could not hide indefinitely from the tuna, however,
for they had to feed themselves.
Such abundance and opportunity excited the tuna, and one could sense the mounting tension,
the imminent collision of forces bound to take place.
Unintimidated by the marauding tuna, the kingfish and wahoo, fierce predators themselves,
cruised the open water seaward of the reef,
relentlessly swimming back and forth, agitated, streaking this way,
cutting that way, keeping everything about them
a bit off balance.

*Scorpionfish Detail*

Unlike the sleek, rocket-like tuna
and the dart-shaped mackerel,
the large snappers had a more brooding appearance, their thick, heavy bodies suggesting
aggressive appetites not easily satisfied.
They eyed the vulnerable baitfish carefully,
but made no immediate move,
seemingly content to bide their time.

The solitary Great Barracuda intimidates its prey not by numbers,
but by its sheer size and gaping mouthful of ragged teeth.
Unlike the other pelagic predators, this six foot carnivore seemed relaxed, even aloof from the agitated surroundings.
Its smaller cousin, the Blackfin Barracuda, in great glorious schools
would drift in and out like storm clouds.

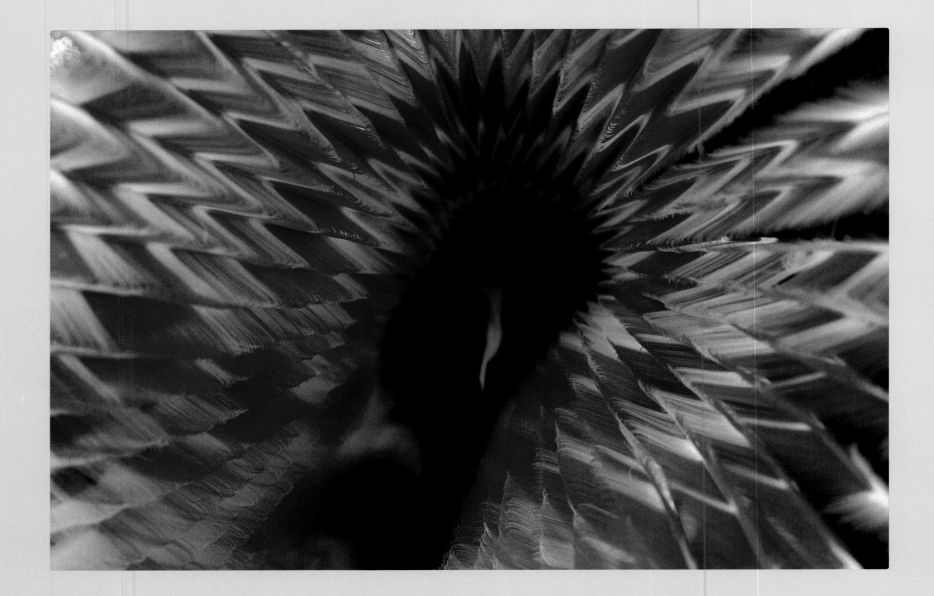

*Feather Duster Worm*

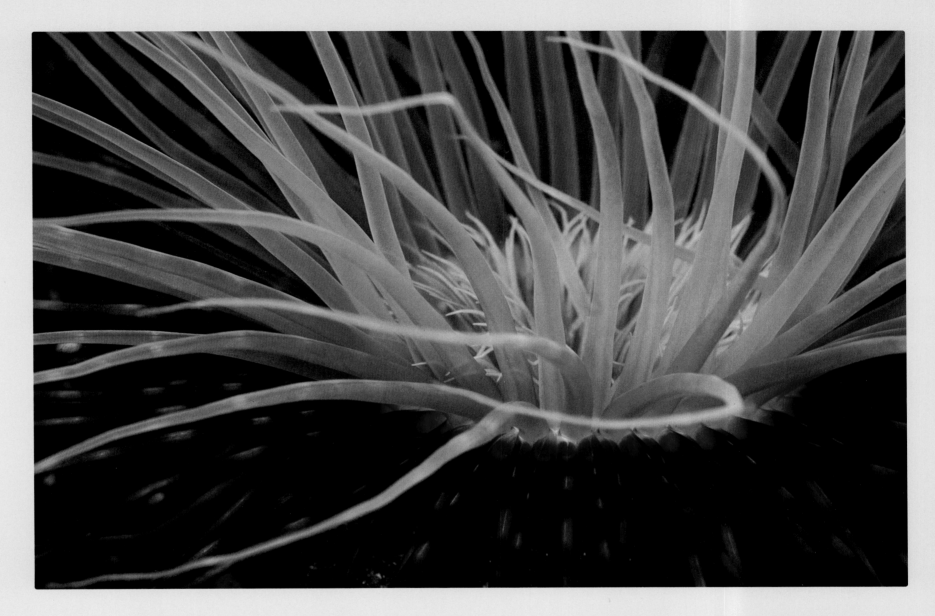

*Tube Anemone*

Periodically condensing, they might pour from the surface like a huge waterfall into the deep.
At other times they would boil out of the sapphire abyss
toward the sunlight above like colossal swirling galaxies.

*Parrotfish Patterns*

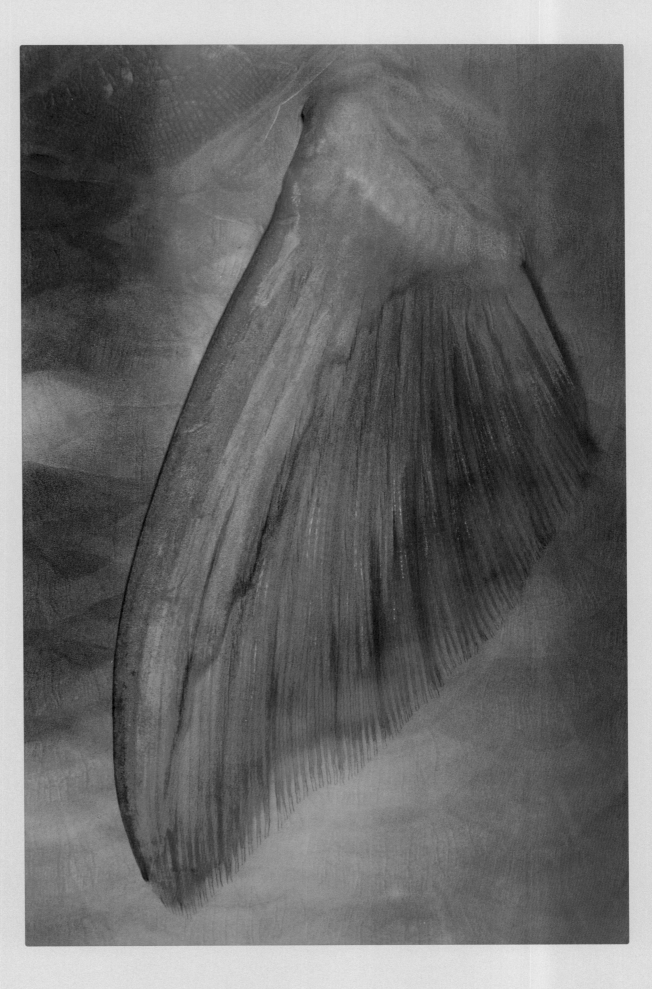

*Parrotfish Pectoral Fin*

My pulse raced and my breathing quickened with the escalating activity around me.
My camera was forgotten as all my senses were focused on the impending frenzy.
At any time the slightest provocation could set everything off,
like some emotional spark igniting an angry mob.
I backed closer to the reef wall, my animal instincts unconsciously
directing my movements, seeking a semblance of shelter.
I was swept into the excitement, and I waited, tense with anticipation.

*Eye of Conch*

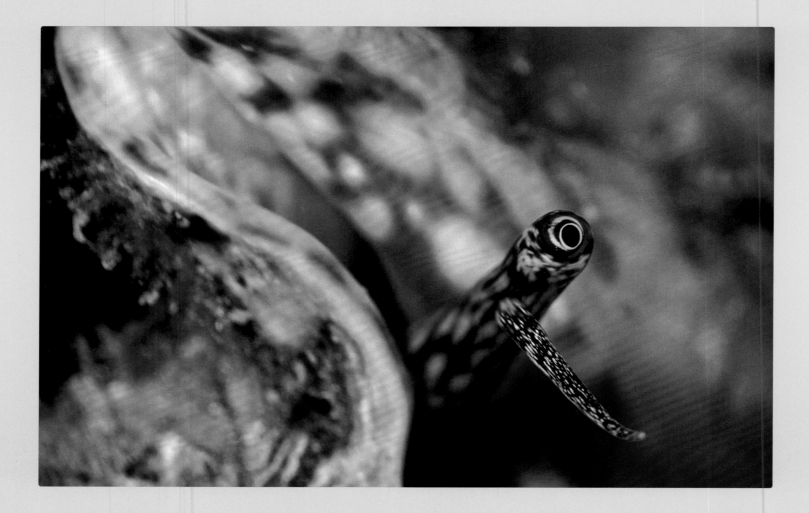

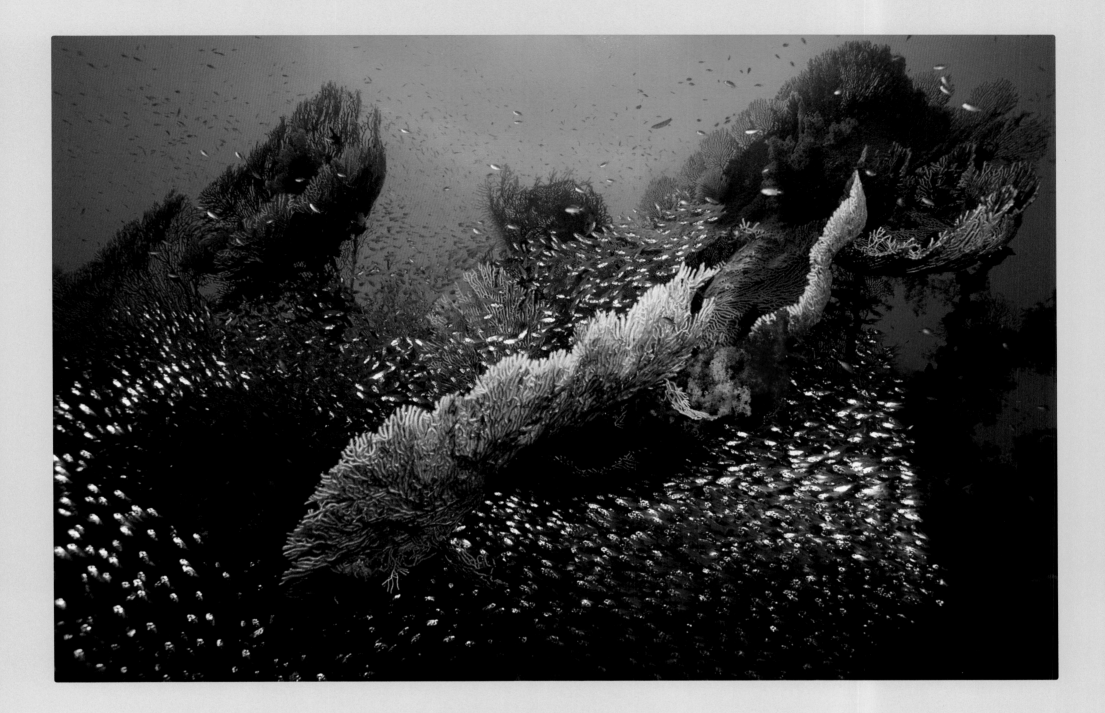

*Sea Fan with Glassfish*

But it was not to happen as I watched,
and I would eventually leave without witnessing the spectacle–
the refinement of life as defined by death, the drama of evolution itself
enacted on a stage of unparalleled abundance.
Nature picks her own time and place to stage her grand shows,
a lesson she will teach me over and over again.

That it would eventually happen was assured.
And when it did,
it would start with a loud rush, like a strong gust of wind
as fusiliers everywhere streaked together in panic,
coalescing like a giant collapsing star.
The jacks, common instigators of the anarchy, would come crashing into the reef,
followed by the staccato popping sounds of fracturing coral and cracking bones as they wildly
assaulted and shredded their prey.
The anthias would dive for the labyrinthine protection of the reef,
while the silversides scattered in fright.
The butterflies and angels would dart frantically for whatever cover was close,
as the jacks smashed into anything slower.
Simultaneously and with astonishing speed the tuna would explode
into pockets of densely schooling fish in the open water,
unleashing their energies on victims helpless against such a furious charge.
In the ensuing chaos,
frightened smaller fish would become confused,
their survival strategies disrupted.
Seizing the opportunity, hungry snapper, razor-toothed wahoo, and powerful kingfish
would eliminate the slow, the weak, or the least clever.

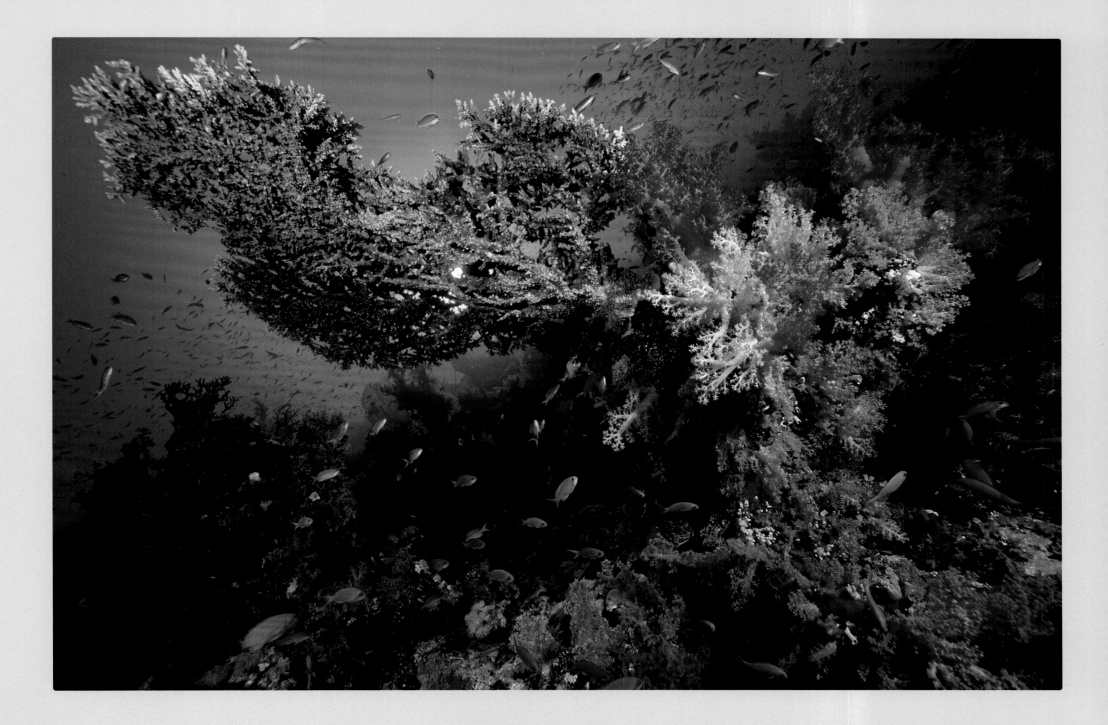

*Coral Reef Scenic*

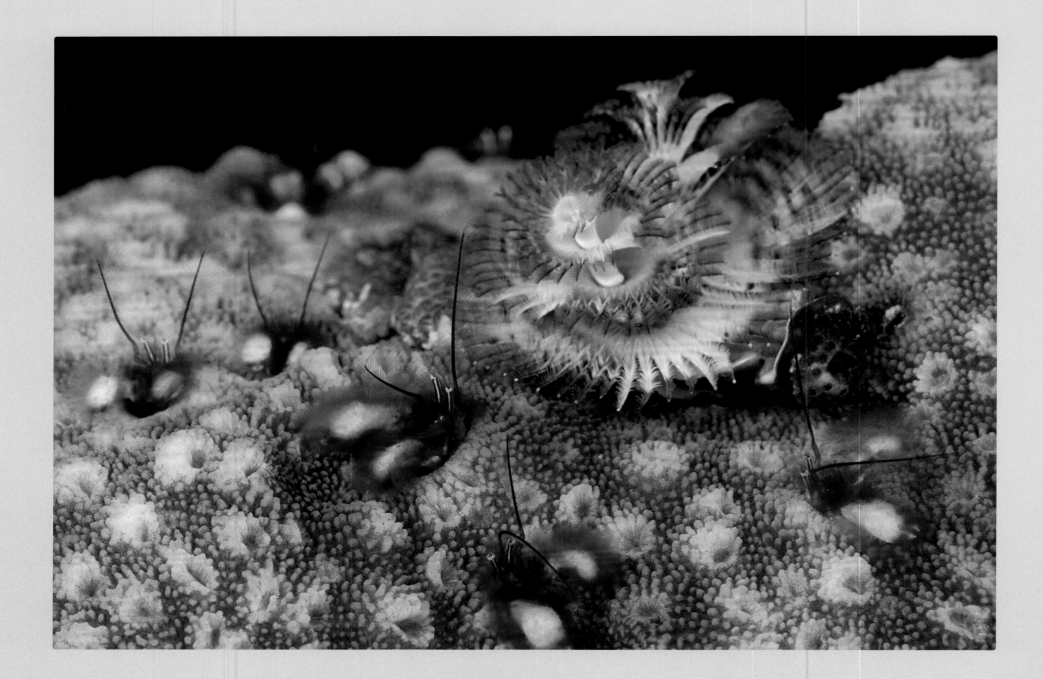

*Serpulid Worm and Hermit Crab Colony*

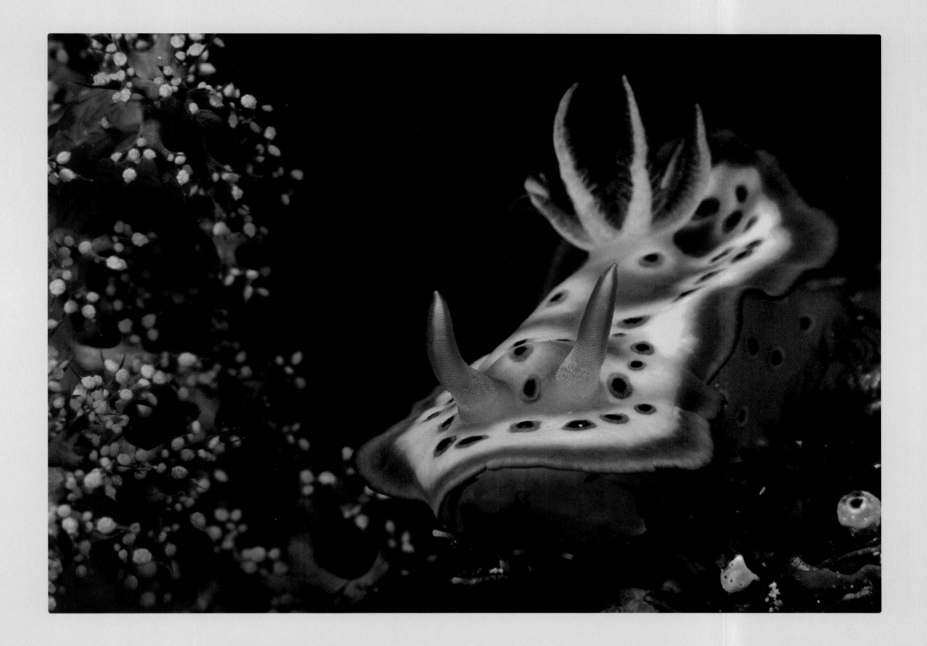

*Chromodoris Nudibranch*

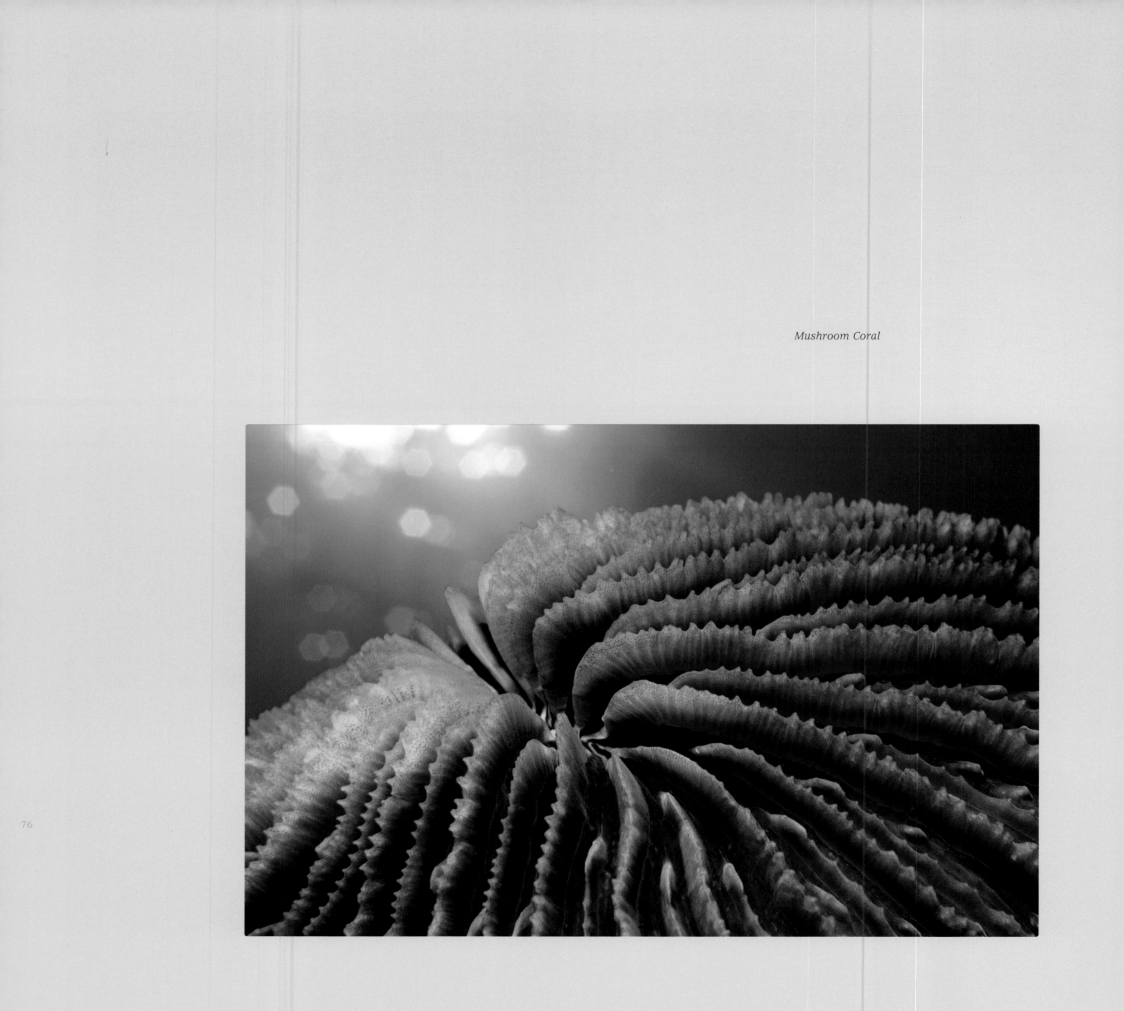

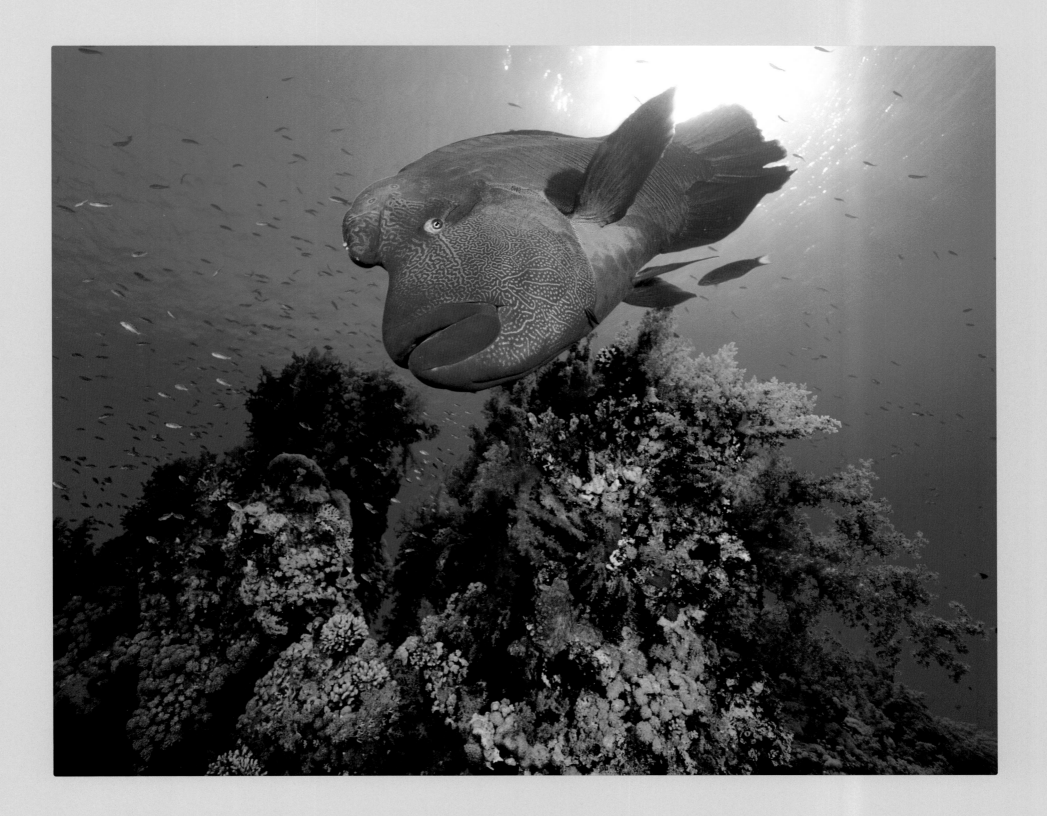

Napoleon Wrasse

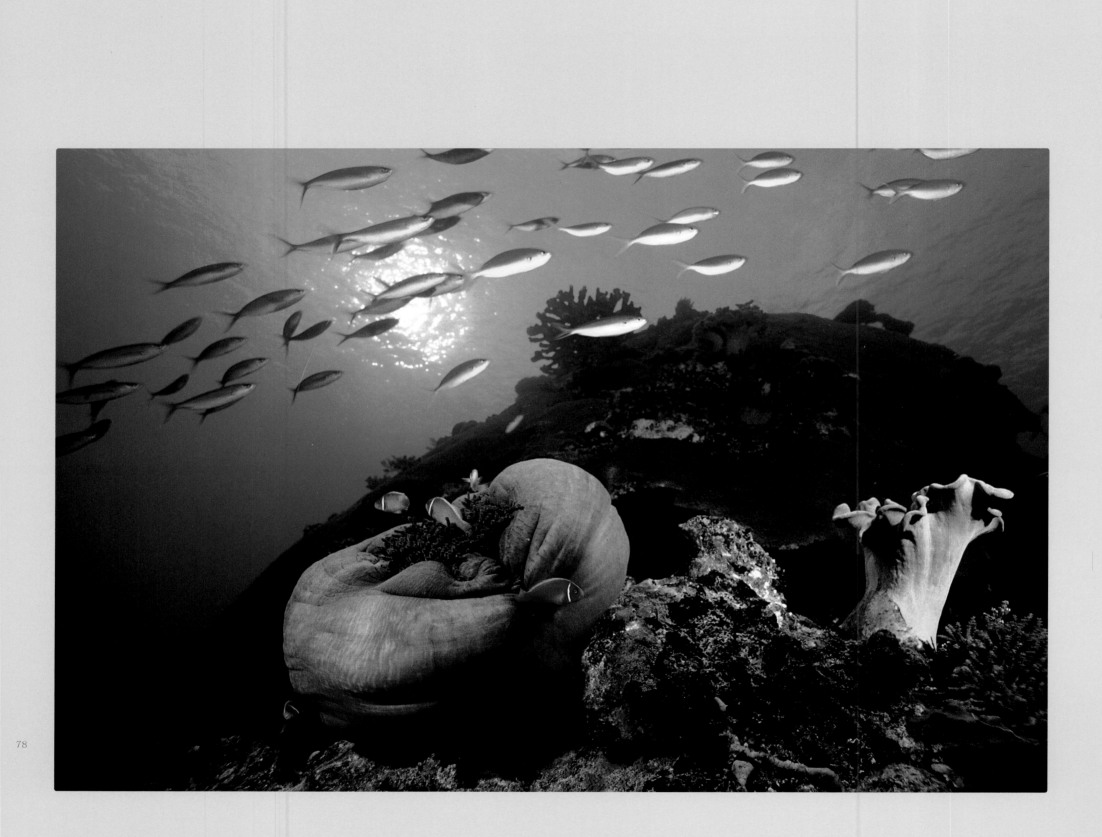

*Sea Anemone and Leather Coral*

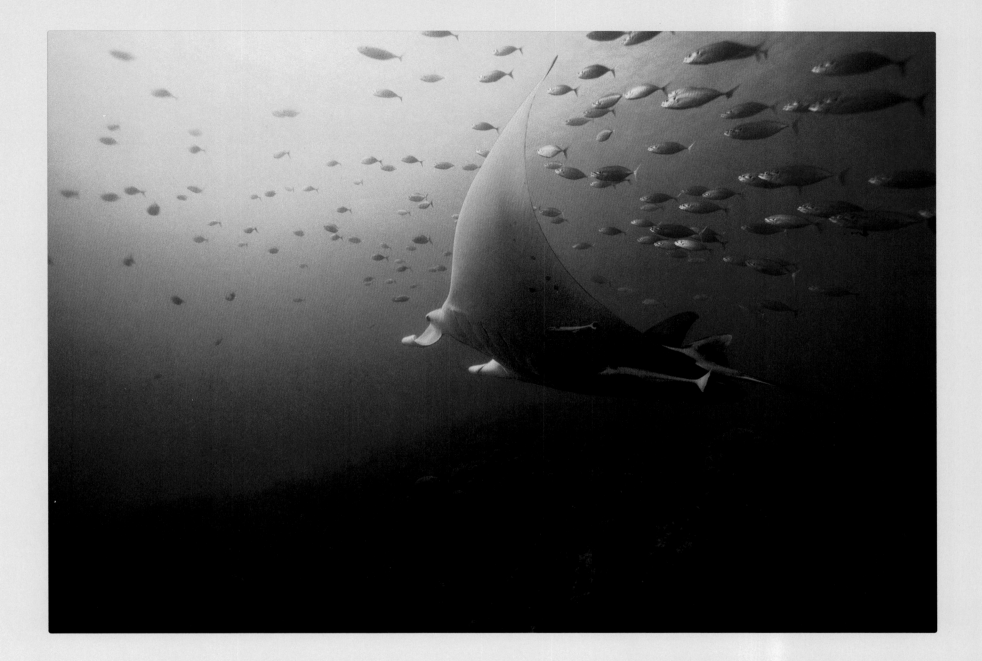

*Manta Ray*

*Goby on Gorgonian Coral*

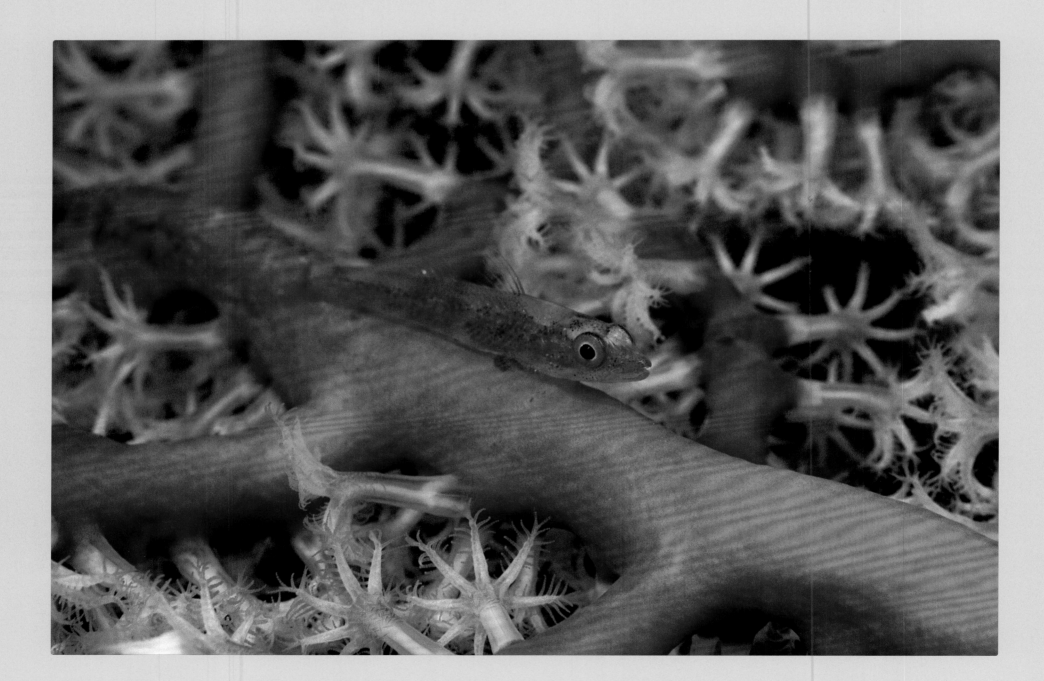

*Orange Spotted Prawn Goby*

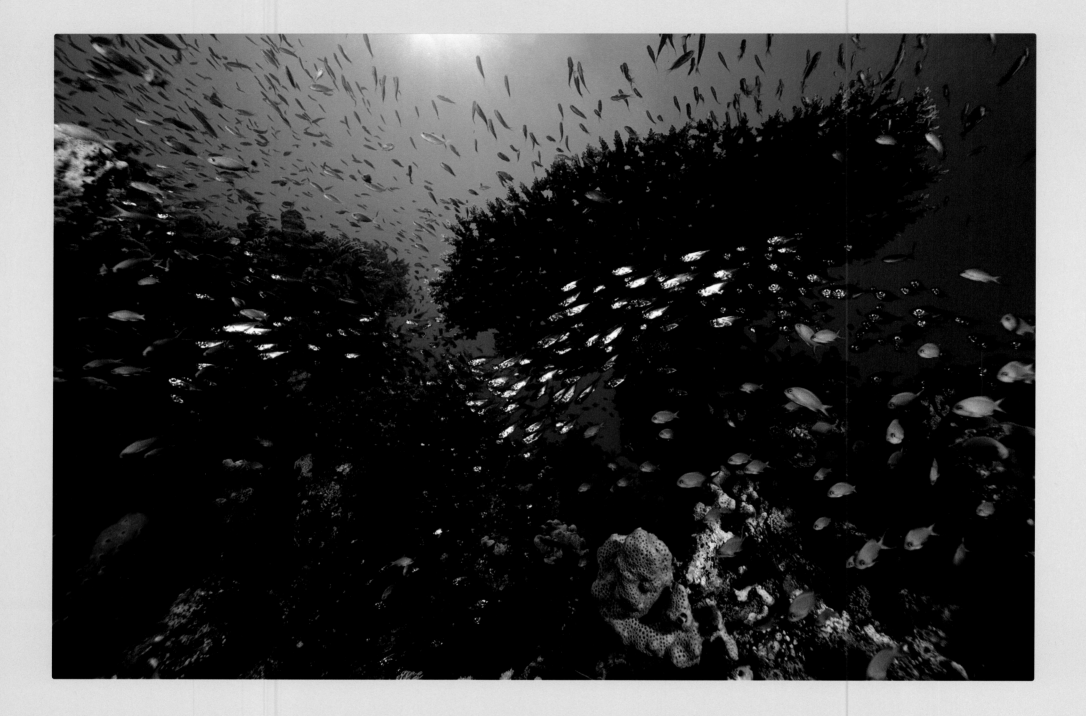

*Table Coral and Glassfish*

There would be a general rampage of feeding that might end as suddenly as it began, but nothing would be spared.
In the aftermath one commonly saw fresh, angry wounds on several of the larger predators,
victims themselves of those yet more powerful and quicker than they.
Preoccupied with their hunt, they became the hunted.
Rejoining their schools, they sought protection among large numbers of their own kind for what might be their final hours.
Uncompromising natural laws ruled this untamed world.
And no tears would fall from the eyes of nature for those that were lost, for her system is perfect,
each taking only what it needs for survival, each species strengthened by the loss of their weak.

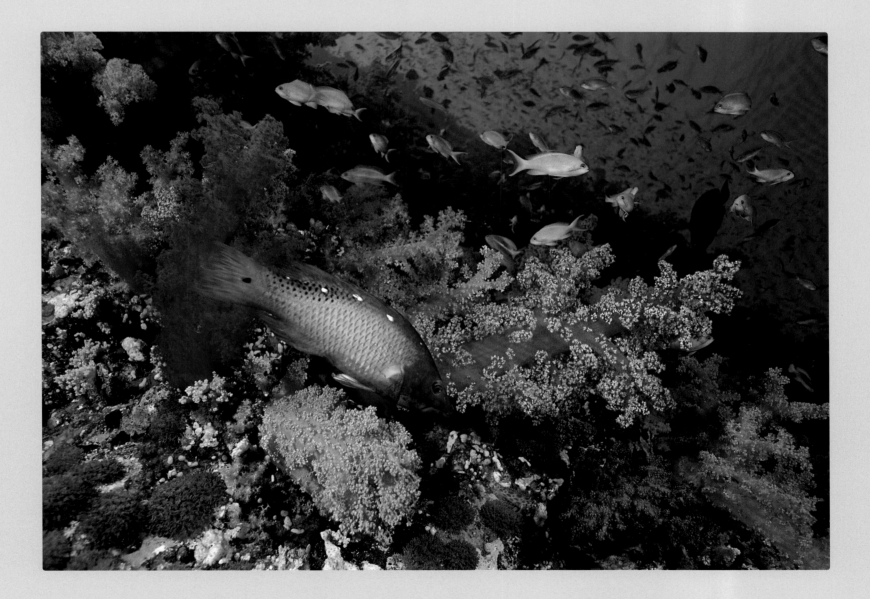

83

*Diana's Wrasse and Soft Coral*

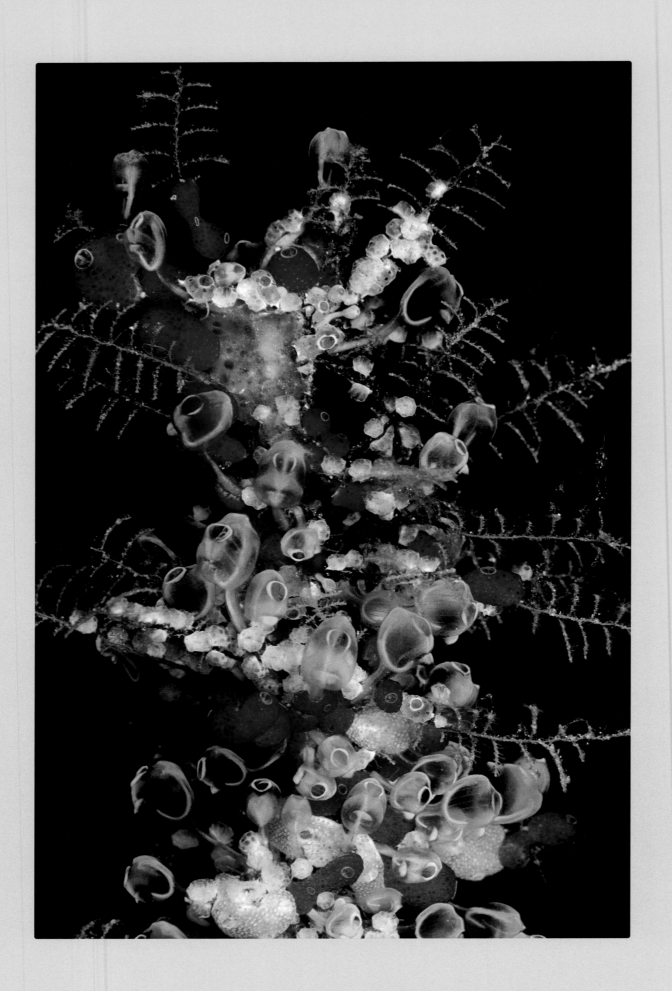

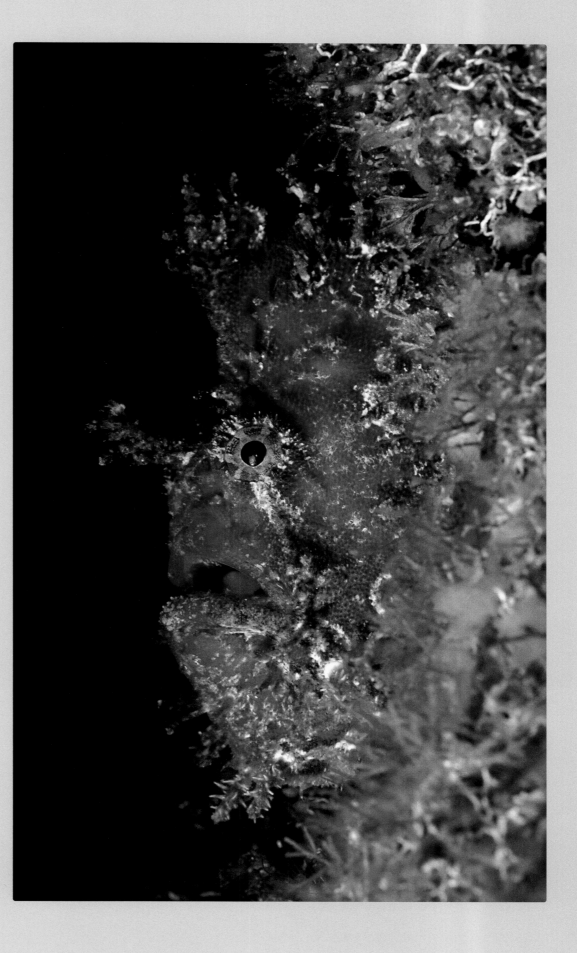

*Frogfish*

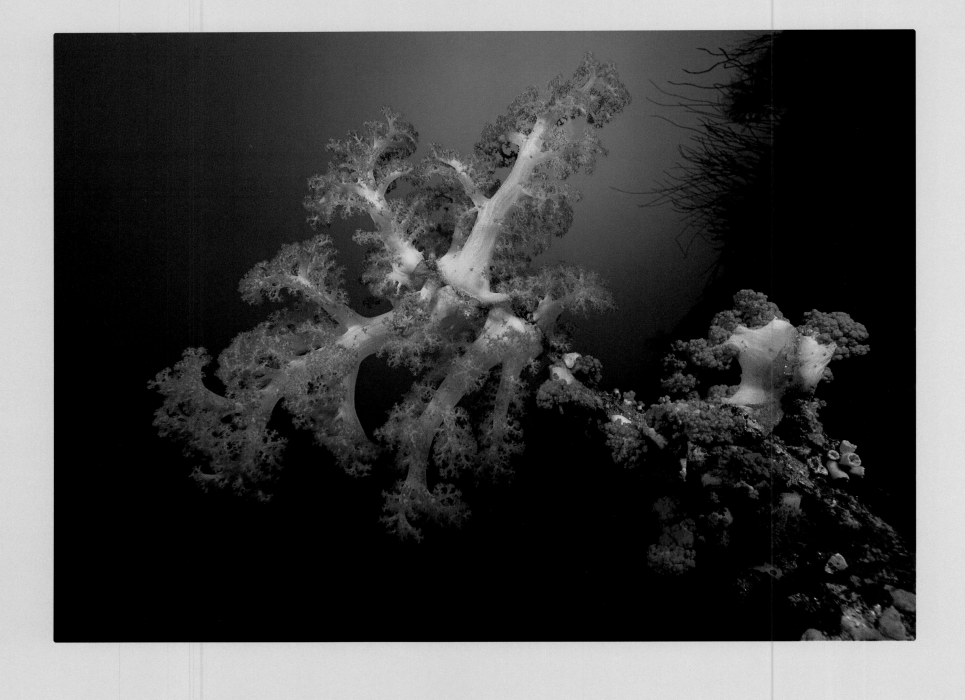

*Soft Coral*

But this time I would not watch, hypnotized by that sometimes terrible beauty of nature in natural selection.
This time I would not experience that adrenaline rush,
though I could feel the electricity building.
This would be a dive of quieter pleasures and unfulfilled expectations, yet one rich in excitement nevertheless,
rich in the pageantry of one of nature's most lavish marine environments.
And that is what lures me on, the sheer diversity of beauty, and knowing that anything can happen at any time.
A stage so abundant with characters performing such intricate roles need not always have a climactic scene,
for this is an ongoing story with a continuously changing plot.
The reward lies in merging with that ageless process.

If the Solomon Islands did not, indeed, exist, I am certain we would invent them,
creating in our minds, in our art, and in our literature such a place as this.
For surely we have a need in our hearts to know that paradise somewhere remains unspoiled.
There is majesty in the hidden world of these untouched reefs, and magic in the special moments one spends there,
for here is truly a place of dreams, a place where nature thrives glorious and free.
But hardly secure. Elsewhere and all too often,
dreams are the only place remaining where great schools of barracuda still coil into the sun,
where dolphin leap, singing to the waves.
For mankind's greed is a voracious predator, devouring our planet's natural riches while plundering her soul.
We often seem swept blindly along by the currents of our genetic predisposition,
unwilling to moderate our all-consuming nature, and perhaps we have arrived at a crossroads.
Will we finally awake one day to find our dreams forever lost?
Or will we realize in time our commonality with all things living, recognizing we share a mutual fate.
The answer dances beyond our reach, like sunlight sparkling on the water's surface.
In this charmed place,
for now at least,
this hungry predator sleeps.

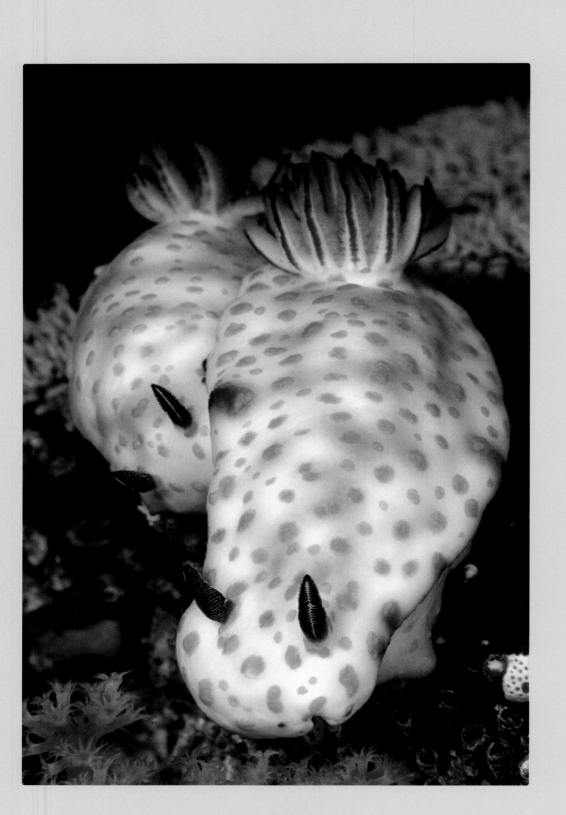

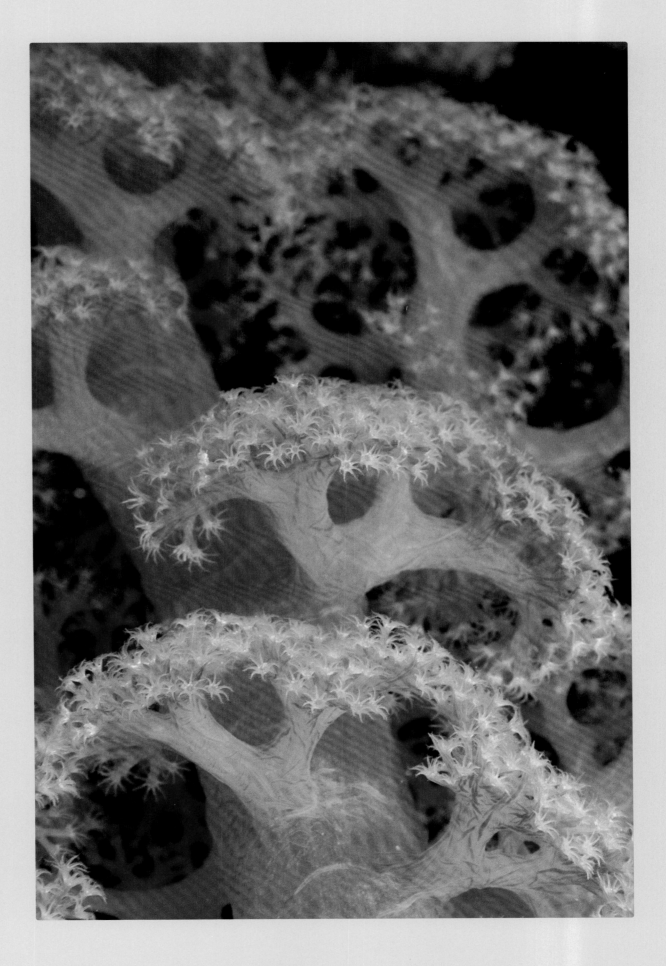

*Soft Coral Polyps*

89

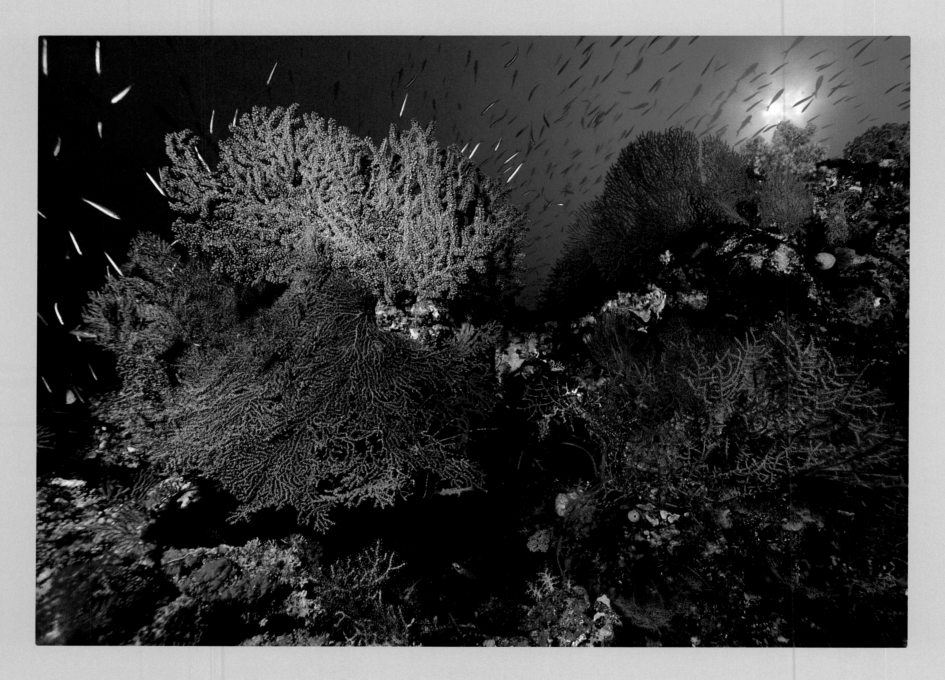

*Solomon Islands Reef Scenic*

As the day grew long, the intense tropical sun drew moisture from the ocean's surface and watched as it rose on lazy air currents.
Encountering cooler temperatures at altitude,
this truant water from the sea then condensed,
forming ever larger clouds, evanescent oceans in the sky.
By late afternoon the jellyfish were gathering once again,
closing in around us.

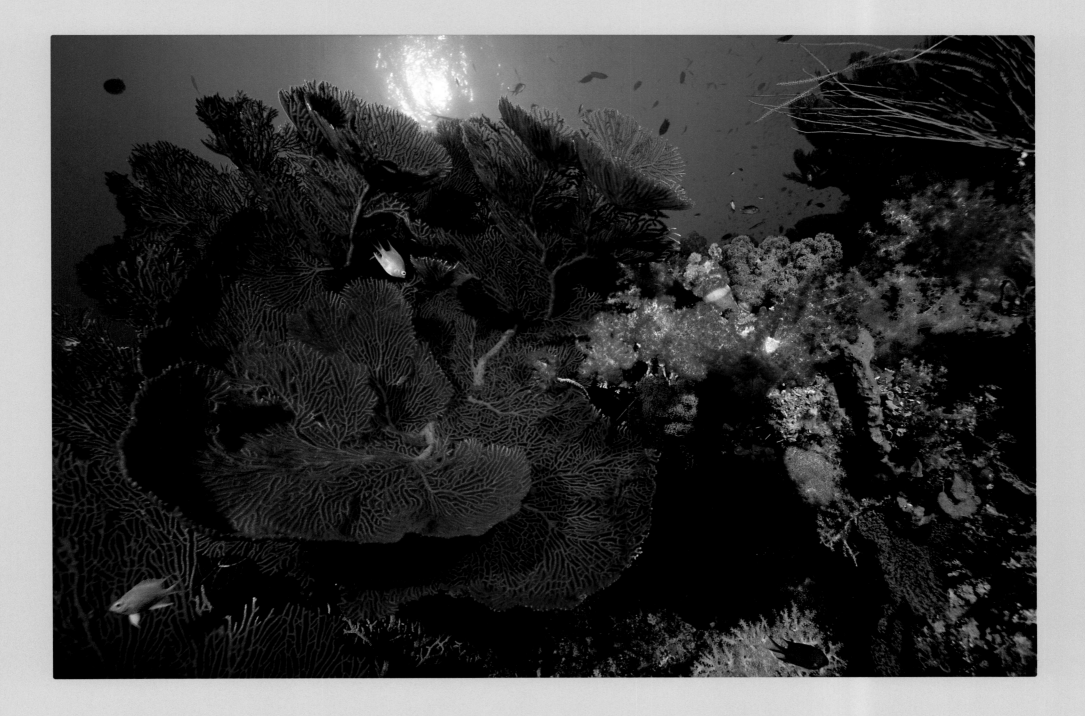

*Crimson Sea Fan*

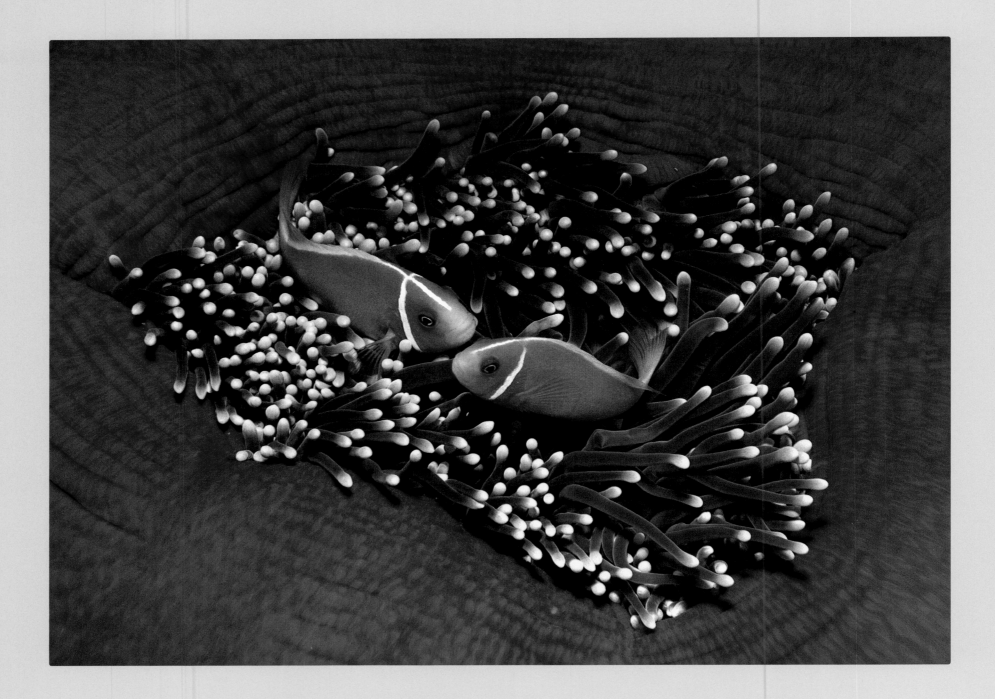

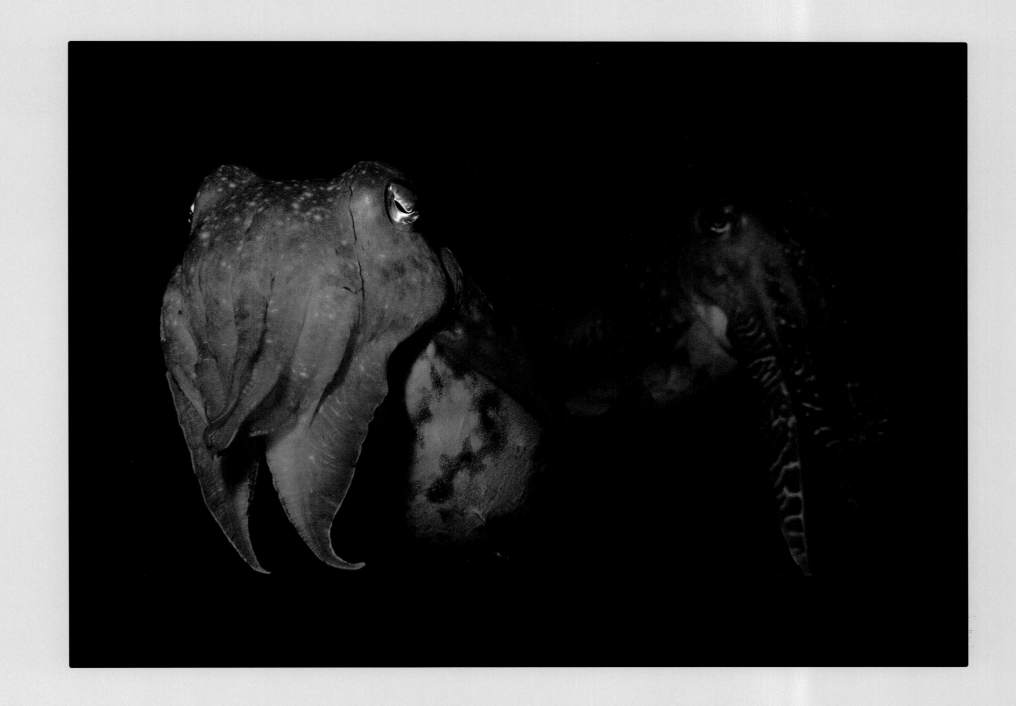

*Cuttlefish*

*Tridacna Clam Siphon*

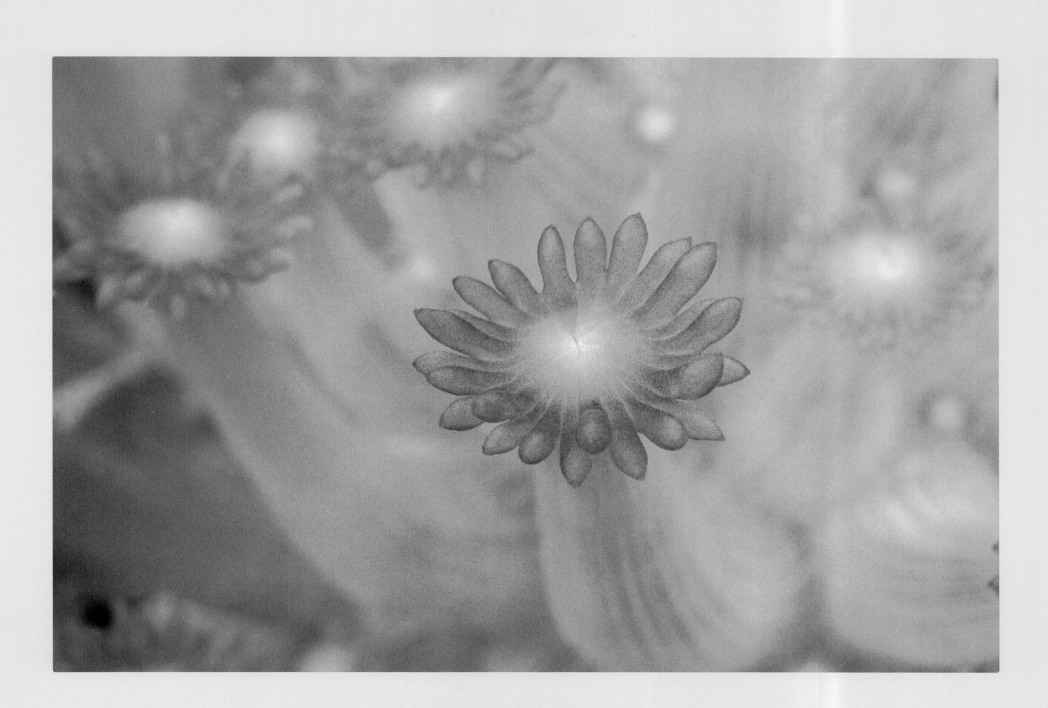

*Coral Polyps*

*Parrotfish Tail*

*Parrotfish Detail*

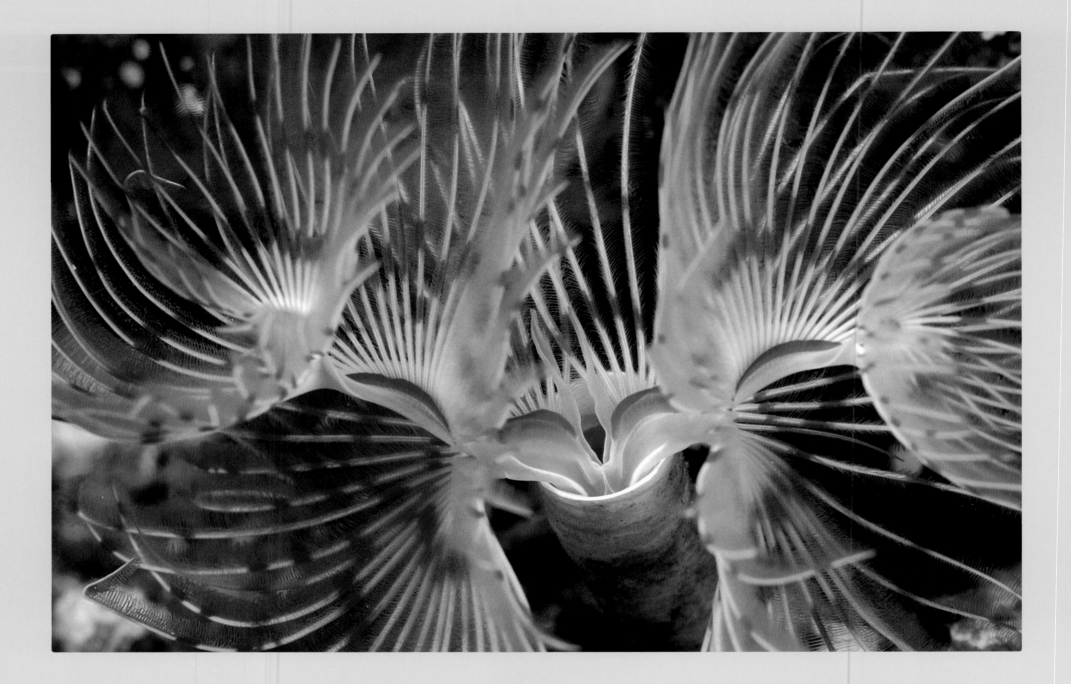

*Feather Duster Worm*

I long to know what their frenetic conversations are saying,
but I must resign myself to them seeing me as an object of ridicule,
as a kind of silly second cousin in my rubber suit and plastic flippers,
one large glass eye and a tube for a blowhole.
I can hear and feel their sonar clicks rapidly scanning my body,
giving them fleeting three dimensional images in sound of my flesh and bones.
No doubt the metallic echo of my large camera housing confuses their dolphin minds.
I open my eyes at last to droves of luminescent grey forms in a deep blue ether drifting past,
and I slowly raise my camera to capture my own
more enduring images in light as they continue gliding by.

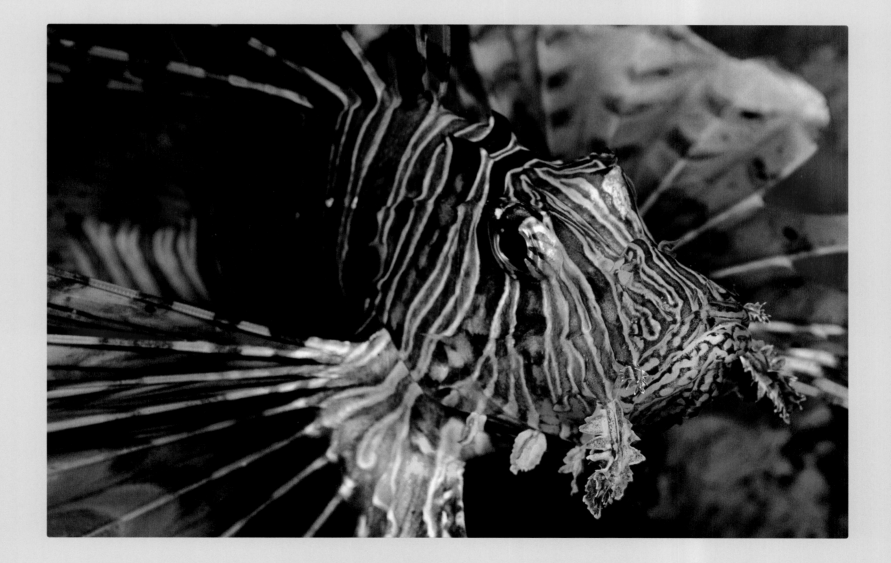

*Lionfish*

101

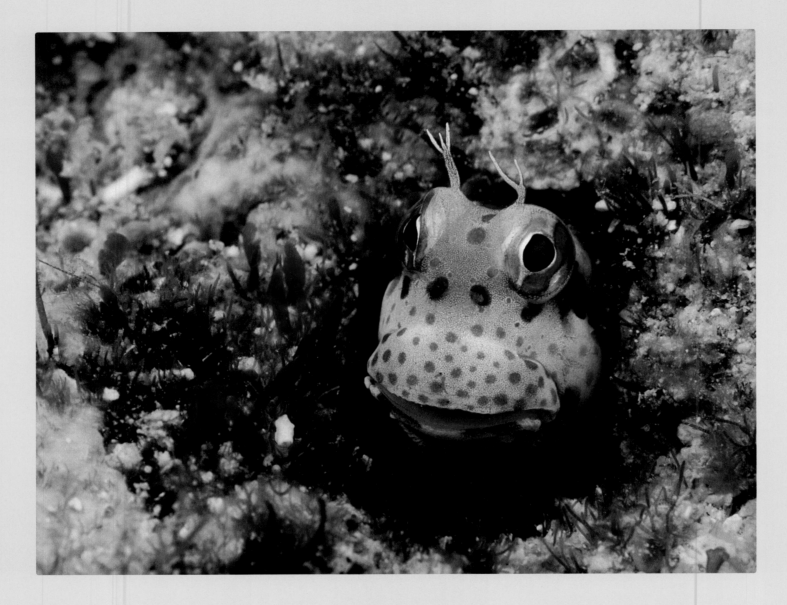

*Freckle Face Blenny*

How different are our means of perception and our processes for assimilating the information
from our senses, yet how similar the structures of both species for examining our environments.
How effortlessly they move through their universe, how gracelessly we tread upon ours.

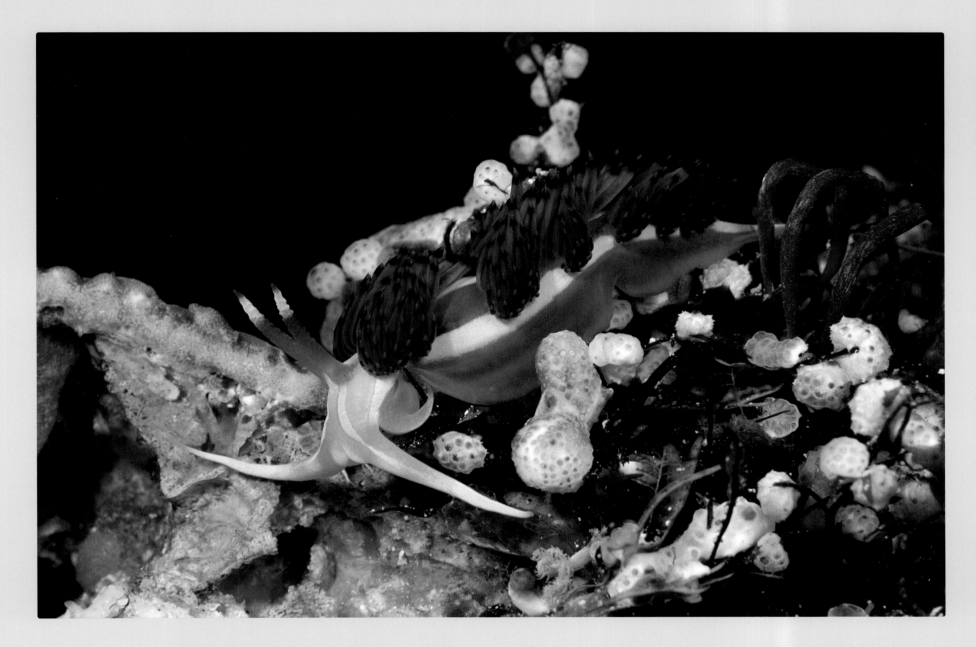

*Nudibranch with Ascidians*

I am submerged for only a minute or so, but in this suspended time, events
are transformed into a dreamy reflection on the puzzle of our ongoing evolution.
Like a marvelous tangle of colorful fibers, the images, sounds, wonder,
and beauty of such experiences have become
permanently woven into the tapestry of my subconscious.

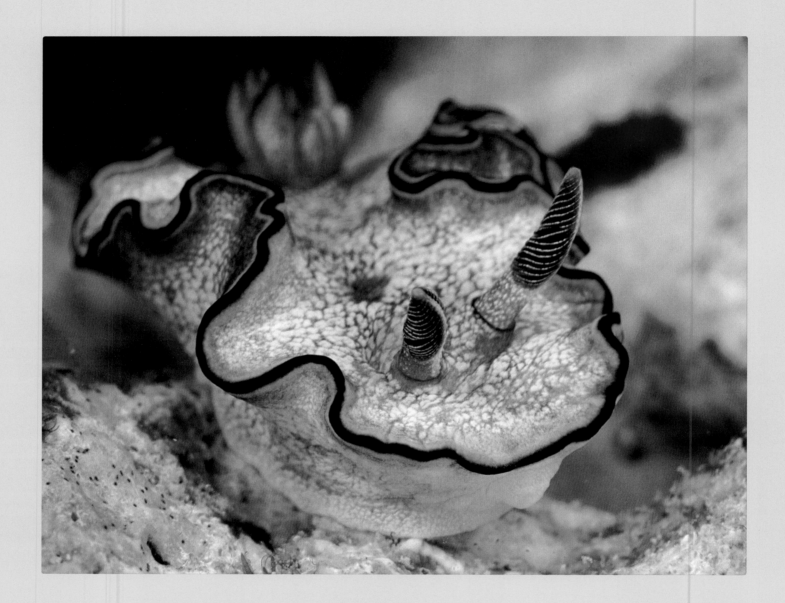

*Nudibranch*

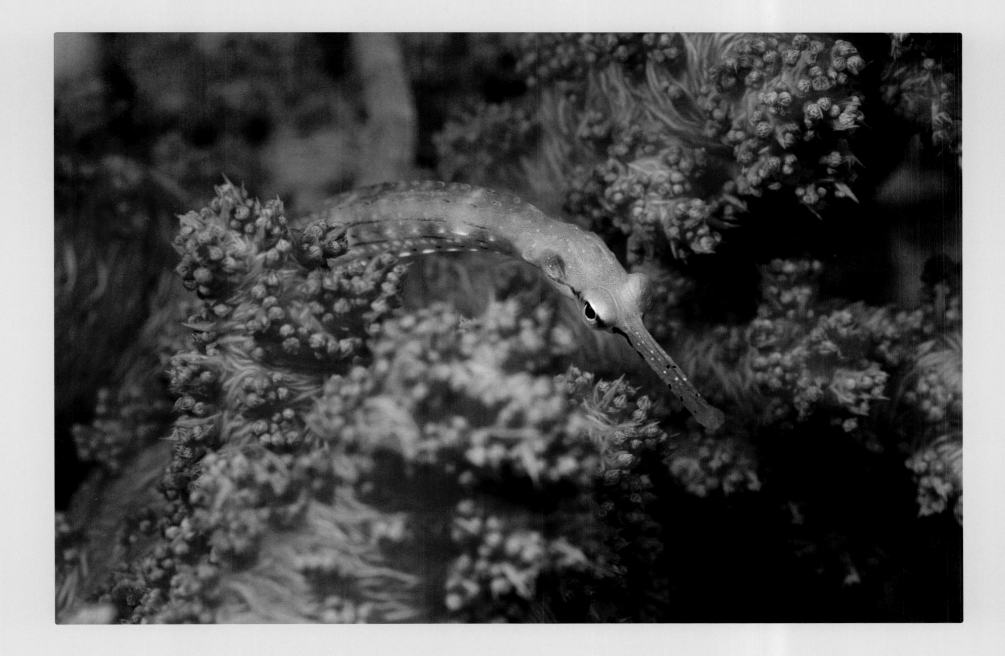

*Gilded Pipefish*

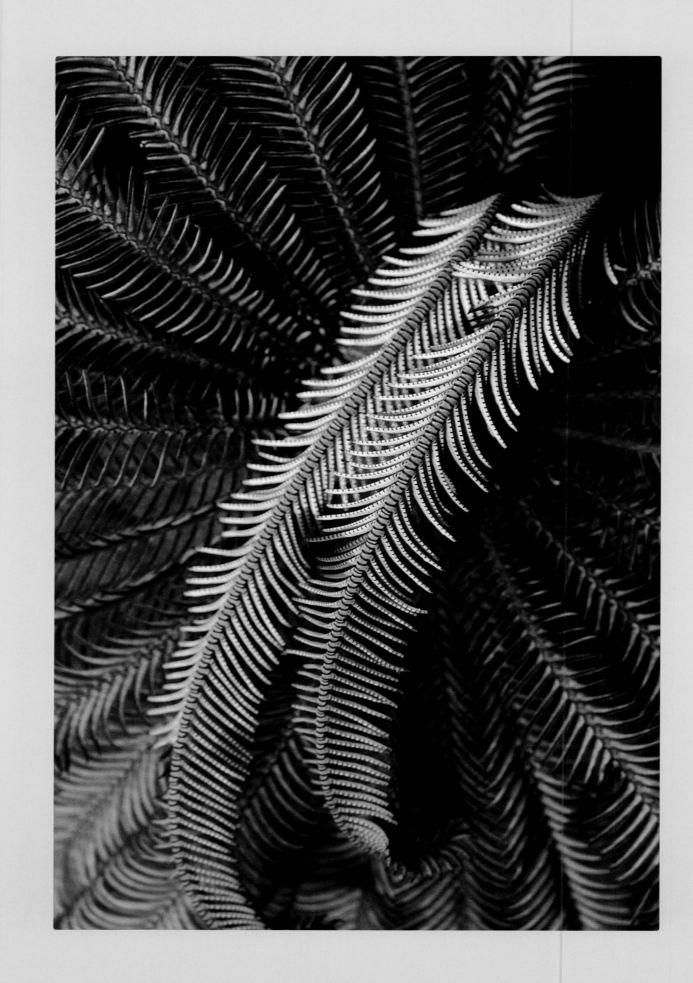

*Crinoid*

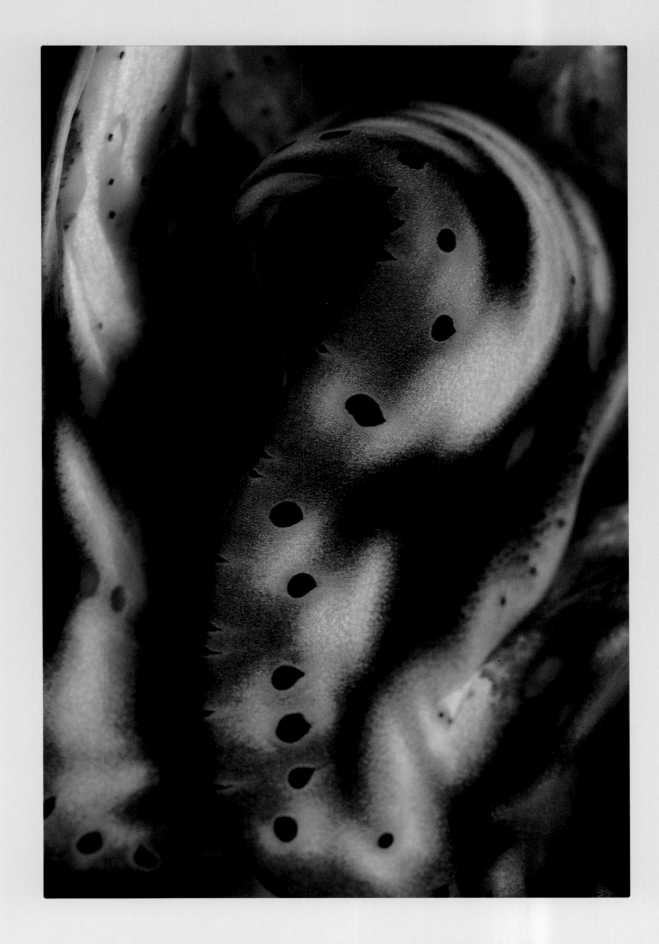

*Tridacna Clam Mantle*

*Stonefish*

*Sea Squirt*

109

But when I dream of the ocean and the pure ecstasy of underwater flight,
when I dream of innocent joy and exuberance,
I am carried in my fantasy to the Galapagos Islands.
I dream now of the sea lion.
More than dolphins, more than any other animals, sea lions bridge the worlds of ocean and air in a manner
that leaves me laughing, envious, and often in awe.  At home in both domains,
the sea lion is dramatically transformed once it enters the water.
On land, however, they are slow, somewhat clumsy, and generally lazy.
Given their particular morphology, we are inclined to expect little of them.  With their appendages having long ago evolved into webbed flippers,
their earth-bound dexterity has suffered accordingly.  In order to move, a sea lion must perch on its front flippers, raising its head and chest off the ground.
With a waddling motion it walks forward on what eons ago were forearms, dragging its hindquarters along the ground behind it.
When more speed or extra power is needed, the sea lion may swing its hips
to one side or the other, then push ahead with its rear flippers.
The process can be exhausting just to watch as they wiggle and heave themselves forward.

Thick layers of fat generously encapsulate sea lion bodies,
weighing heavily on them when out of the water, though keeping them warm while submerged.
Because moving about on land requires such an effort,
they normally prefer to lie around under the equatorial sun like bloated tourists on Miami Beach,
occasionally erupting into discordant choruses of bellows, bleats, belches, and moans.
While you can approach them quite closely, you should not underestimate the sudden,
short bursts of speed they are actually capable of,
even with gravity and evolution burdening their every movement.
The bulls can be particularly cantankerous as they jealously guard their comely harems,
and they are best given a wide berth.

In spite of their handicaps on land, sea lions have an astounding ability to climb rocks and slippery vertical terrain
which even we bipeds would find challenging and dangerous.
Many times I have watched in amazement as a sea lion would struggle up some towering cliff to a ledge
or precipice high above the water. With the determination and acumen of a hobbled mountain guide,
the sea lion would lurch and strain over jagged outcroppings, leverage itself across deep crevices,
squirm through narrow gaps, and by sheer force of will, defy any sense of the possible.

Then many times having finally attained its improbable goal high on some lava bluff,
the sea lion would haul its blubbery mass to the edge of the rock, hang its whiskered muzzle
over the lip of the cliff, look down, then with one last thrust,
lunge forward, free-falling headfirst into the sea far below.

And there would be magic in that leap, a wondrous release and a profound transformation.
For in those split seconds of free fall, the sea lion would metamorphose from a slow, awkward,
struggling creature on land into the quintessence of speed, agility, and grace beneath the waves.
Relieved from gravity, they are physically transfigured once underwater.
Their bulging, sagging blubber is now stretched taut as their bodies elongate and taper.

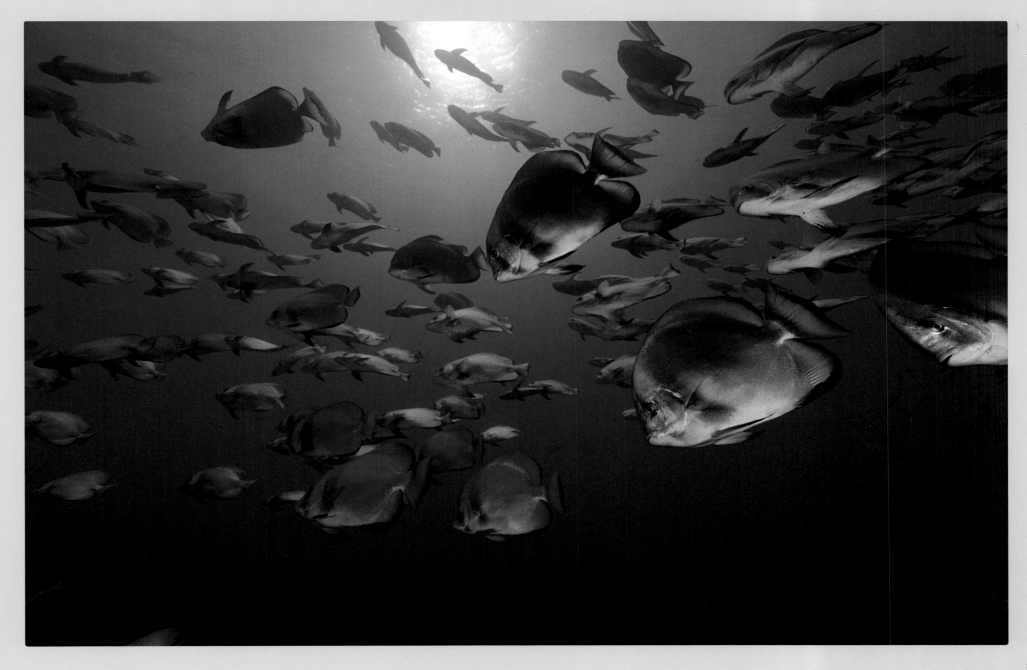

The outer layers of their tawny, heavily oiled fur turn rich chocolate brown when wet,
slicked back and laying perfectly flat over their smooth contours.
They are suddenly sleek, astoundingly athletic.
Their squinting, bleary eyes become bright and wide, alive with excitement.

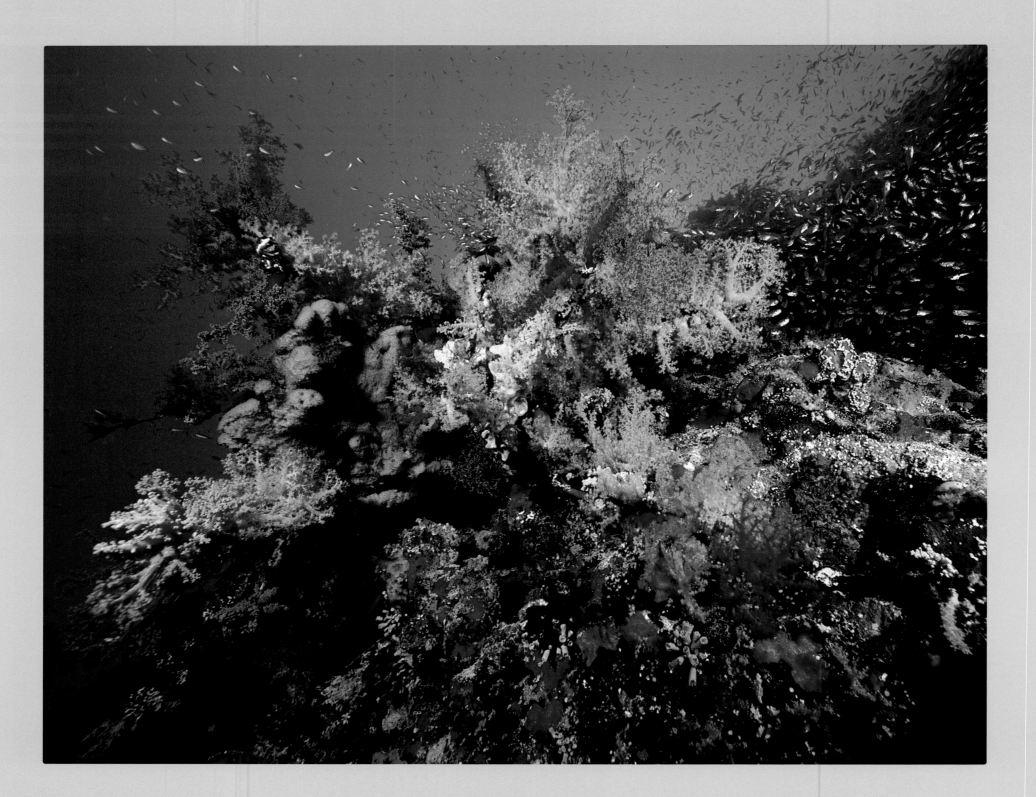

*Reef Scenic*

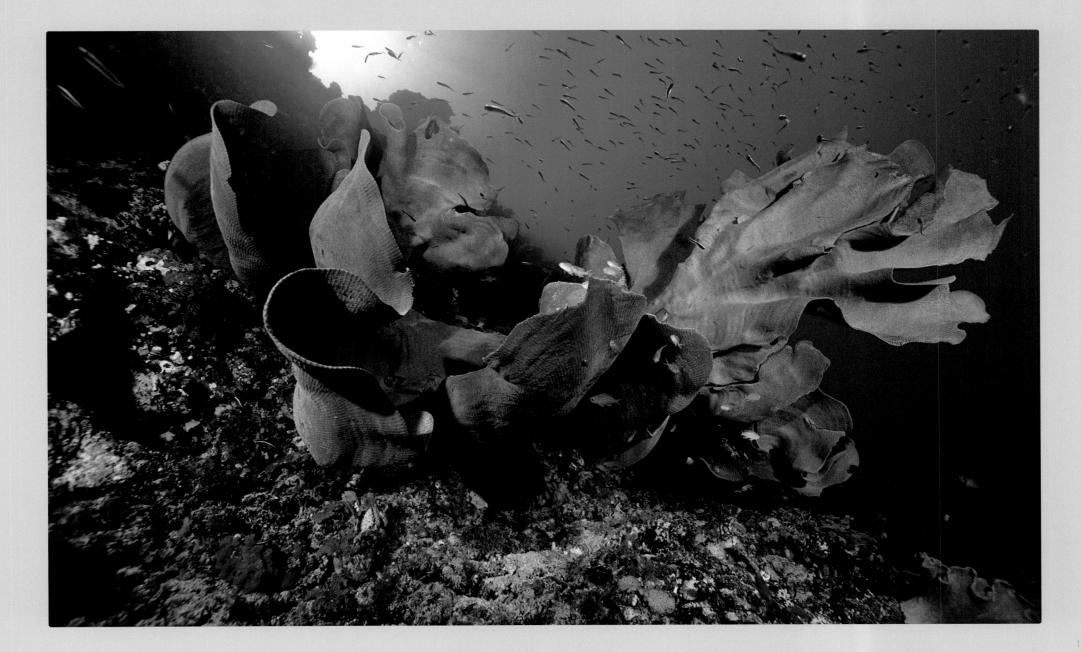

*Elephant Ear Sponge*

Coming nose to nose with me and staring curiously into my face mask,
they sparkle with mischief, exuding a sense of childlike playfulness and joy.
I watch from below as water brings sea lions to life,
unlocking their spirits and giving wings to their souls.
They plunge through the surface like torpedoes, erupting with energy and excitement as bubbles explode around them.
Flying through the sea with rapturous ease,
they will roll, turn, bank, and spiral with abandon.

*Sailfin Leaffish*

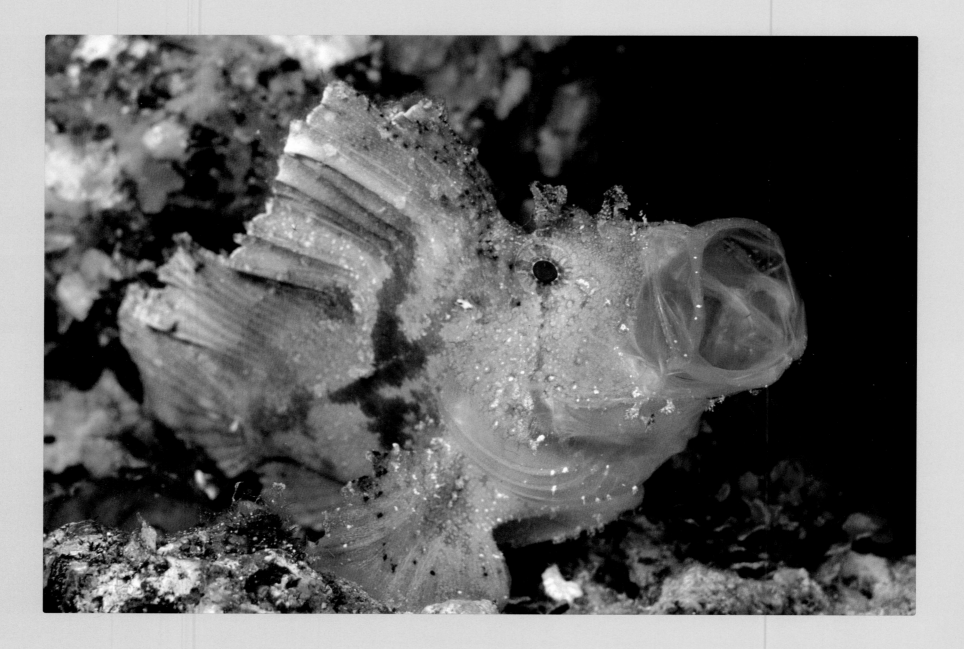

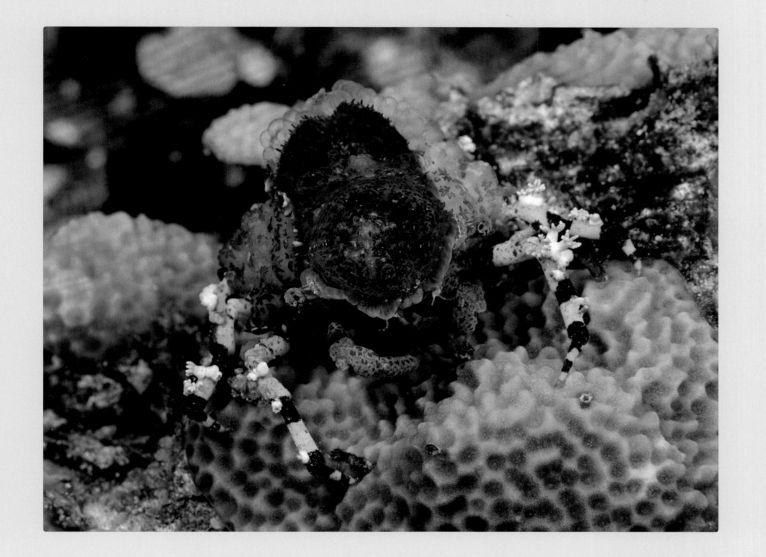

*Decorator Crab*

Pouring from the surface far above, dozens of sea lions race toward me like a swarm of underage outlaw bikers.
I revel in the attack!
Coming from all angles, upside down, right-side up,
flippers pulled tightly against their sides,
contrails of trapped air bubbles streaming from their thick fur coats,
the excited sea lions corkscrew wildly about me.

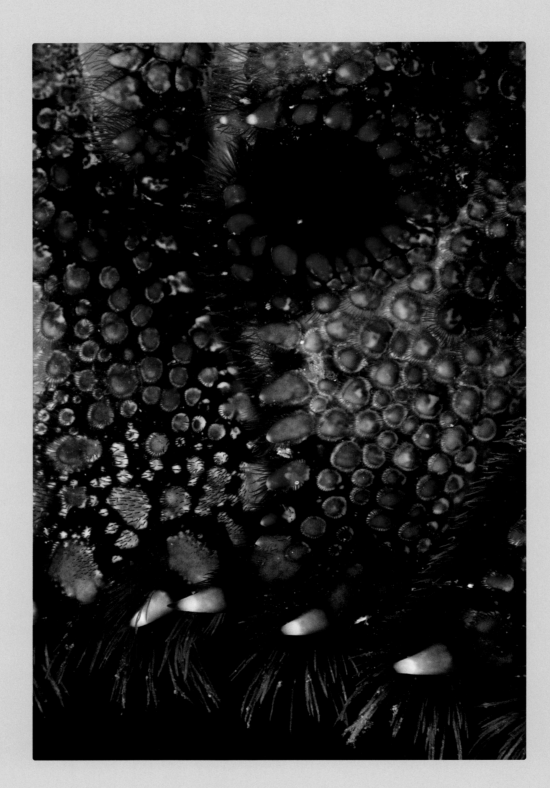

*Slipper Lobster Eye*

I am consumed by the infectious play in this riot,
        so I try to match their maneuvers,
           launching into a series of laborious rolls and inept twirls, fins flapping, arms flailing.
    But I am a hopeless mimic, a lumbering elephant in a weightless ballet.
          They seem amused and sympathetic, though determined to humble me.
   Arching their backs, thrusting their chests forward, and spreading their pectoral flippers wide like a swan diver,
       they execute perfect backward loops, one after another in dizzying succession.

My leg is suddenly yanked in one direction as a sea lion has grabbed one of my fins in its mouth.
Now my face mask strap is seized by another, and it threatens to pull the mask completely off my head. I am under siege.
Everything they encounter becomes a toy. A starfish, my arm, my underwater strobes.
I have been reduced to a kind of underwater jungle gym for sea lions,
though I can't tell whether I'm being played with or mugged.
Even passing predators are fair game for their pestering or curious investigations,
as they mercilessly harass large Galapagos sharks many times their size and weight,
but with only a fraction of their speed and agility.

*Bravo Blenny*

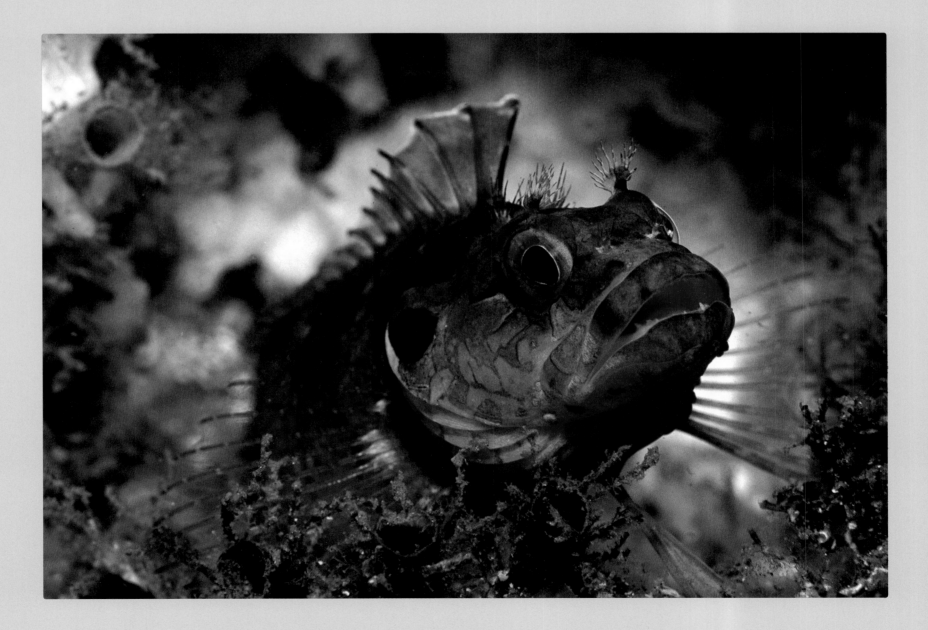

117

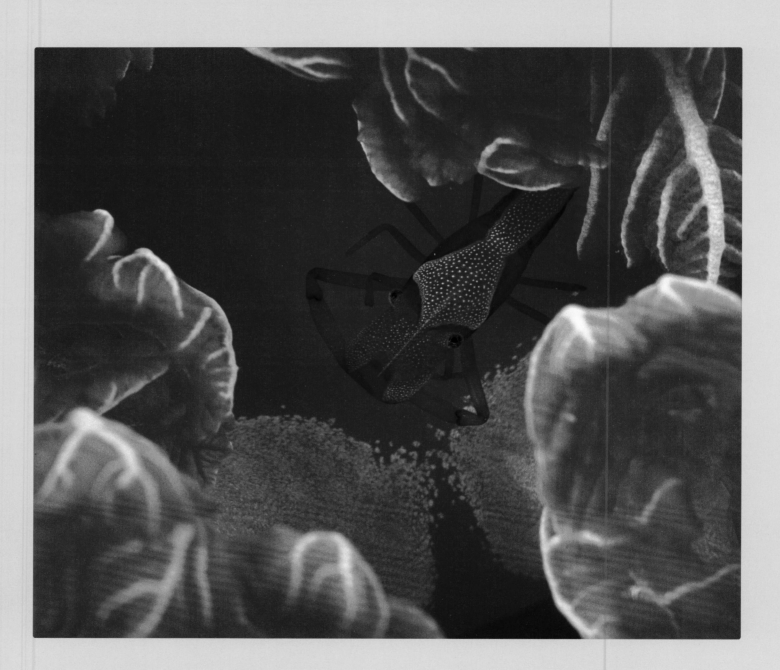

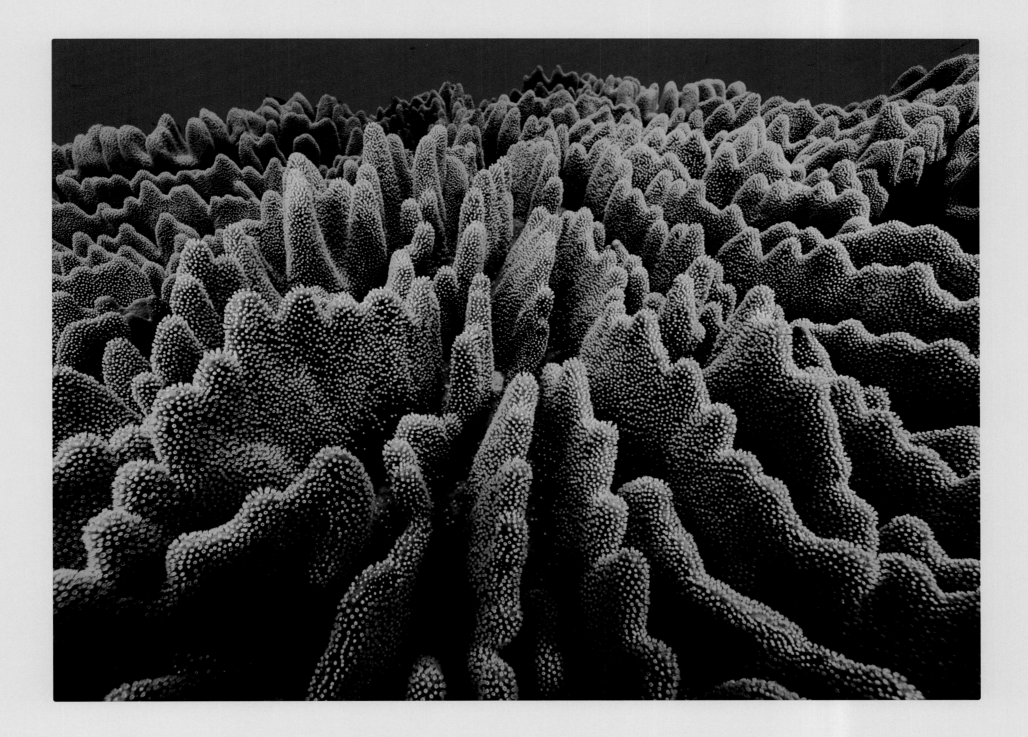

*Field of Leather Coral*

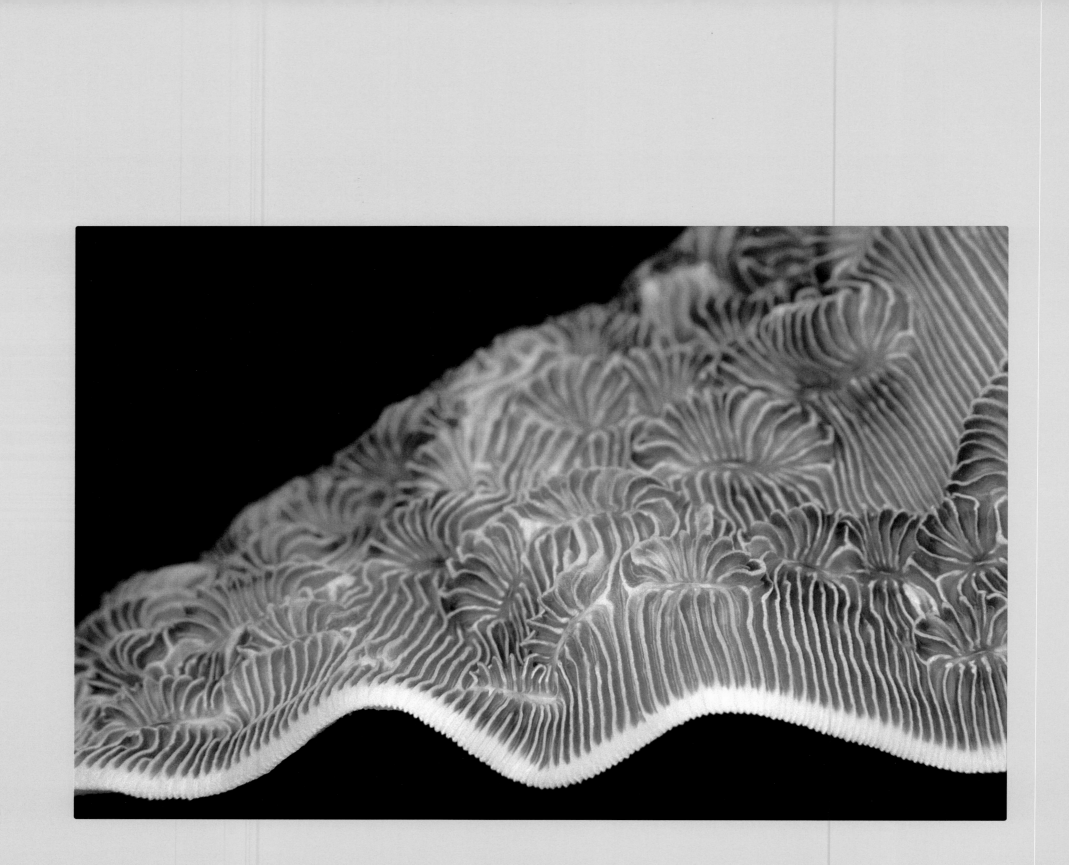

*Plate Coral*

*Soft Coral Spicules*

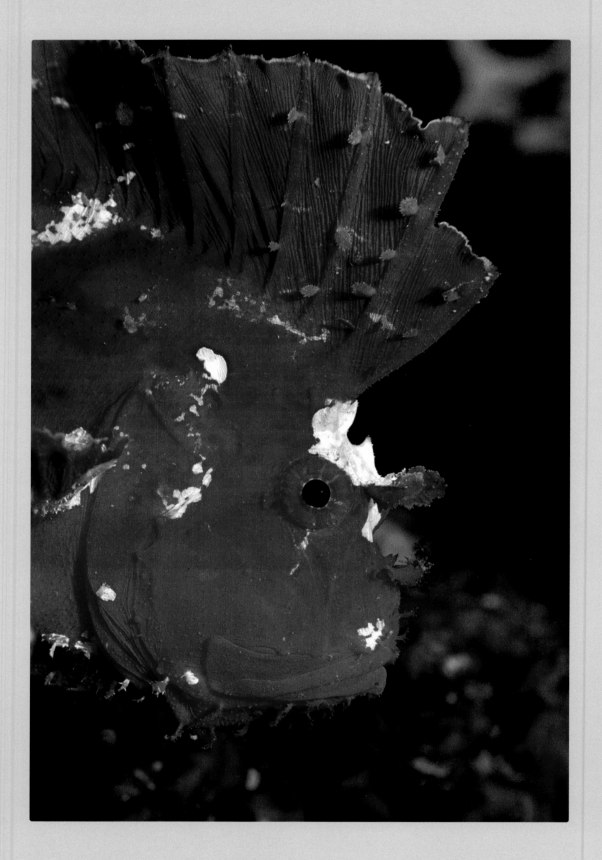

*Sailfin Leaffish*

How very opposite we are, I think, yet how much we share.
We, who have achieved a degree of coordination and grace on land, are rendered embarrassingly slow and clumsy underwater.
While these animals are vibrant sparks of life in a watery universe, they have carried with them the gift of play
on their long evolutionary journey back into the sea.
They are the child in us all as they fly, pirouette, and dive without effort, carefree and endlessly frolicsome.
To what purpose is this perpetual devotion to their own amusement?
Certainly the constant chasing, their rumble-tumble contests of speed and dexterity, and their games of tag or keep-away
must sharpen their senses and quicken their reactions, keeping them nimble and alert.
To that extent such exercises would serve an obvious evolutionary goal.
But I prefer to think the sparkle in their eyes emanates from a brighter inner light.
They play,
I believe, because burning within them
is an unequaled spirit of joy.

To have a sea lion press its whiskered snout into
the dome port of your camera,
or steal the mask from your face while another
tugs playfully at your hand,
or to have a sea lion burst through a wall
of shimmering silver baitfish,
exploding them wildly like a million shards of mirrored glass,
here is the very essence of the Galapagos experience:
nature at once wild and free,
yet comfortable in the presence of man.
To swim within an exuberant colony of sea lions is like being
immersed in a pool of hyperactive puppies.
Each sea lion is a dream of innocence and bliss,
and each embodies our fantasies of
freedom and of flight.
Among them and in this special place,
I was adrift in a sea of joy.

The waters of the Galapagos Islands instruct me in the secrets of the underwater world, teaching me lessons in a frequently exaggerated,
often challenging, but always unforgettable fashion.
Natural events unfold here as a unique form of drama, leaving striking images
to script my dreams for a lifetime.

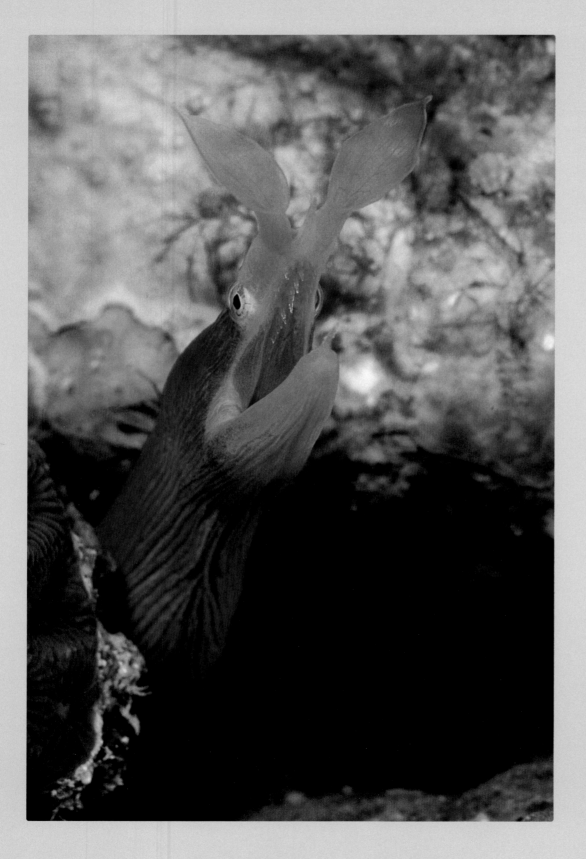

124

Descending about fifty yards before
the steeply sloping rock reef,
I was greeted by dozens of wahoo
racing through swollen shoals
of rainbow runners
lingering aimlessly in the gentle current.
Thousands of creole fish draped
the water around me,
so thick in many areas
I could not see through them.
The craggy contours of the reef
took shape as I approached.

Small, jagged craters of countless barnacles clawed my wetsuit as I lowered into a crevice
among the giant boulders tumbled helter skelter across the bottom.
A strong surge swept back and forth,
but in the protection of these rocks I had found a quiet refuge,
not unlike a hunter's blind, from which I was able to survey the surrounding activity unnoticed.

*Stonefish Portrait*

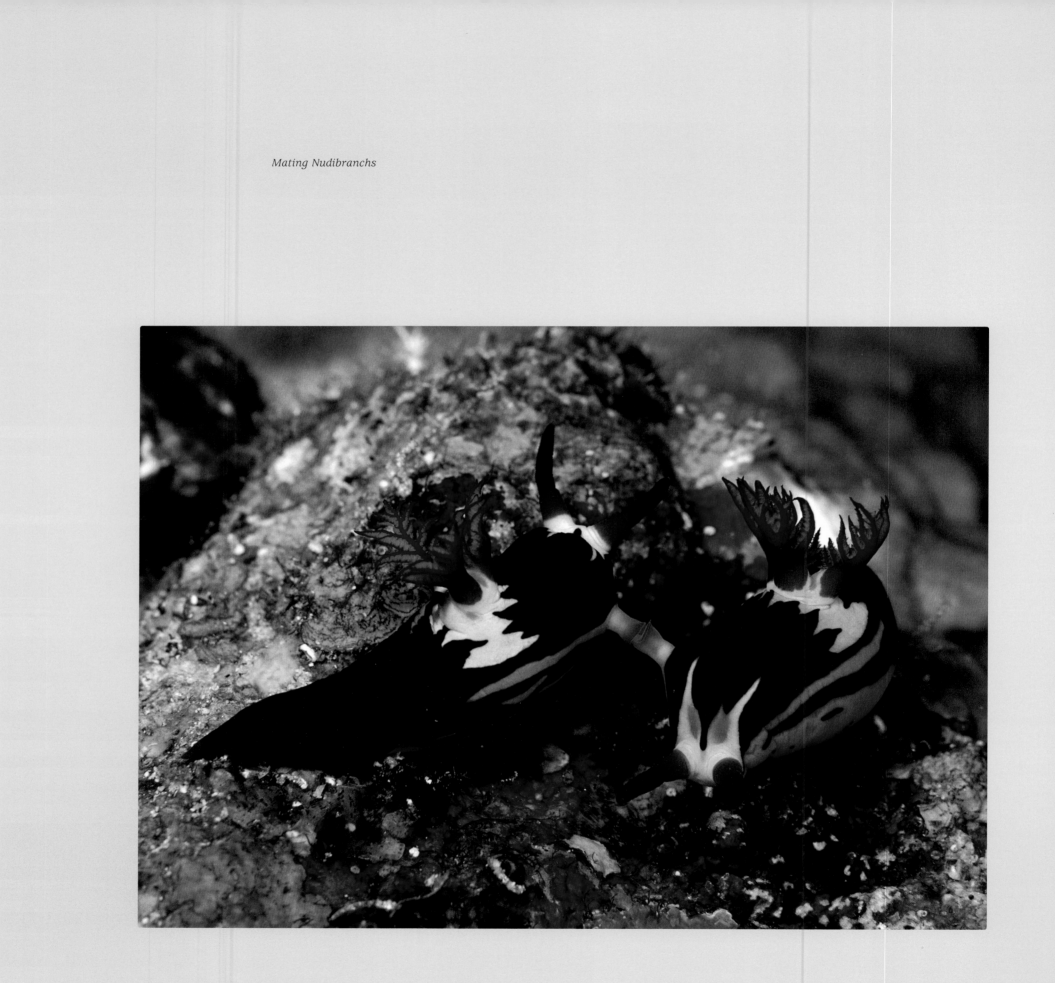

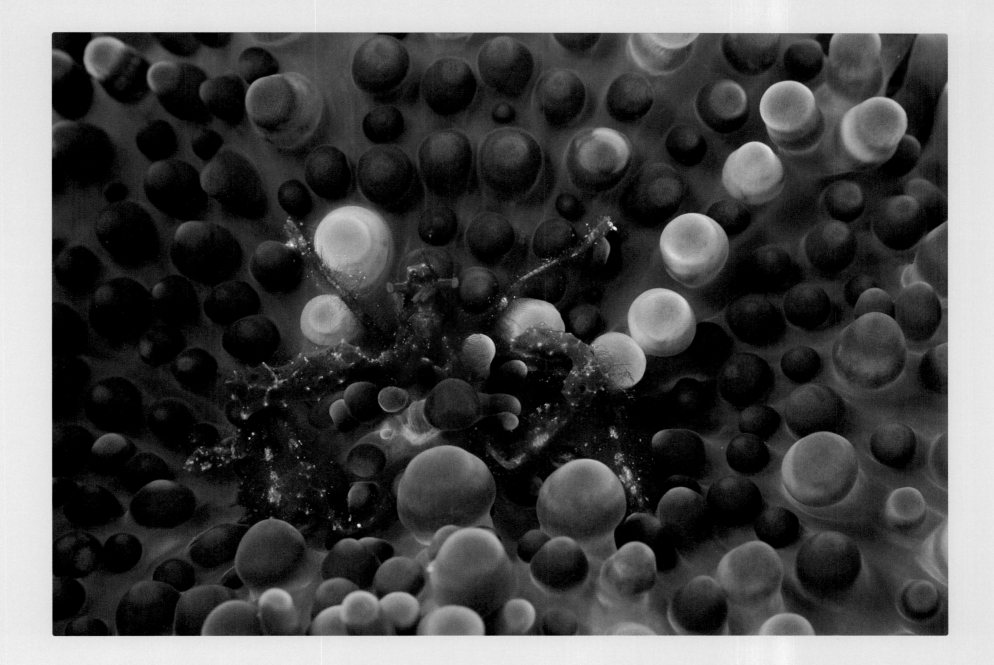

*Decorator Crab in Corallimorpharid*

Relaxed and now at rest, I could hold my breath considerably longer,
the diminished bubbles further concealing my presence from the sea life coalescing around me.
But I was hardly alone in this shelter.
Looking down toward my fins I noticed perhaps a dozen moray eels who called this place home.
From numerous holes and cracks,
they would extend their heads, mouths agape,
then duck back inside, only to emerge moments later.

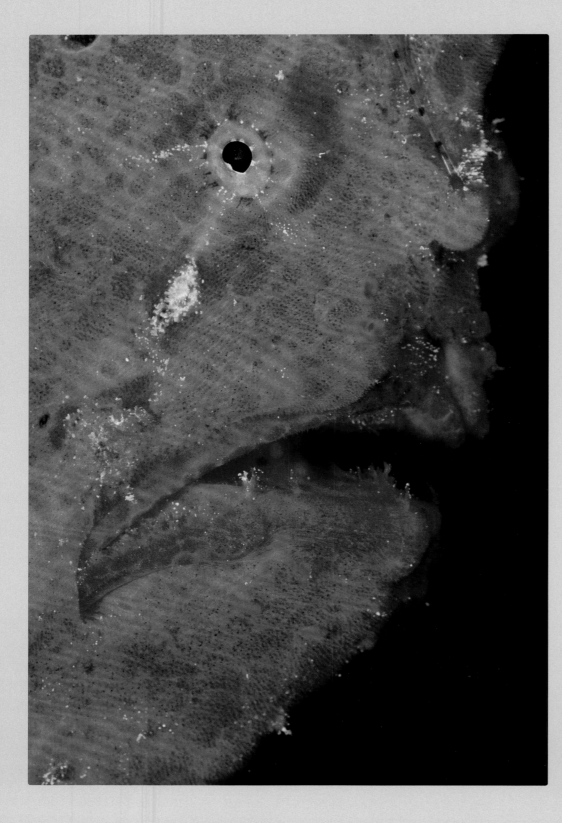

Mimicking their larger relatives,
tiny blennies would pop in and out
of old barnacle holes,
cocking their heads
from one side to the other,
perhaps not quite believing their eyes.
They created a zany kind of a rhythm,
dancing in this comical
undersea chorus line.
Everywhere I looked within my sanctuary,
eels and blennies,
out, then in,
appearing and disappearing,
mouths opening,
then shutting,
never quite in sync with each other.

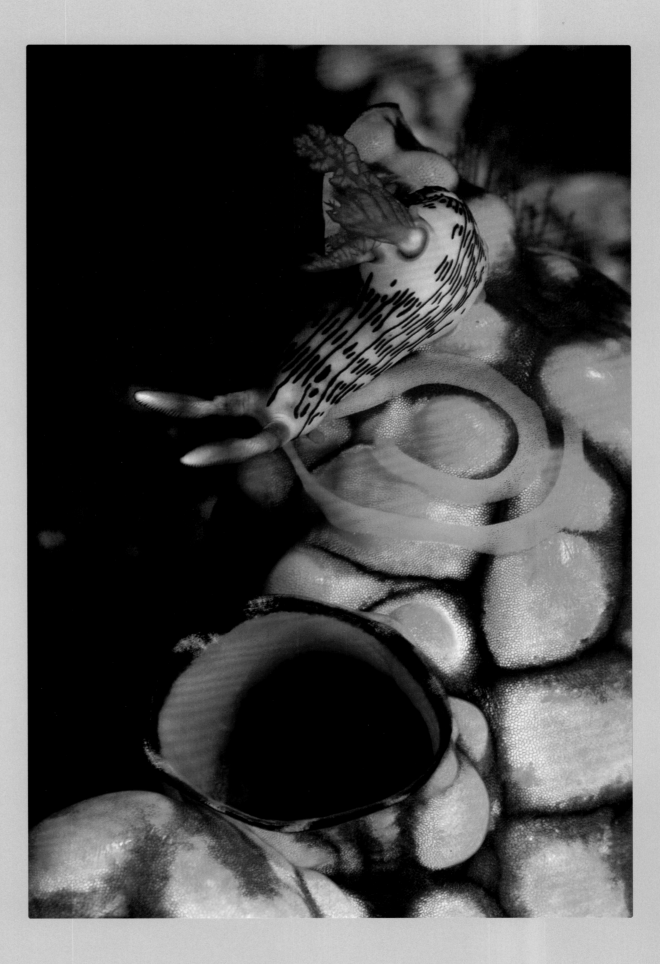

*Nudibranch Laying Eggs on Sea Squirt*

129

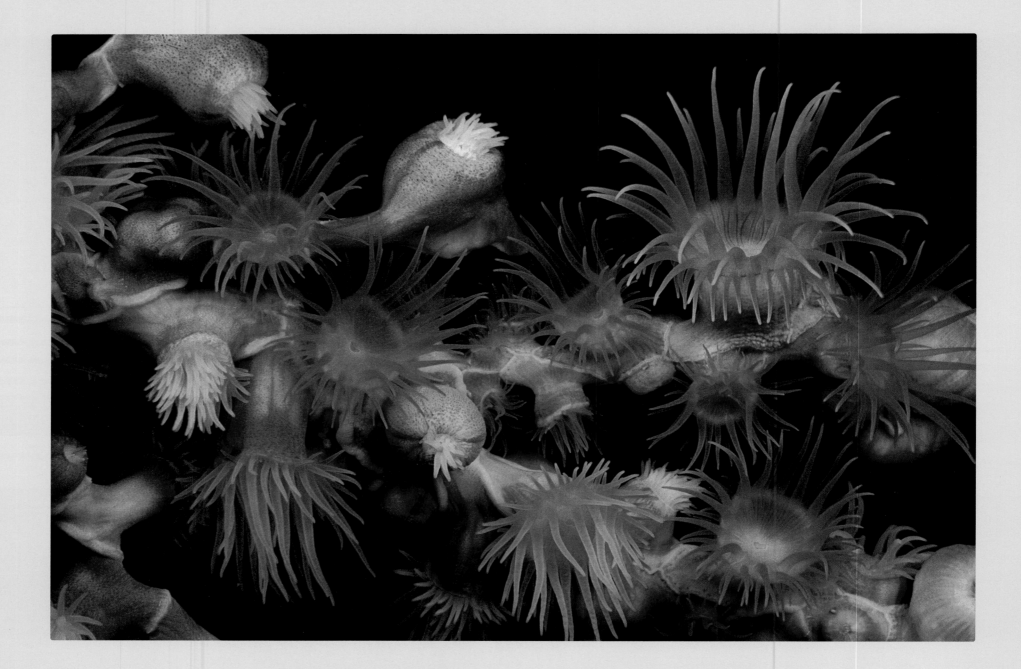

*Parasitic Anemones*

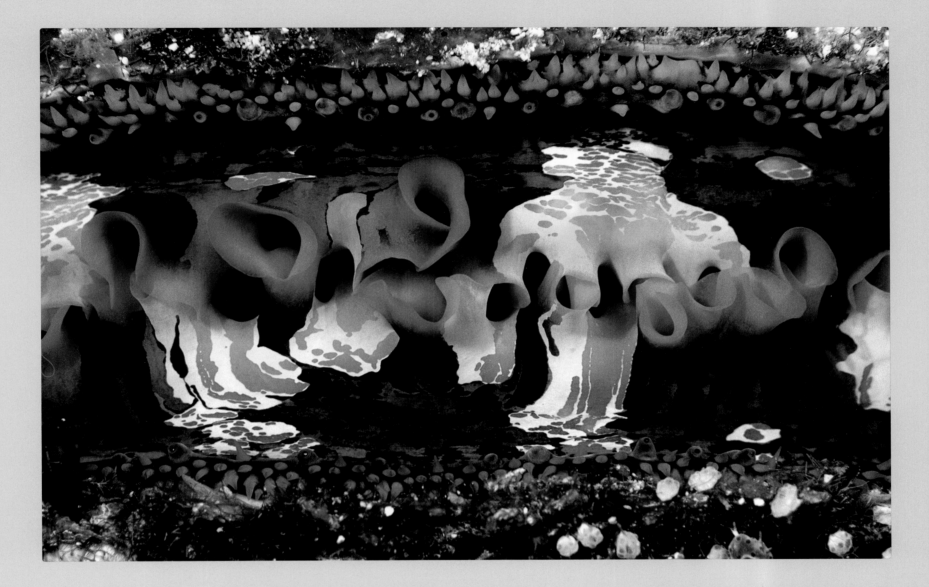

*Thorny Oyster Mantle*

Like stage curtains, the dense wall of creole fish still separated the shallows from the open sea.
Cool, deep-water currents engage the sloping island shores,
sweeping a rich payload of nutrients upward and luring these dusky planktivores
by the multi-thousands into the unprotected open water.
The sheer volume of this biomass was astonishing.
But it was a barrier easily breached,
and through this living curtain danced a remarkable cast of characters,
players in an intense spectacle unfolding on the rocky reef before me.

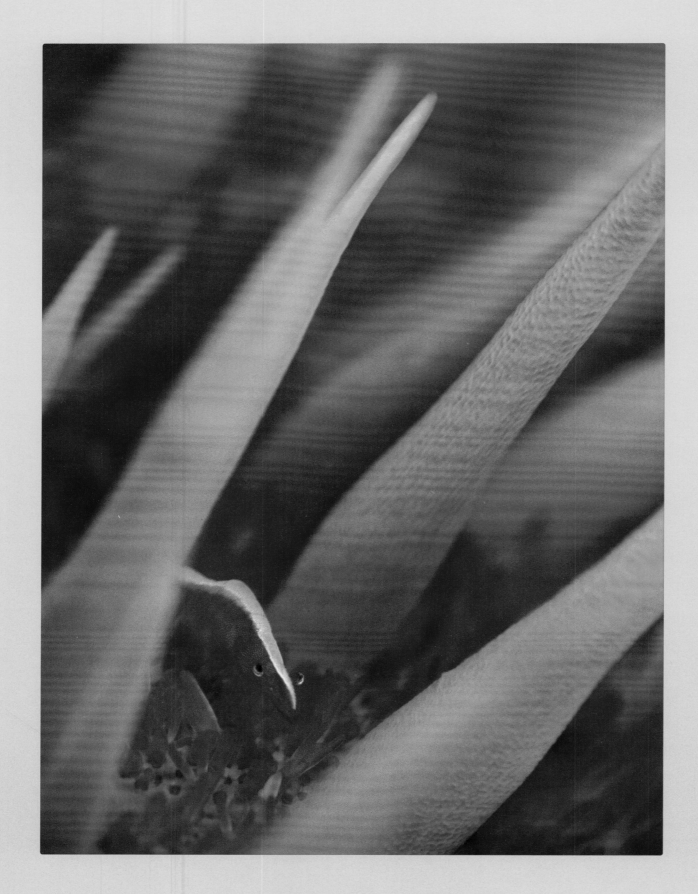

132

*Shrimp on Crown of Thorns Starfish*

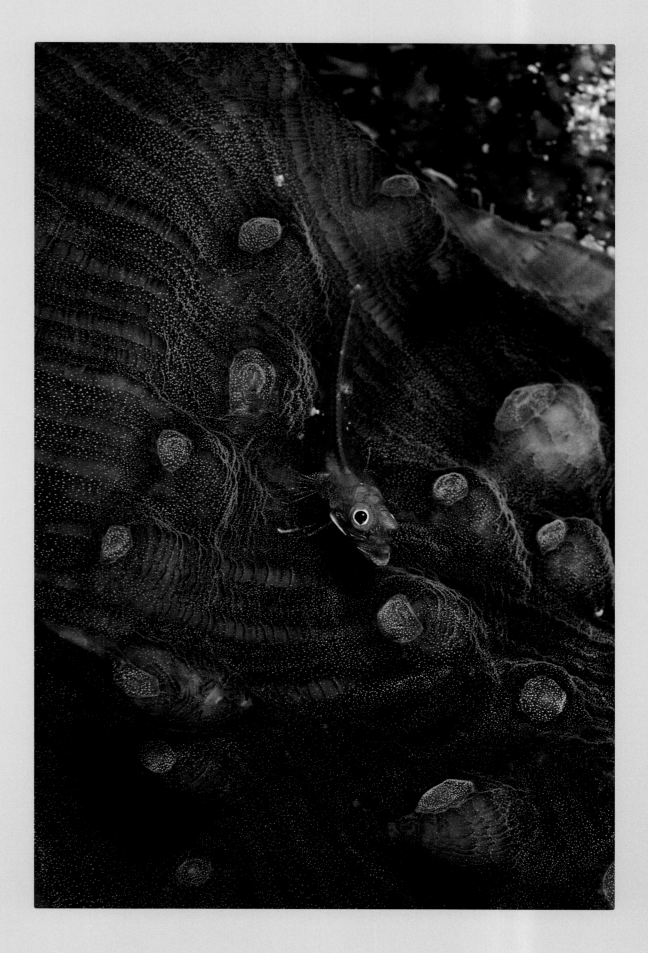

*Goby on Coral*

133

Their signature shape was immediately recognizable.
The large, robust bodies, high dorsal fins,
and extended scythe-like tails spelled hammerheads well before I could read the elongated lobes of their heads,
with those large black eyes perched so vulnerably on either end.
What puzzled me as they came more fully into view was their uncharacteristic movement.
Gone were the grand sweeps of their huge tails tracing graceful arcs through the sea.
Gone was the pendulum swing of their heads clearing the space before them.
Gone was the commanding glide produced by these powerful, resolute strokes.
Now moving slowly, listing noticeably to one side with their heads arched slightly back,
the sharks shimmied and jerked forward, as if almost in a trance,
unaware of their surroundings.  As they came closer still,
I saw that several dozen king angelfish were scouring their backs and sides,
acting for all the world like cleaner fish.
Of course! They *were* cleaner fish.
I had stumbled into the middle of a vast hammerhead shark cleaning station.
Deep fresh wounds on the flanks of one shark suggested recent courtship and mating.
Quick scrutiny of the pelvic fin area confirmed that this animal was indeed a female,
lacking the characteristic clasper fins of the male.  Perhaps this cleaning activity is a consequence
of their mating ritual, helping to rid the shark not only of normal parasites,
but also bits of dead flesh remaining from their violent unions.

As soon as these sharks passed,
I turned to see several more emerging through swarms of fish
seemingly unconcerned about the passage of these large predators.
Rainbow runners abounded, while huge amberjack drifted warily about.
Barely noticeable between the bands of hammerheads were dozens of brawny Galapagos sharks.
Large tuna stalked the open water.
At one point I turned my head to see a hammerhead and a green sea turtle being cleaned side by side.
Sharks eat turtles, after all, but this did not seem to matter.  They seemed oblivious to each other,
perhaps observing some unspoken truce.
An eagle ray circled, and the sharks kept coming.  But they were just an overture for the movement to follow.
I was absolutely surrounded by bustling sea life of all descriptions,
a huge pelagic soup stirred daily by the tides.

Within minutes dozens more hammerheads appeared, and every so often,
one would drop out of formation and go into that peculiar trance.
And as this would happen, I would invariably notice numerous
king angels combing the twelve foot length of these sharks.
Was the strange behavior of the hammerheads
a reaction to the tactile stimulation of the cleaner angels,
I wondered, or an invitation to them?

Speculation about this was quickly forgotten, as larger schools of hammerheads now began to pass.
For what started as a trickle was now a flood.
Hammerheads were everywhere, teeming about in huge numbers.
It was as if someone was pouring giant bucket loads of hammerheads over me from above.
As long as I stayed low in the rocks and breathed slowly the hammerheads
were unafraid of my presence, often passing within feet of my hidden foxhole.
The hammerhead, for all of its foreboding size and frightening power, does not usually represent a threat to divers.
Rather, these large carnivores can be quite timid of humans,
normally keeping a respectable distance when one encounters them in the open.

But out of film and with nothing to lose by scaring them away,
I quietly pulled myself free of the rocks and began kicking gently,
merging myself with the undulating waves of sharks rolling by.
Incredibly, they weren't disturbed by my presence this time, or even by the commotion of my exhaled bubbles.
I was completely enveloped by them, with hammerheads at touching distance above, below, and to either side.
Forward and together we swam in a slow, perfect rhythm,
creatures separated now by millions of years of evolution,
yet joined once again in this moment,
sharing some silent communion and intuitive trust.

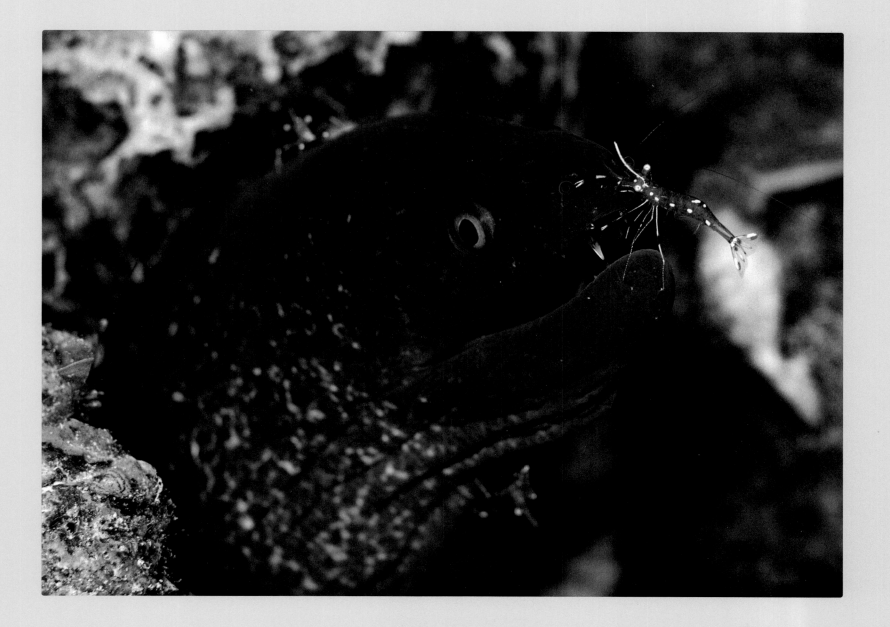

135

*Cleaner Shrimp on Yellowmargin Moray Eel*

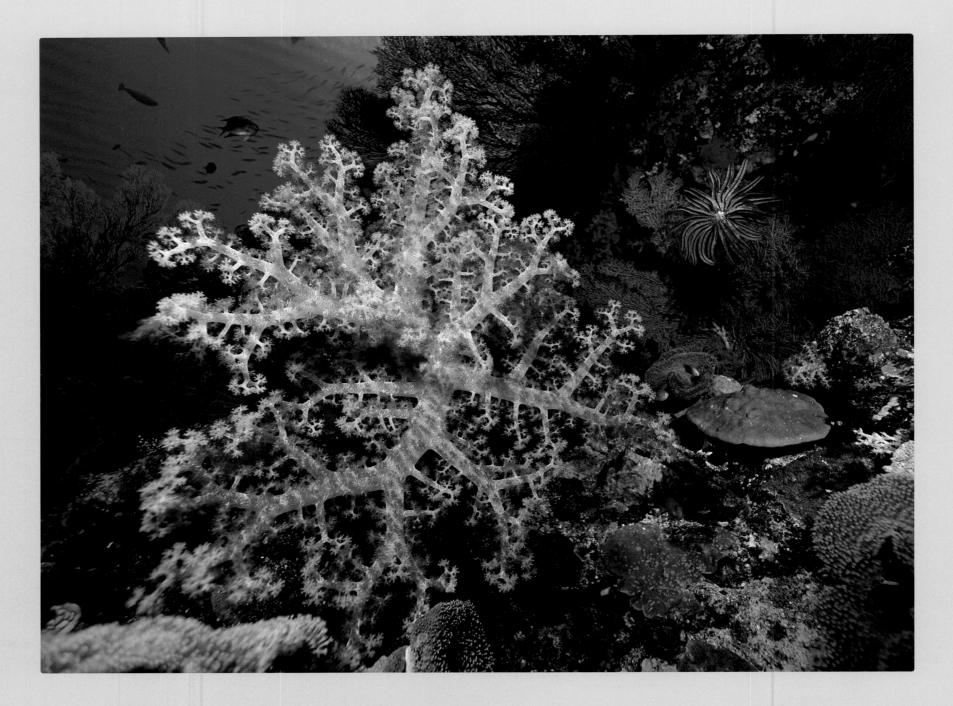

*Soft Coral Tree*

Time has long since passed the shark by, as they achieved a utilitarian perfection millions of years ago.
They remain as living dinosaurs, still roaming the seas as they did in prehistoric times.
But evolution has left our species poor swimmers, and inevitably the sharks passed me by.
I watched in quiet awe as the school gradually vanished in the mist.
All that remained was the faint waving of their large, graceful tails,
and that vision too soon disappeared.

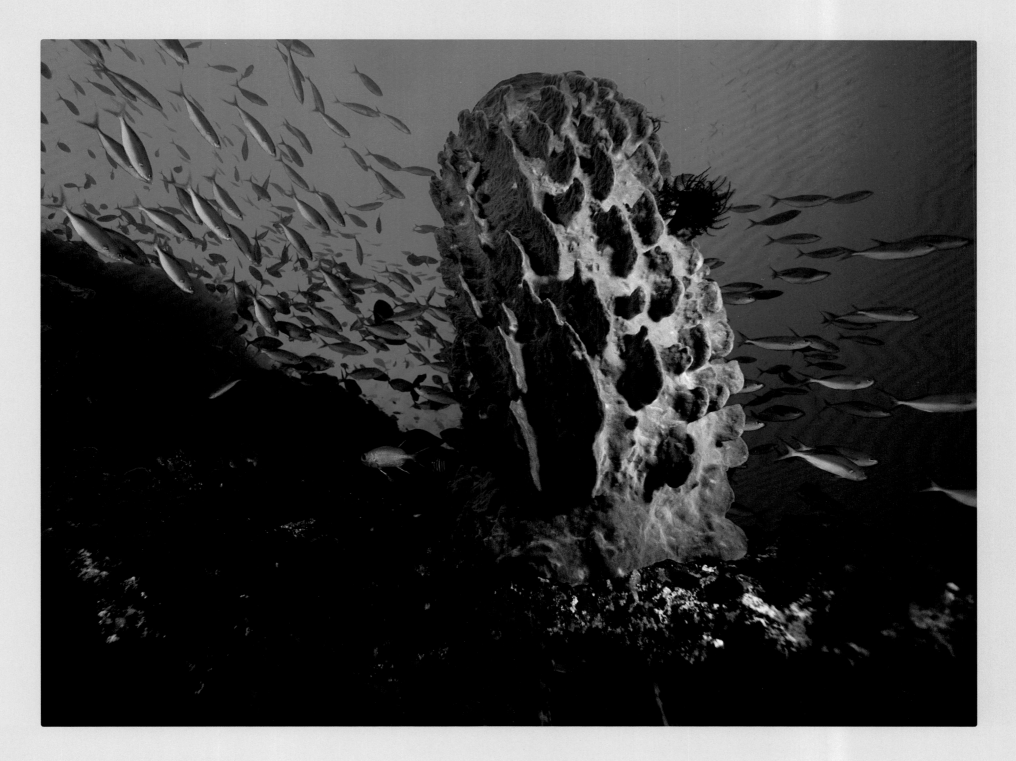

*Barrel Sponge*

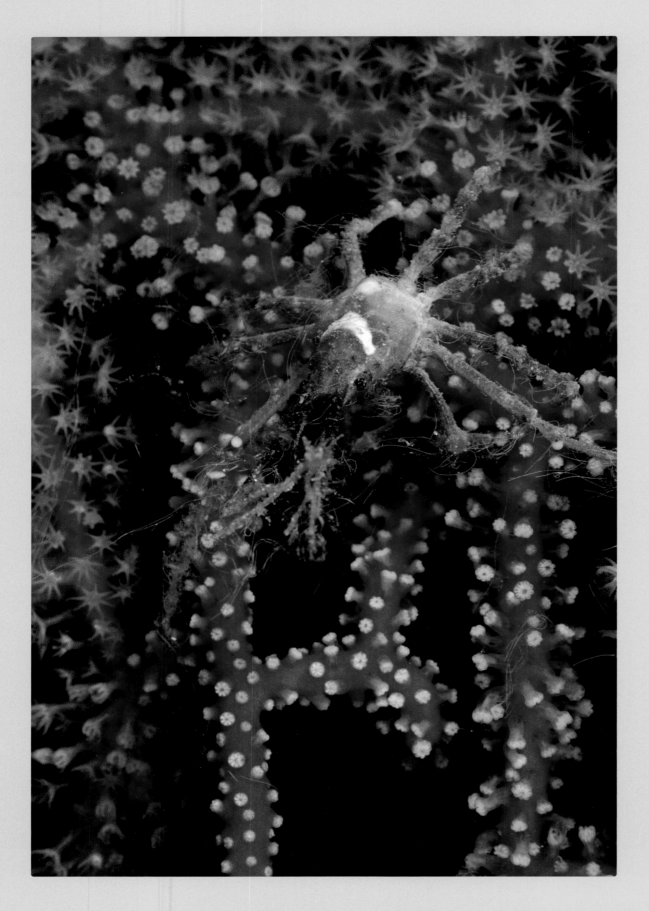

*Decorator Crab on Sea Fan*

The day had become lightly overcast, softly diffusing the afternoon sun.  I returned on a subsequent dive to the exact same spot,
but the reef lay empty, silent, and still.
So I headed off into the deep water blue.
The bottom dropped away quickly, and soon I lost sight of any points of reference.
I was back in the formless void,
that paradoxical expanse of mystery so full of nothing,
yet brimming with the unexpected.

*Caledonian Stinger*

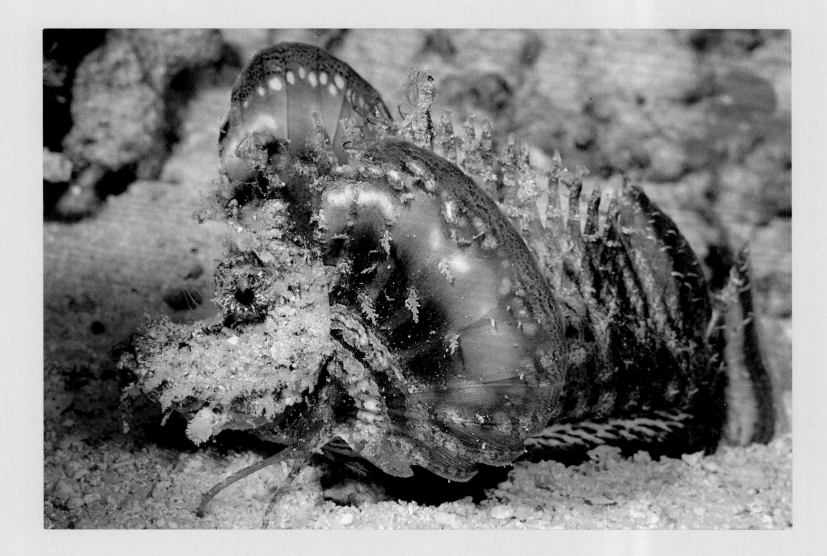

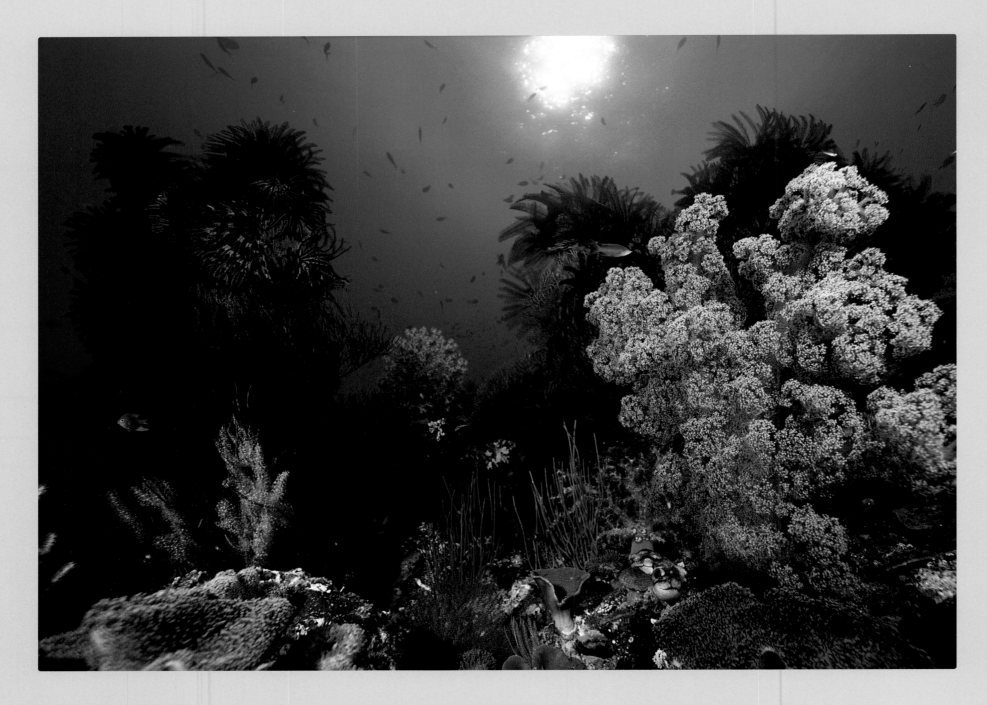

*Reef Scenic*

I eventually noticed a few jacks and a handful of rainbow runners milling about,
meager signs of life in this measureless blank space.
The fish were sparse at first, but the farther I ventured into the open sea,
the more fish seemed to gather around me.  I wondered what my attraction was to them,
and whether their primitive thought processes included a sense of curiosity.

Or was I lowered in their view to a mere artificial reef,
like a floating log or a drifting cargo net, known to attract entire pelagic food chains.
Before very long I was surrounded by huge numbers of rainbow runners and rainbow chub,
mixed with small mackerel and bonito.  Larger trevally threaded their way through this growing glut of fish,
and, off in the distance there looked to be an immense school of big-eyed jacks,
though I could only make out
the vaguest of images, mere hints of light against a featureless blue background.

From the direction of the jacks they first became visible.  Dozens of large hammerheads were coming toward me.
Dozens grew to hundreds in just moments, and soon countless shapes were materializing out of the obscurity.
As they surrounded me, growing bolder and moving closer, I grew dizzy at the spectacle embracing me.
Looking toward the surface eighty feet above, and scanning through the water column to the unseen depths
hundreds of feet beneath me, all I could see were hammerheads.
I was astonished at the realization that the large school of jacks I thought I saw in the distance were not jacks at all,
but a great swirling vortex of these magnificent sharks.
They loomed around me now like giant thunderheads,
rising from below and mushrooming toward the sun.
I was suspended in plunging open-water canyons separating the tremendous spiraling clusters of hammerheads,
gliding like a bird among these rotating dark clouds.
Who could even count them?  There were thousands, so relaxed and peaceful.

The tranquillity of the moment was not to last.
From somewhere in the distance behind me something occurred.
Though unknown to me, it was instantly telegraphed to the primal senses of the animals
filling the expansive sea before me, igniting their instincts, firing their fury.
At once and everywhere, the aimlessly swimming hammerheads snapped abruptly in my direction.
Fierce lashes of their tails launched them toward me by the score,
too quickly to allow fear to register within me.
I could only watch dumbfounded and confused as countless hammerheads exploded from all directions.
I pulled my eye involuntarily from the camera.
My lens made everything seem small and distant,
but now their staggering size, their numbers,
and the speed at which they were hurtling at me came into alarming perspective.
With the bottom far below and the reef distant, I was naked of protection.
On they came in a thrilling, frightful torrent.
But just as the assault seemed inevitable,
they parted ever so slightly, careening past me on either side in a breathtaking rush.
By the hundreds they went by.
Pressure pulses from the thrust of their tails buffeted my body, so close was their onslaught.
It was as if I was watching a slow motion movie,
time itself overpowered by the energy bursting like fireworks around me.

*Parrotfish Tail*

*Lyre-tailed Sea Slug*

And then they were gone.
All signs of life had suddenly vanished, leaving the water empty and silent once again.
Swept along with the hammerheads were the other schools of fish that moments before clouded the water everywhere.
I was eerily alone, bewildered and disoriented.
In a fleeting moment I had gone from the focus of all life to realizing I was nothing at all,
a mere floating speck like all the other plankton, of no individual consequence to the world I was in.
Instinctively I touched myself, looking at my arms and legs,
to assure that I was still whole.
I tried to regain my senses,
as if I were waking from a dream.

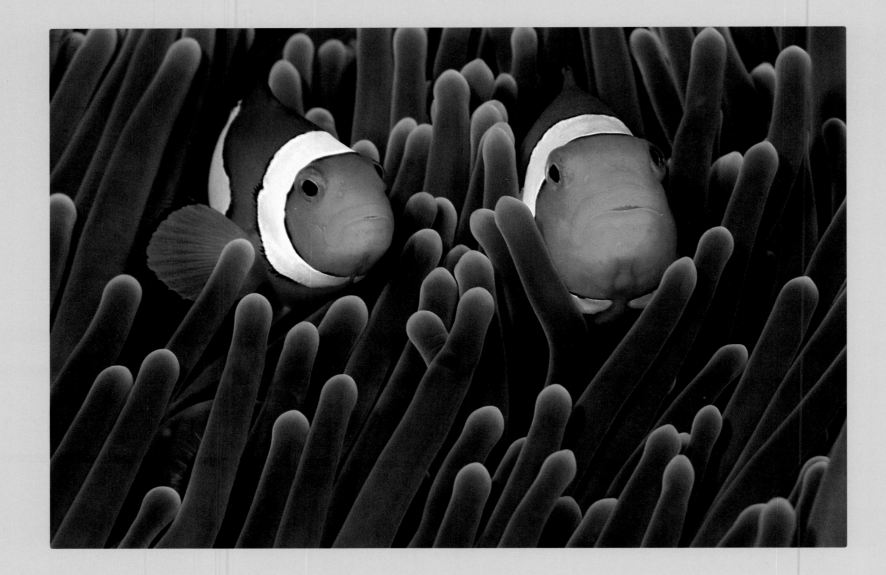

*Clownfish in Anemone*

The meaning of that event is an enigma to me.
I will never know what catalyzed such a striking mass reaction from the sharks.
Nature's rhythms unfolded in a fresh, impromptu symphony, where the performers may know their own parts,
but the larger composition remains obscure.
It was enough to be there then,
so close to the primal rhythms of life and death I was pounded by the furious beat.

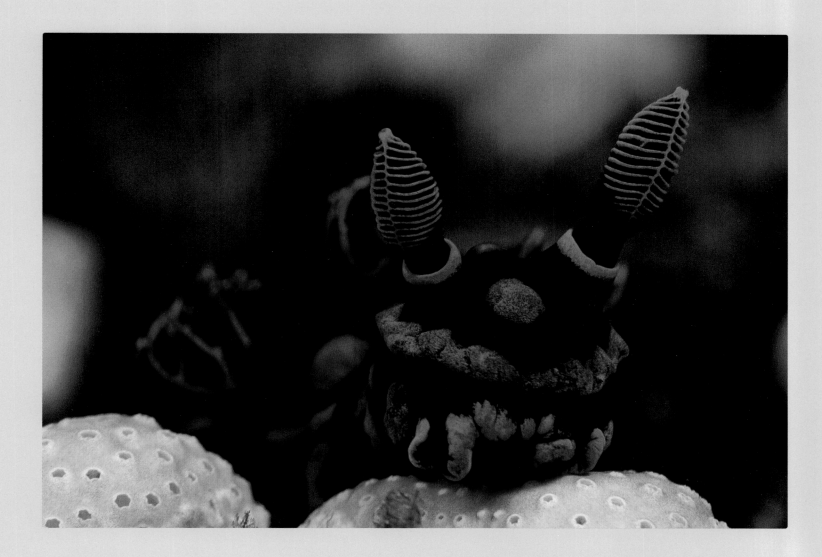

*Fluorescent Nudibranch*

Once more the Galapagos had proved a magical guide, leading me down unexpected paths.
Nature sometimes holds up such experiences to us simply as a mirror,
allowing us to see deeper into ourselves, to that private part of our souls
where we confront the question of our own mortality.
Or perhaps she offers such an experience as a lens, permitting us to focus
more precisely on our own connection to all her creations,
to the source of our mutual existence.

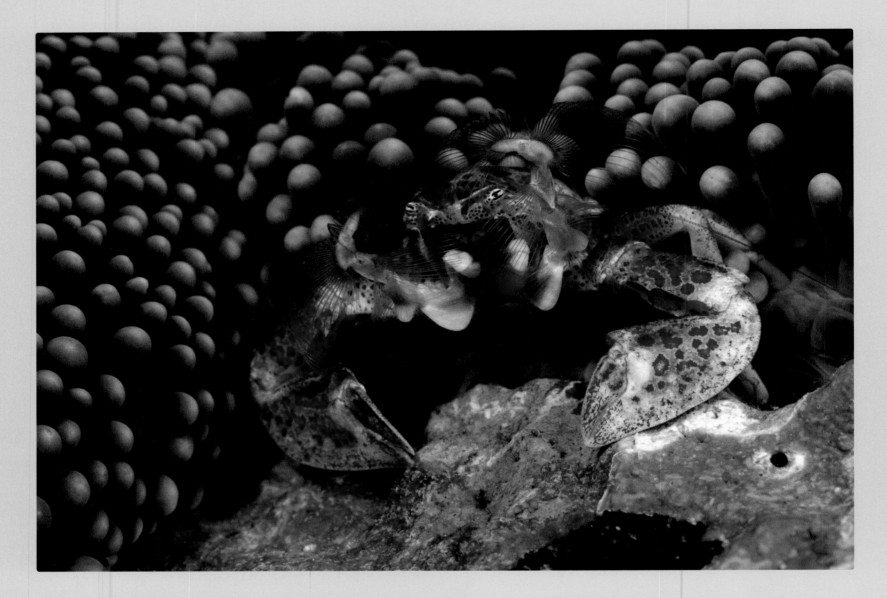

*Porcelain Crab and Sea Anemone*

It was a brief and fragile moment,
one so easily lost.
But as I once became part of them,
all these creatures of the sea are now a part of me, in my mind, in my soul, in my dreams.
Towering waves of hammerheads swirl through my memory, filling me with quiet reverence.
Sea lions tug playfully at my heart, making me smile, and
dolphins glide gracefully within my thoughts, giving me inspiration.
They are with me now, and I can see them all,
adrift in a sea of dreams.

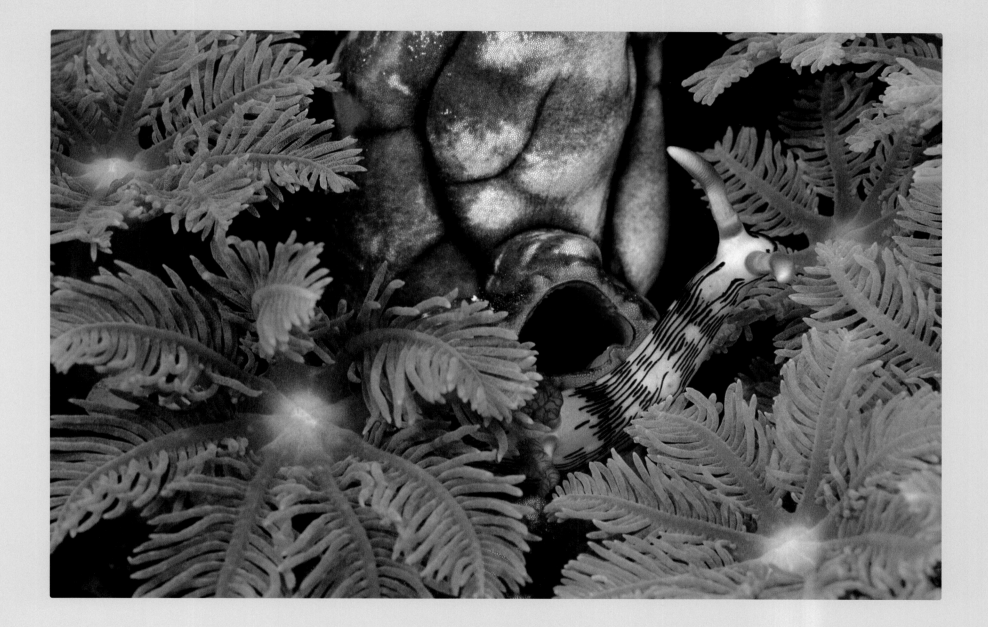

*Invertebrate Tableaux*

Rising faintly out of the depths, a low, brooding murmur reverberated
softly through the hull of my Boston Whaler.
This fiberglass shell separating me from the sea was becoming an amplification chamber now connecting
me to one of her most majestic creatures.
I lay down in the boat to better hear the singing of an enormous humpback whale
floating perhaps a hundred feet below.

I felt strangely guilty, as if I were an intruder eavesdropping on the private musing of this ninety thousand pound mammal.
A series of low, guttural grunts expanded to a rich bass, rose to a supple alto,
and merged at last into a sustained, bittersweet moan.
The voice carried a haunting loneliness as it resonated through the empty sea.
I sensed a deep emotional anguish in this lament, but then thought how foolish it was of me to project my human
feelings on the voice of so great and mysterious a creature.
The moans slowly transformed to a high-pitched, plaintive cry,
undulating in gentle rhythm with the waves that rocked my boat.

No one really knows why these whales sing or the meaning of their hypnotic songs.
Theories vary as greatly as the notes that whales reach with their incredible range of sound.
Unlike those of dolphins and other toothed cetaceans,
the vocalizations of the humpback do not serve the function of echolocation.
Some students of whale behavior believe that only solitary whales sing,
that the sounds are likely a type of mating call.
Still others suggest the songs are designed to space adult males some distance apart,
reducing the frequency of their often violent rivalry for females.
Yet I have drifted above two stationary humpbacks resting side by side, one of which was singing so loudly
the vibrations caused surface layers of its skin to slough off, clouding the water above.
I free-dived toward them and collected a piece.  Whale skin, how thin and delicate it was,
a translucent light grey.  Not at all what I might have imagined.
And, except for the color, how much like human skin it felt to my touch.
Quite possibly their reasons for singing may forever remain a mystery to us.
They sound this way,
I suppose,
simply because they are whales.

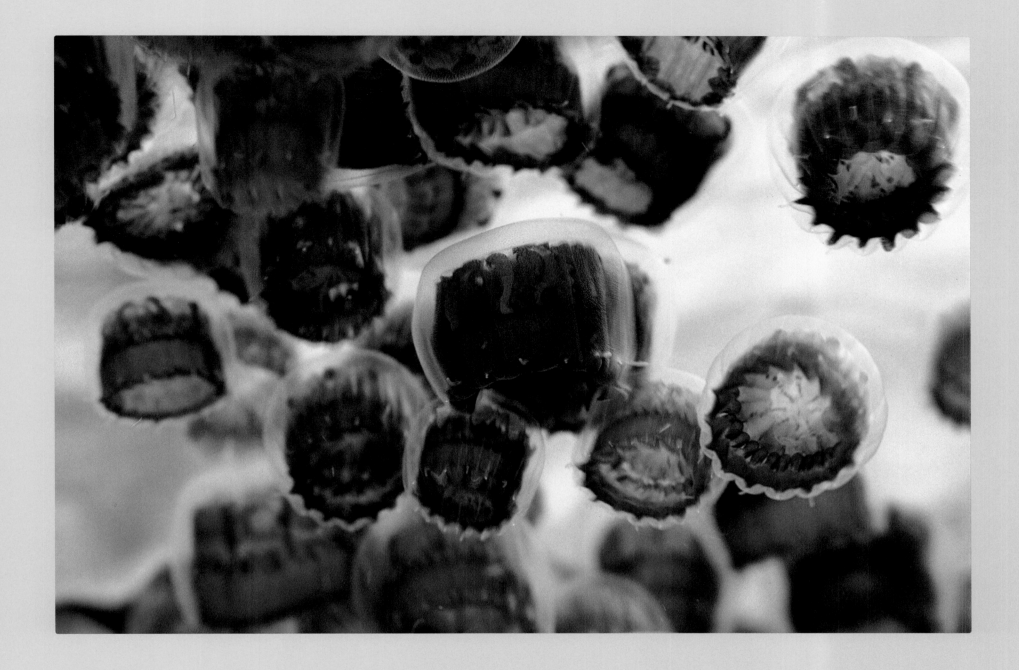

Thimble Jellyfish

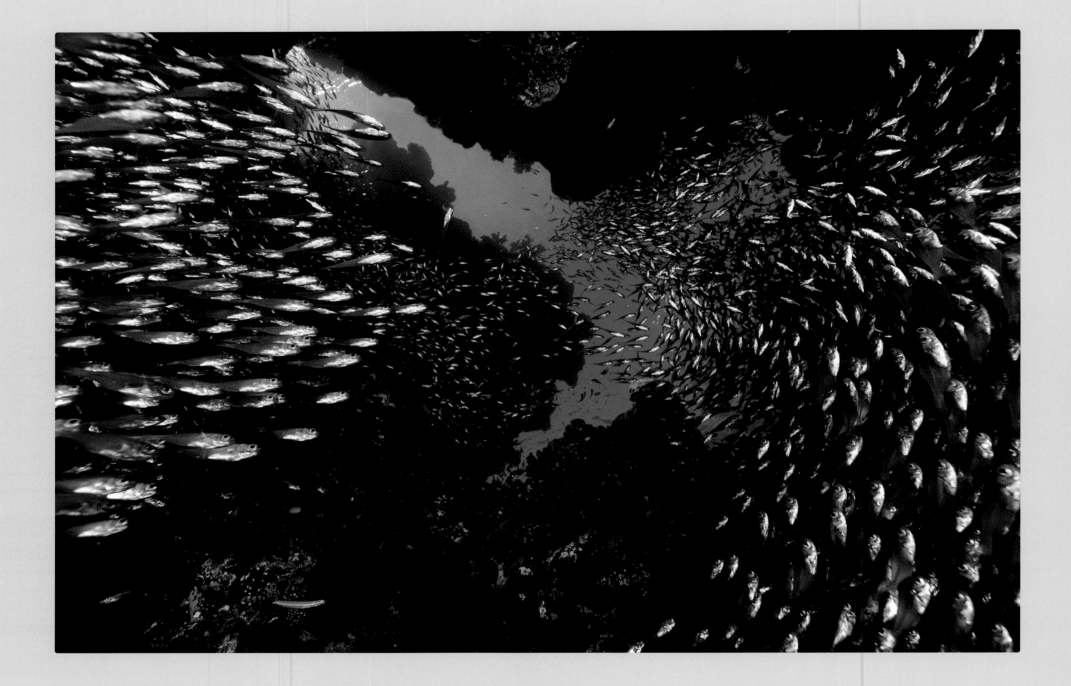

*Glassfish in Cave*

I normally do not have good luck photographing singing humpbacks.
Their appearances on the surface are so very brief, just long enough for the whales to take a few fresh breaths
before descending once again to continue their songs.
The length of time they spend submerged differs widely,
but one can often expect them to be down as long as twenty-five minutes before reappearing.
Obviously photo opportunities topside are fleeting at best.
Underwater,
they are nearly impossible.

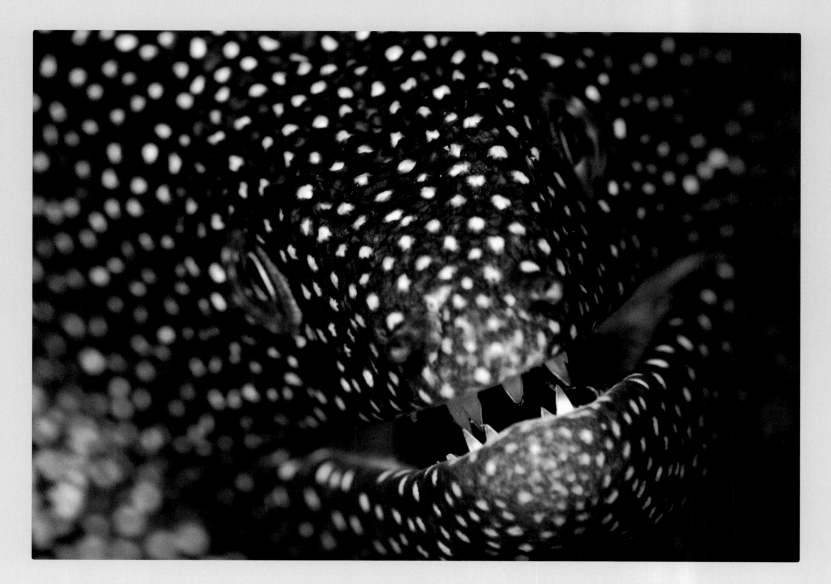

*Spotted Moray Eel*

151

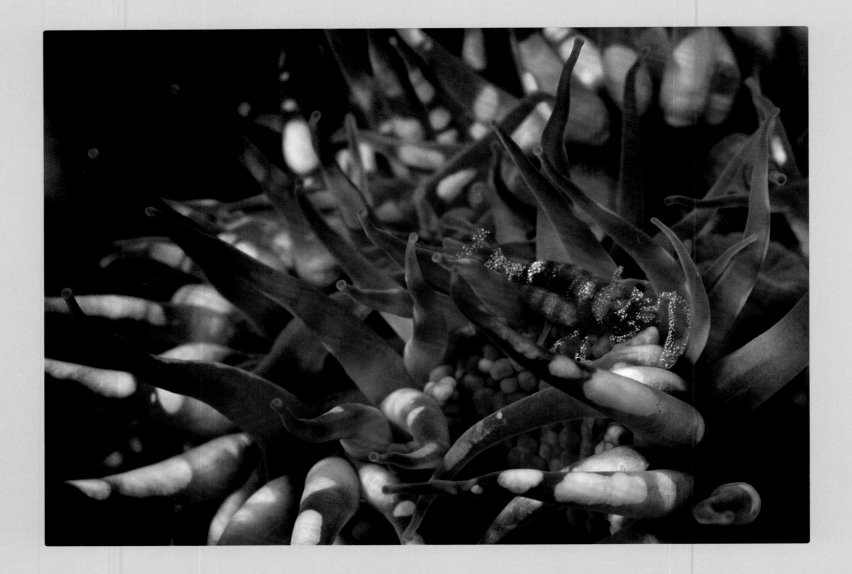

For a few minutes after a whale dives its "footprint" lingers on the surface,
a large slick area marking where the whale has passed before descending.
It is formed by a combination of the whale's huge mass and oils secreted from its skin.
But the *sense* one has–the feeling one gets when very near them–is that a great whale is so commanding a presence
that even the sea quiets in its path, even the waves bow in respect.

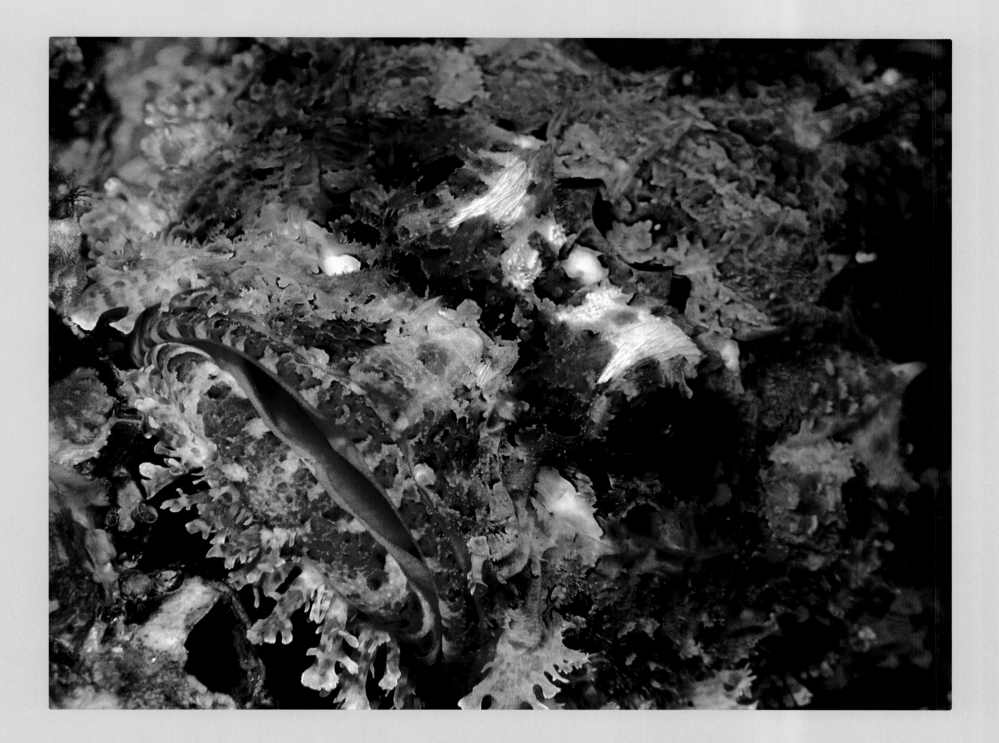

*Scorpionfish*

My boat drifted before just such a footprint,
marking the last spot this whale had surfaced.  If I guessed correctly,
the whale was not traveling in any given direction,
but merely ascending
then descending in the same general location.
I would wait and watch.
As long as it took.

*Marbled Ray*

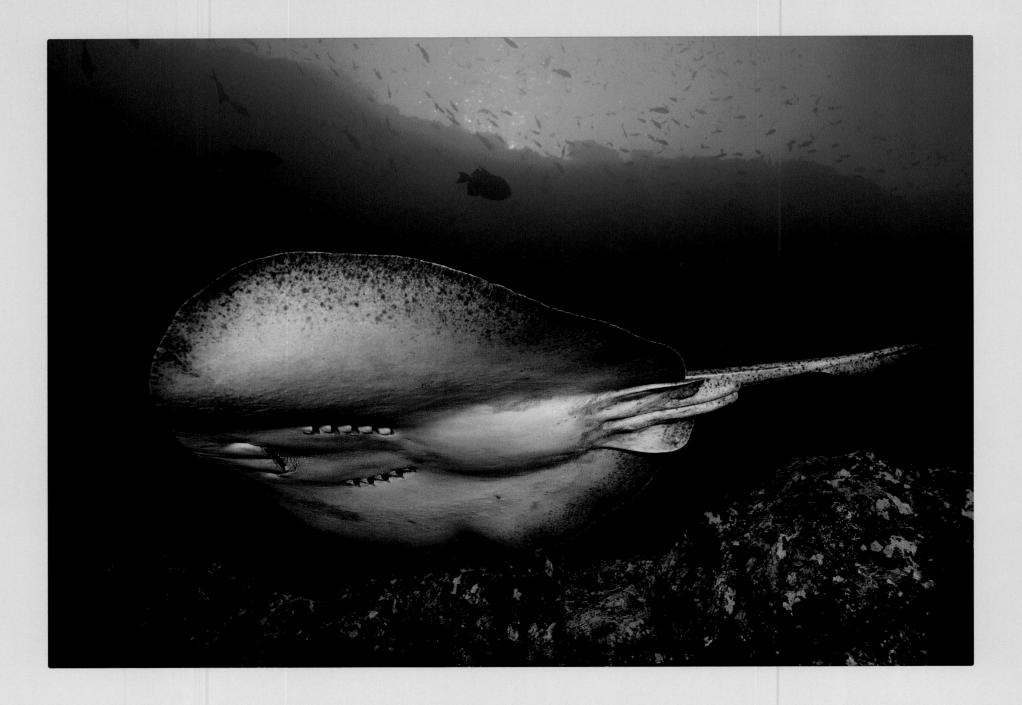

154

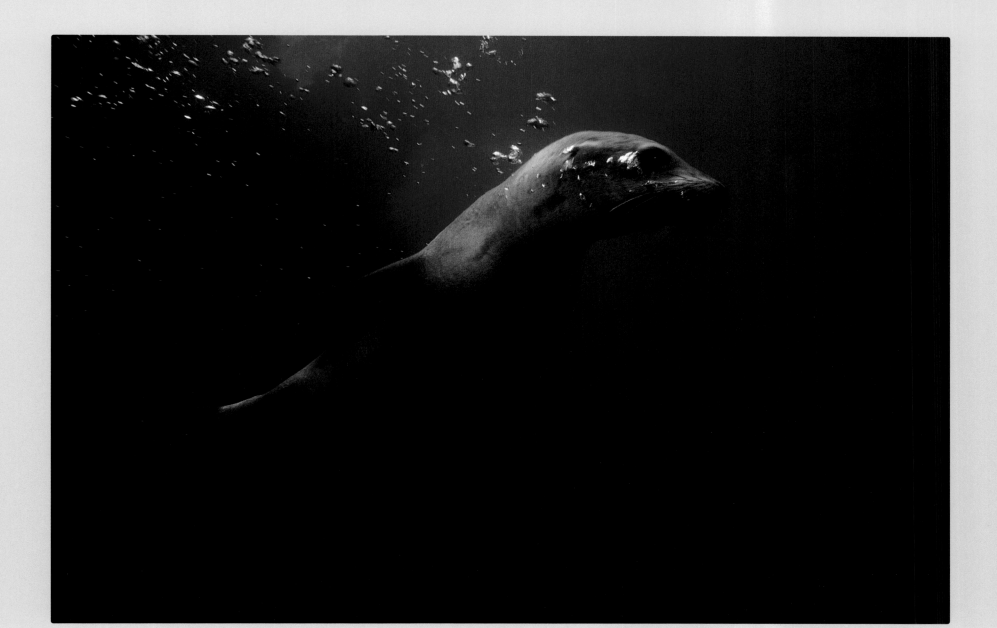

*Sea Lion*

Just minutes later a thundering rush of air and spray was followed instantly by a forceful suction, shattering the silence as the whale
surfaced and blew directly behind me.  The exchange of breath took barely over a second,
with air speed through the blowhole approaching two hundred miles per hour.
There is no sound quite like this in nature, for nature has no equivalent to the great whales.
It is an unforgettable sound, and it can become a sound that one yearns for,
a sound so big and powerful, so intimidating and exhilarating
that it compels you to pay attention,
hammering your heart,
snapping your head, popping your eyes wide.

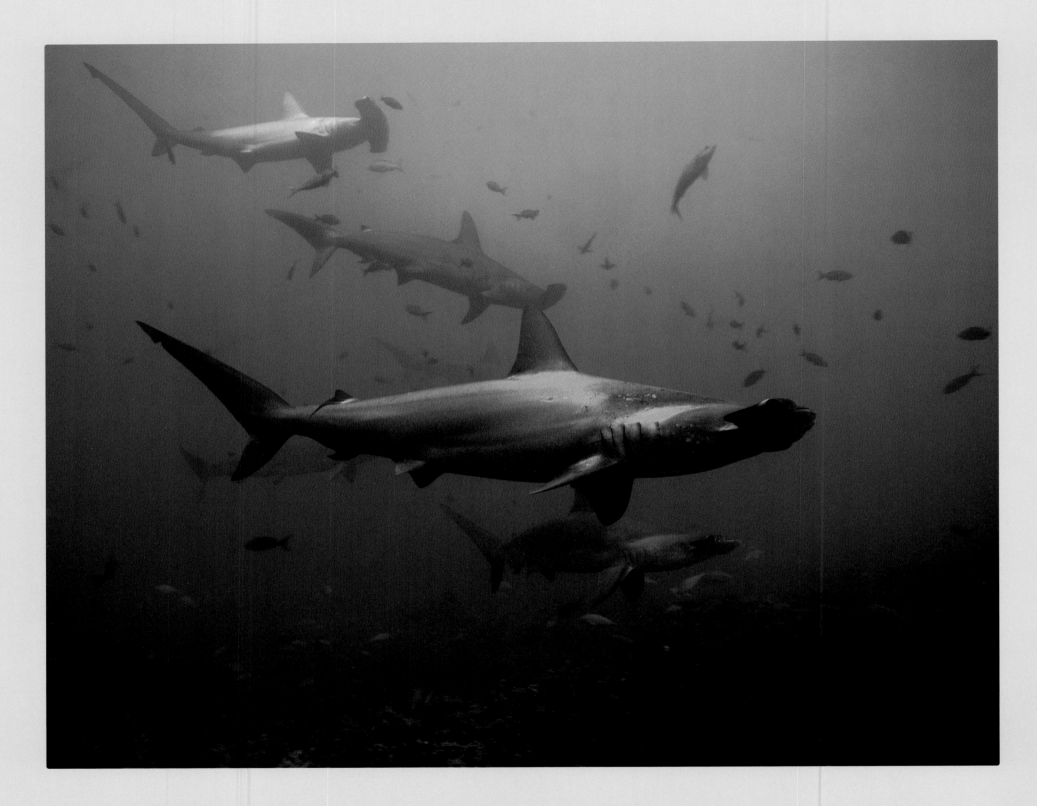

*Scalloped Hammerhead Sharks*

I whipped around instantly
to see the slick grey-black back of the whale break the surface.
A thin vapor of seawater hung in the air,
ephemeral testimony to the passage of one of earth's largest beings–
a whale's breath of life writ in vanishing mist,
symbol of our shared ancestry through the ages, token of our common bond today.
And then quickly again another colossal rush. Fifteen hundred liters of air exploded through both of its six inch nostril openings
as the whale exhaled, then took a second breath.  Circling tightly and probingly around my boat,
the whale blew three more times before arching its back sharply,
dropping its enormous head,
then raising its tail vertically in the air,
propelling itself into the depths.

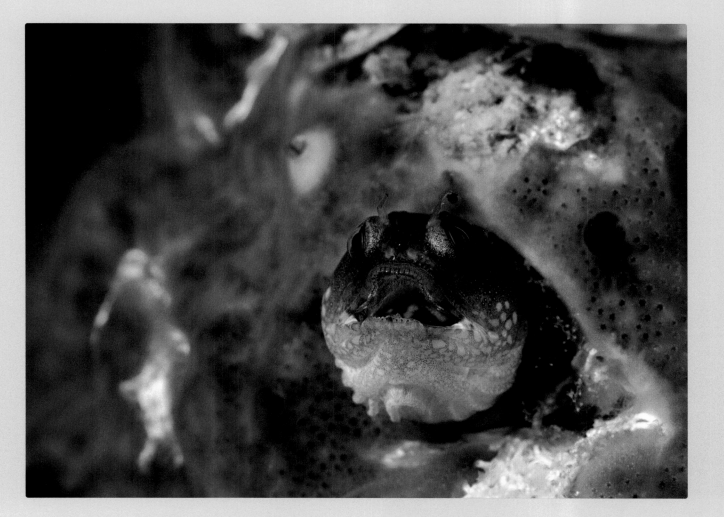

*Barnacle Blenny in Sponge*

157

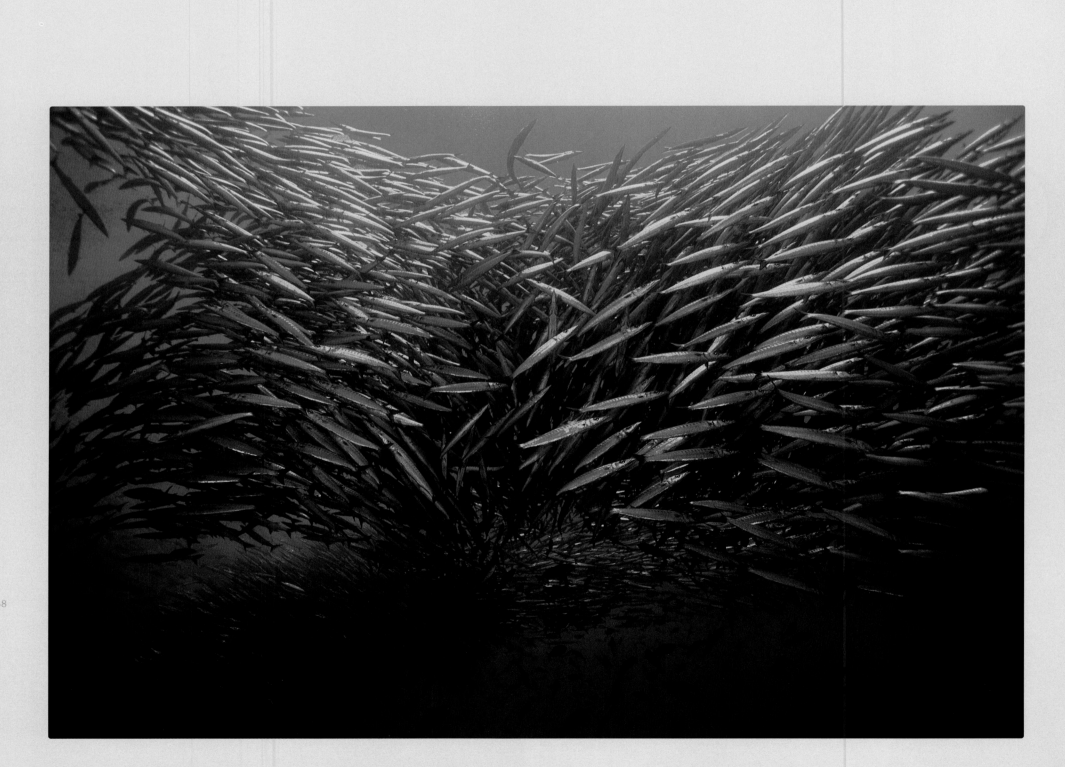

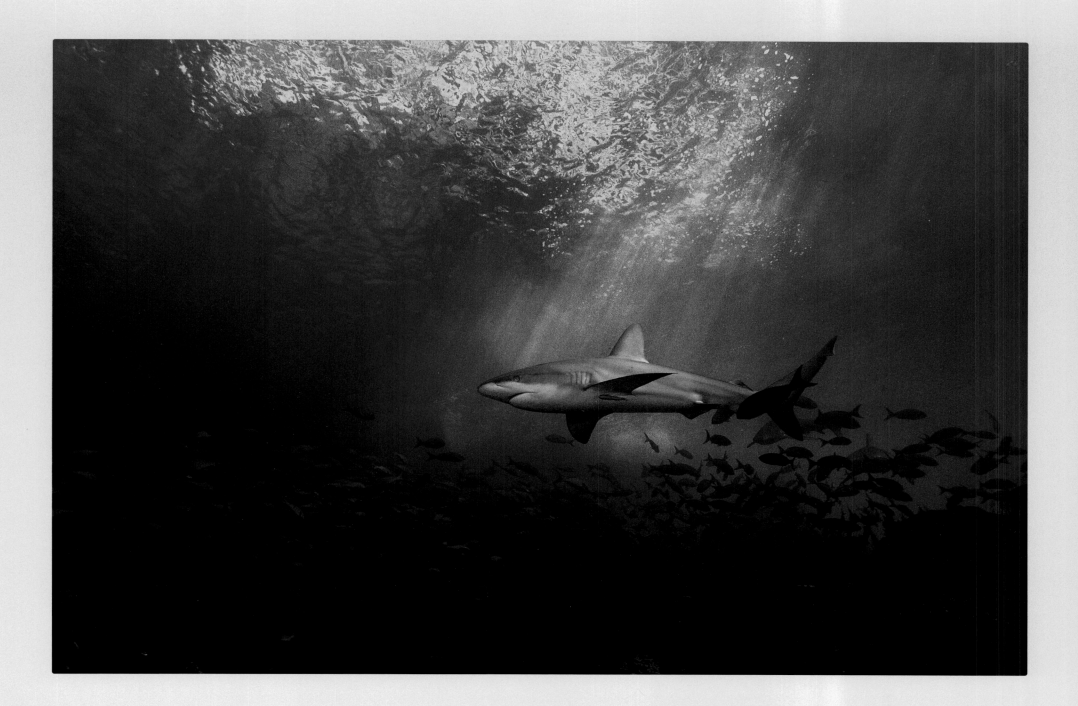

*Galapagos Shark*

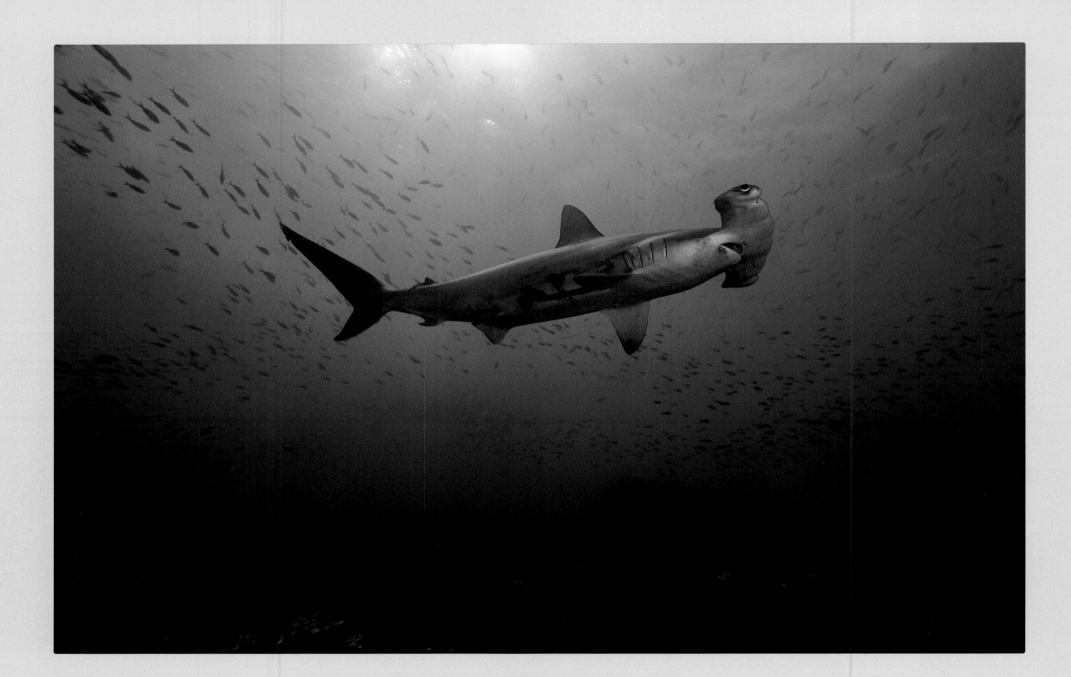

*Scalloped Hammerhead Shark*

As the whale disappeared beneath the waves,
a large swell of water boiled to the surface, momentarily forming a dome-shaped cap several feet across.
And for a brief and wonderful moment, that dome of water created a convex lens on the surface of the sea,
a magic window to a dream world below.

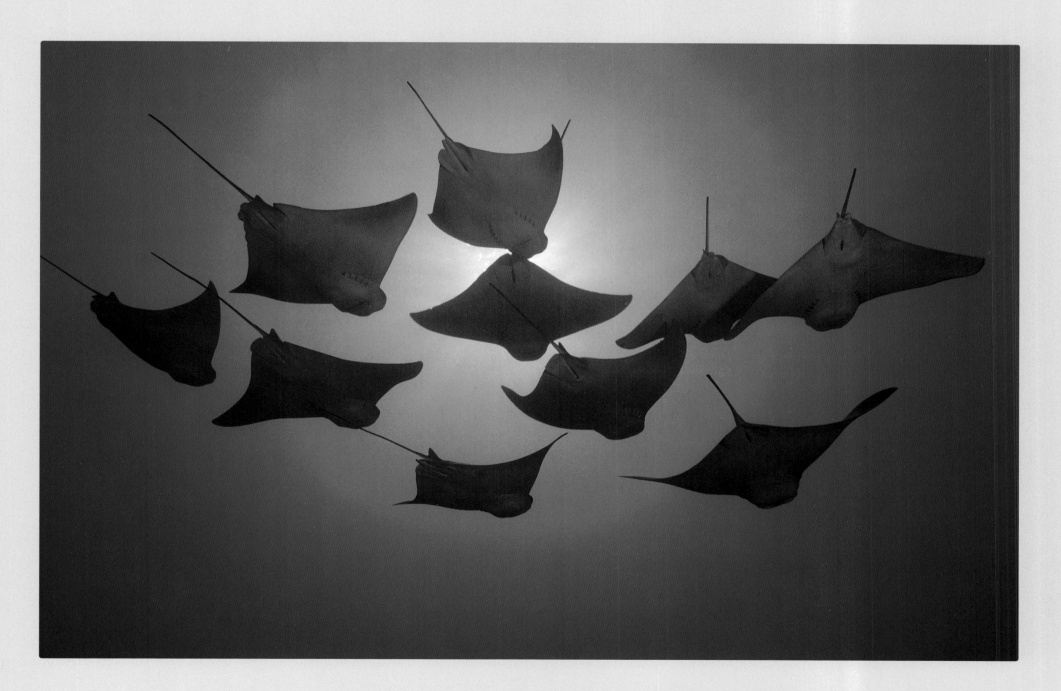

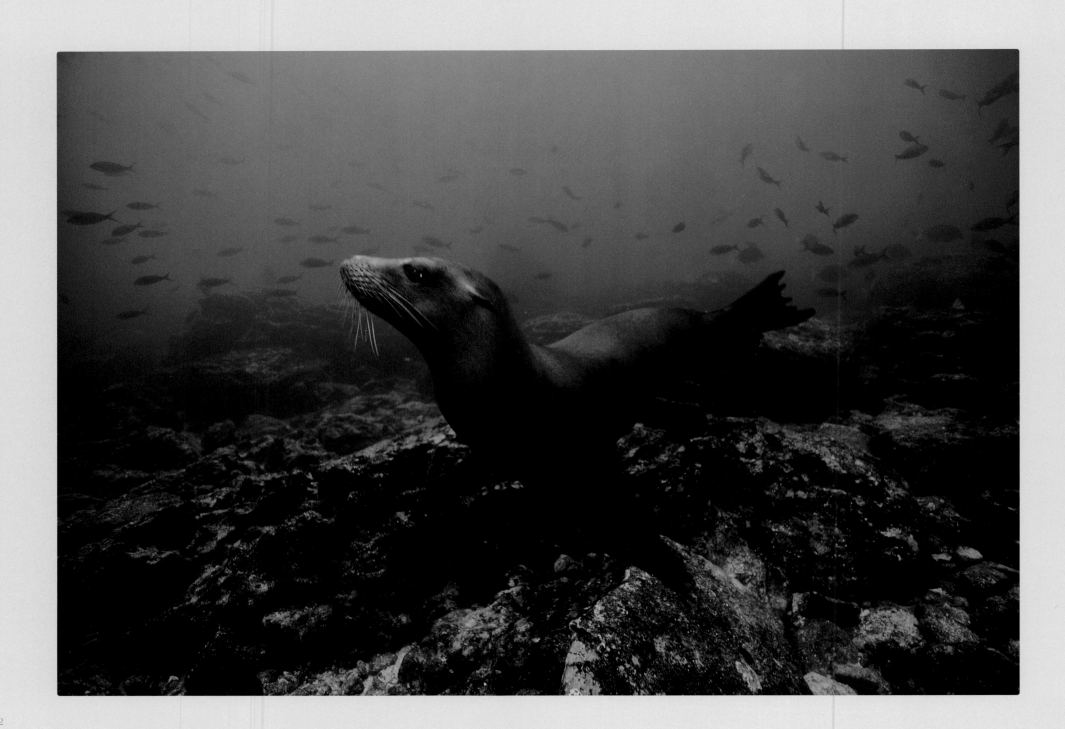

*Sea Lion*

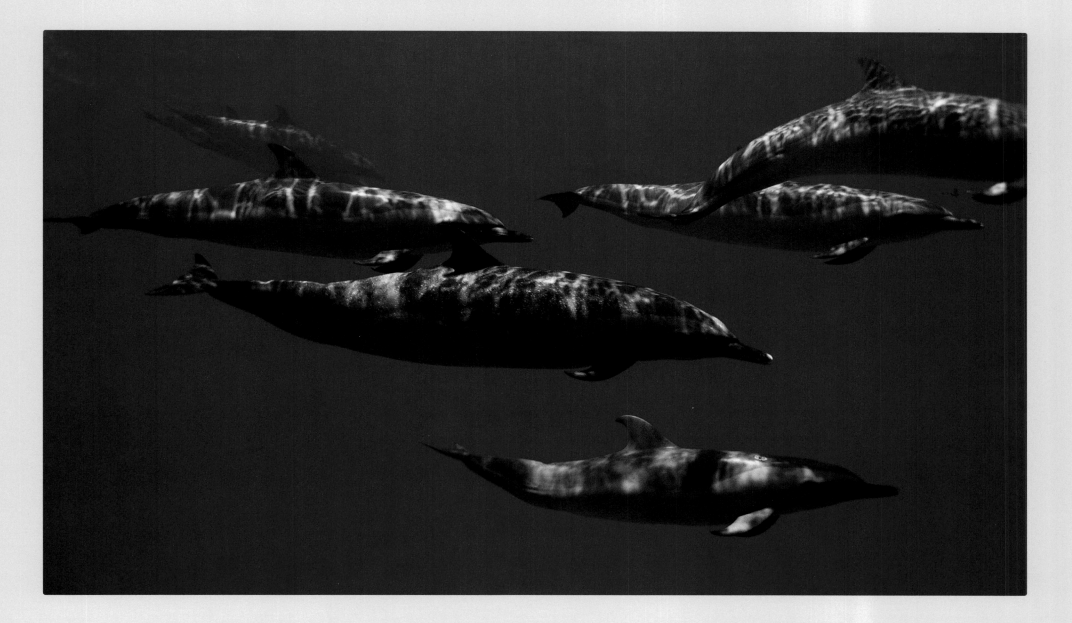

*Pacific Spotted Dolphins*

Through this transitory liquid optic I saw projected up into our world of air a flawless,
miniature image of the entire fifty foot whale, rolling on its side, one eye cast back toward me as it spiraled ever downward.
Mine would be the only fortunate eyes to gather that fleeting illusion,
though the light from this special moment is radiating upward still.
Quickly the dome flattened and the lens was gone.
The great whale had vanished.

Slipping quietly over the side of the boat with snorkel gear,
I peered into the sun-streaked blue nothingness below.
The dancing beams of light found no whale,
but I was enveloped in a pulsing, eerie sound,
as though the ocean itself was calling out.

Kicking slowly forward in ever widening circles from my boat,
I strained my eyes for any clue as to the source of this sound.
A slight hint of white, barely visible, first caught my eye.
Then several more faint markings,
scratches and old battle scars on the back of the whale dimly radiated from the depths.

Taking several deep breaths,
I dived toward these remote telltale signs until I could descend no further.
Now more clearly visible, though still far below,
the whale rested, either unaware or uncaring of my scrutiny.
Completely submerged as I was, and now half again as close to the source, the sound grew immense.
I literally shook in its surging vibration.

Far short of reaching the whale, and hungry for air, I returned to the surface,
for it was too deep for decent photographs unless I could somehow get much closer.
Unfortunately, bubbles from scuba often frighten whales away,
so generally such equipment defeats its purpose.
Some have suggested that when cetaceans emit bubbles from their blowholes while underwater,
it is a sign of aggression, possibly anger.
A diver's bubbles might therefore be interpreted by the whale as an aggressive display.
At the very least, the noise would alert the animal to my presence and disrupt its behavior.
But I felt if I could swim up to the whale from behind using a tank,
it would never see me,
and considering the volume of its singing,
it certainly would never hear me.

So with camera and scuba I returned to the area where I last had seen faint glimpses of the whale,
and I began my drop into the void.
I could see nothing save the blueness consuming me.
Falling and falling,
a lazy descent,
ever deeper,
ever darker and cooler.
There was no bottom below, just an emptiness around me
filled only with the scattered remnants of sunlight.

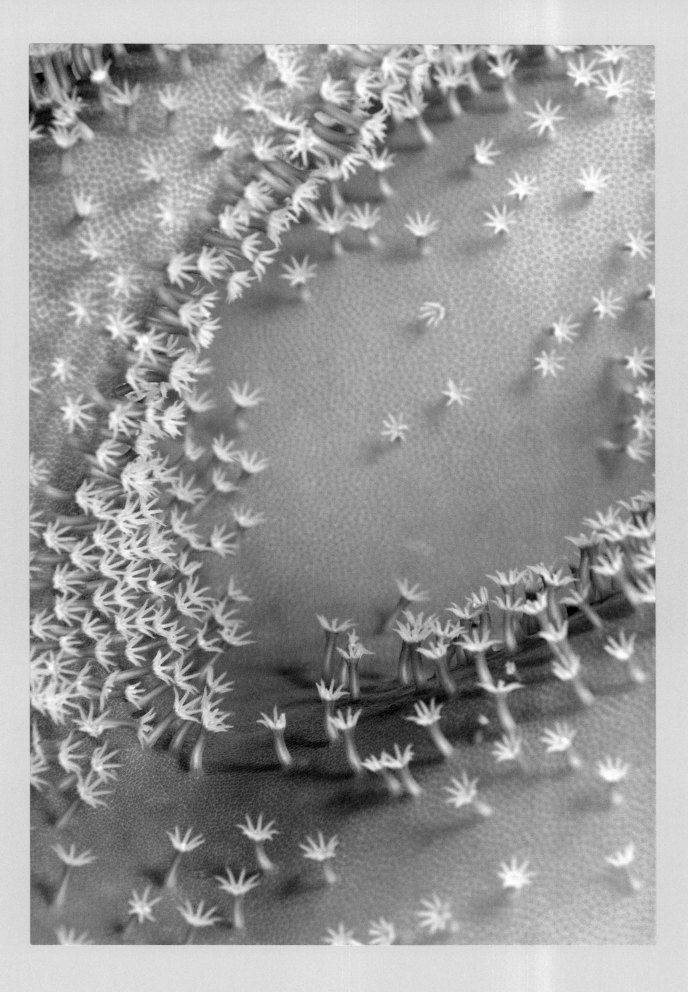

Leather Coral

*Parrotfish Detail*

In this strange and directionless space, the unearthly song was my only beacon,
a melodic signal seemingly beamed from an immense, invisible source,
a source all around me yet nowhere at all.
And toward it I was drawn, exhilarated and expectant, but cautious and apprehensive.

There was something out there of overwhelming size, power, and portent,
but I didn't know if I was merely moving toward it or being swallowed by it.
Then shrouded by blue mist like a ghost ship becalmed,
the great whale materialized with almost reluctant slowness.
Every foot of my advance unveiled a bit more of the enormous creature from its cover of foggy light.
Its size was truly disorienting, for it appeared to stretch endlessly into the distance.

*Crocodilefish Pectoral Fin*

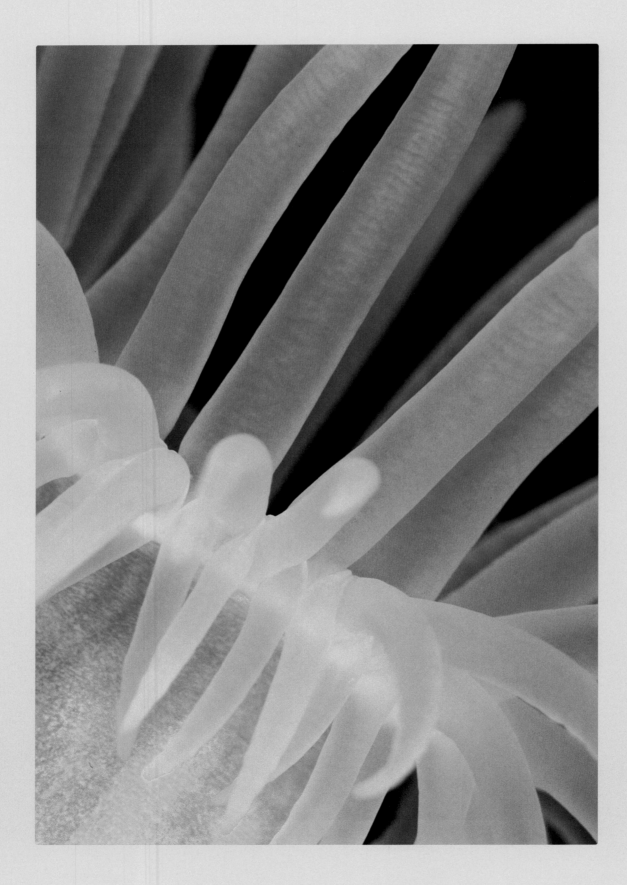

*Anemone Tentacles*

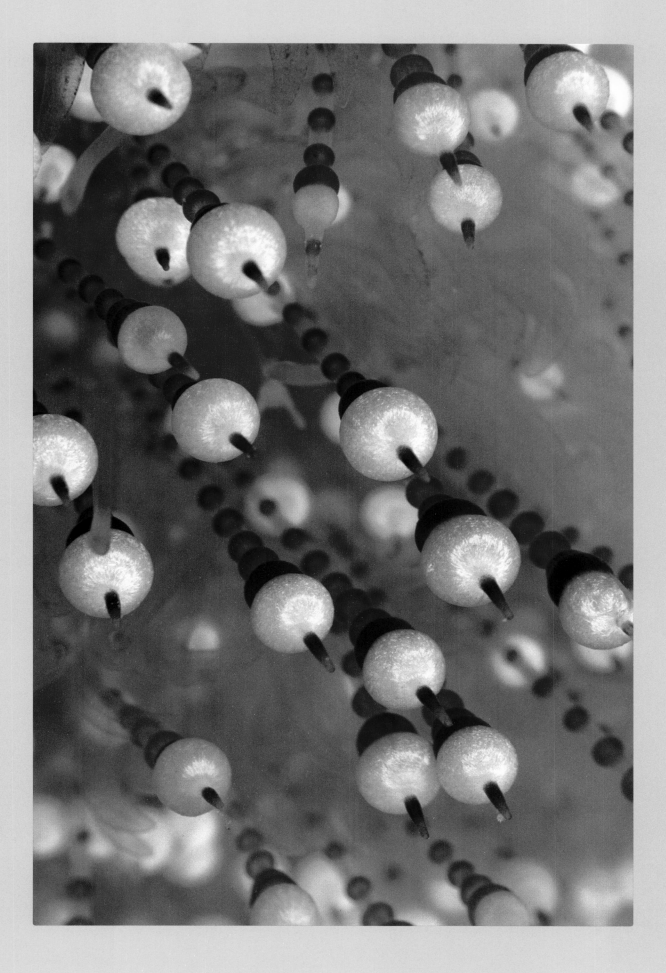

*Sea Urchin Spines*

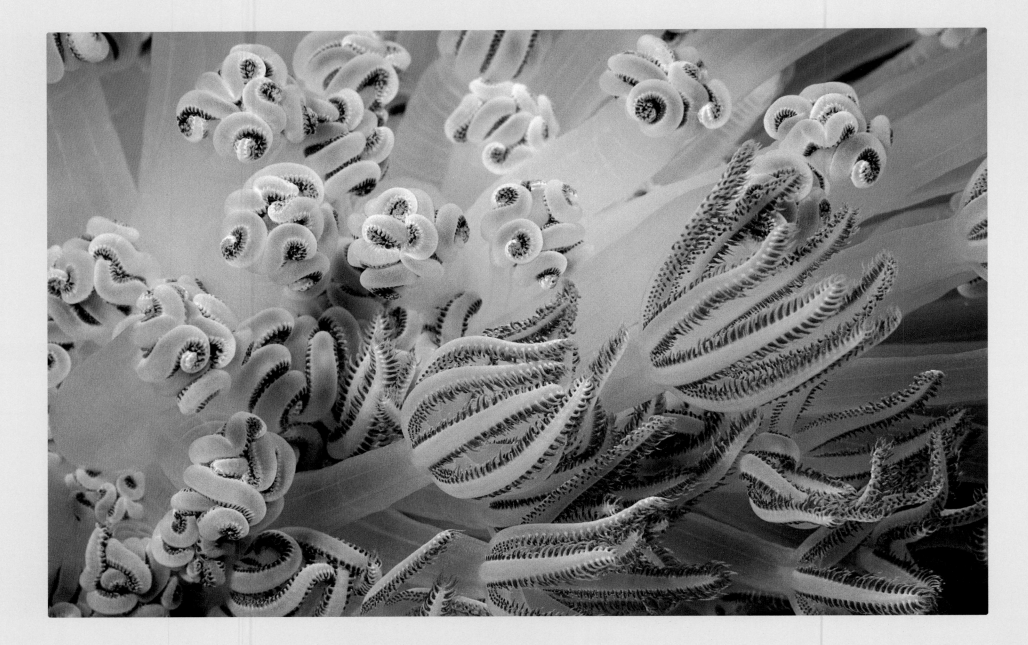

*Octocoral Polyps*

As I had hoped,
I was approaching the whale from behind.
Its ten foot wide flukes loomed ever larger before me the closer I swam,
while the sound swelled to a forbidding intensity.
The whale gave no indication it was aware of my proximity.
I forced myself to breathe slowly, though excitement and intimidation burned my lungs.
Then, holding my breath so no bubbles would rise beneath the whale,
I ventured directly under the giant tail.

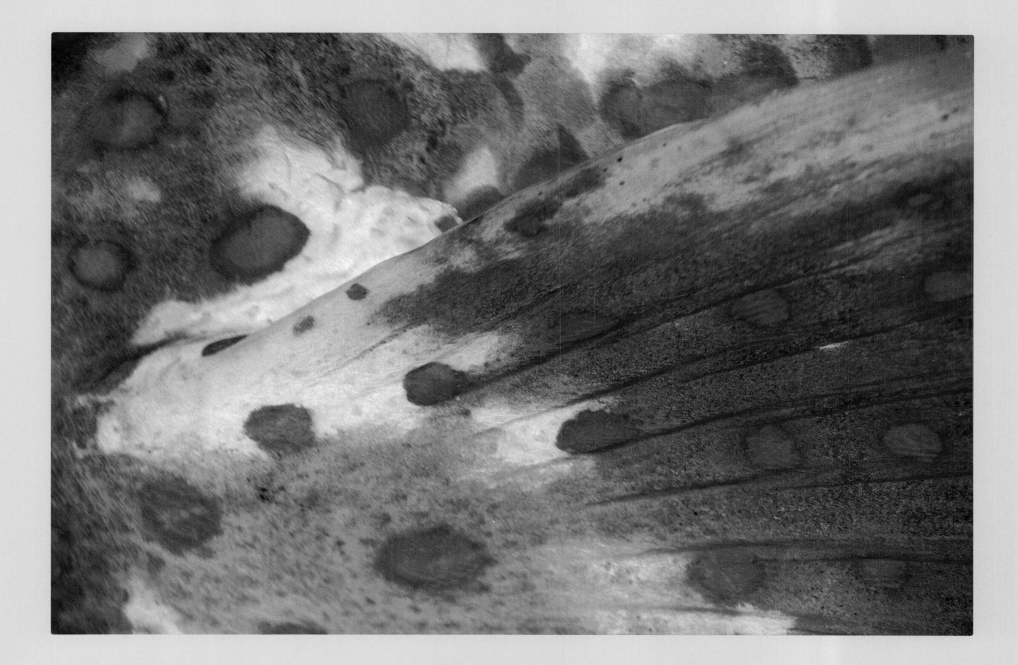

*Half-spotted Grouper Pectoral Fin*

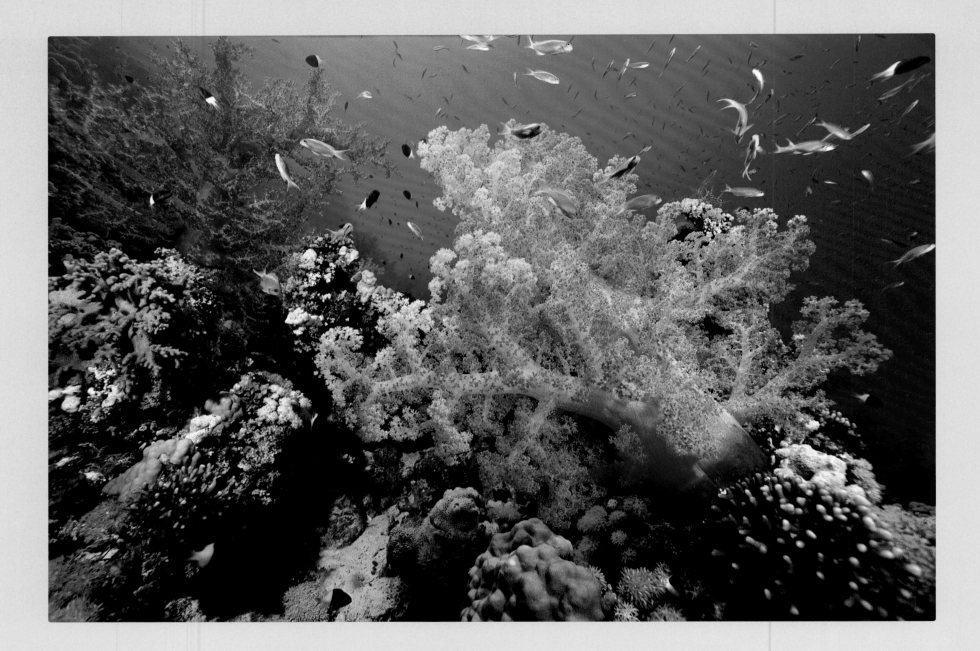

*Soft Corals*

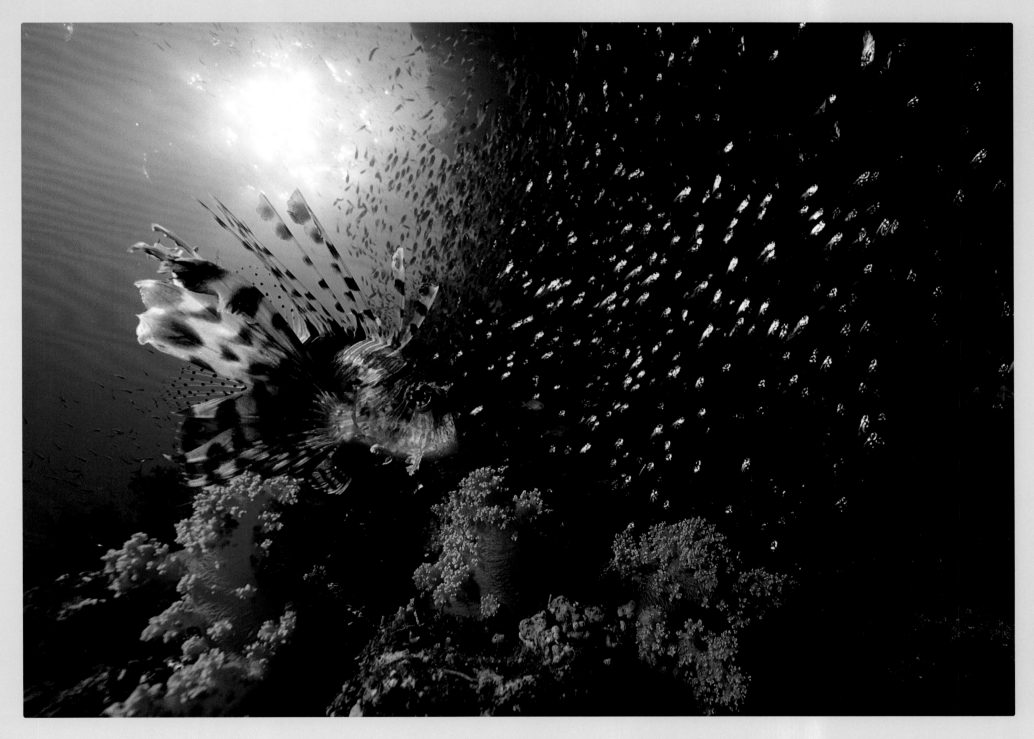

173

*Lionfish*

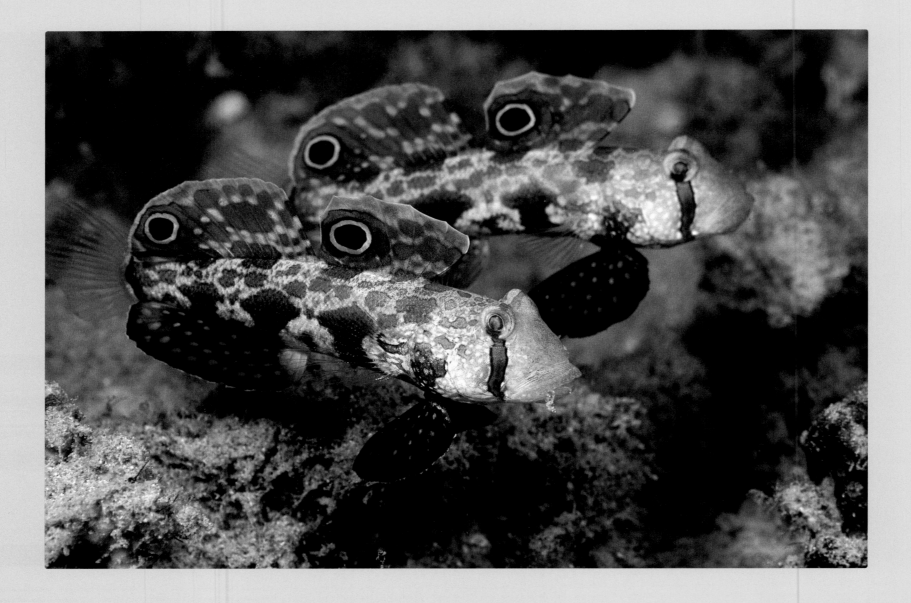

*Two-spot Gobies*

*Irish Setter Pipefish*

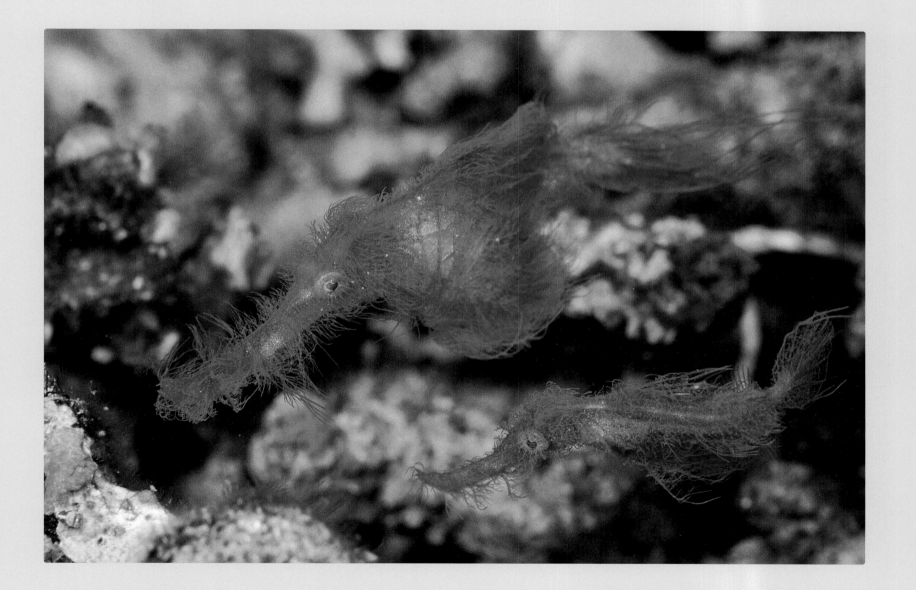

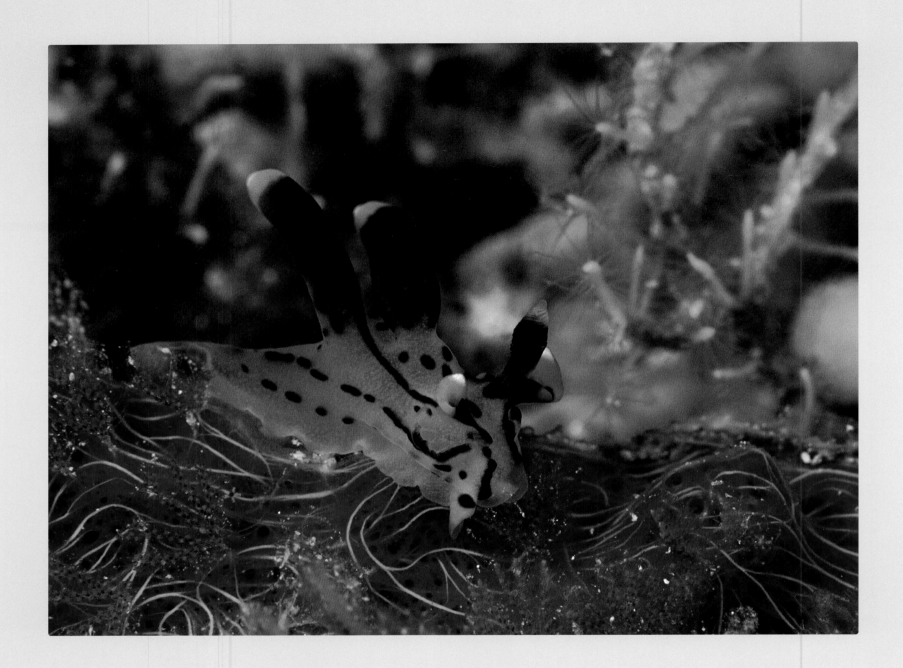

*Nudibranch on Sponge*

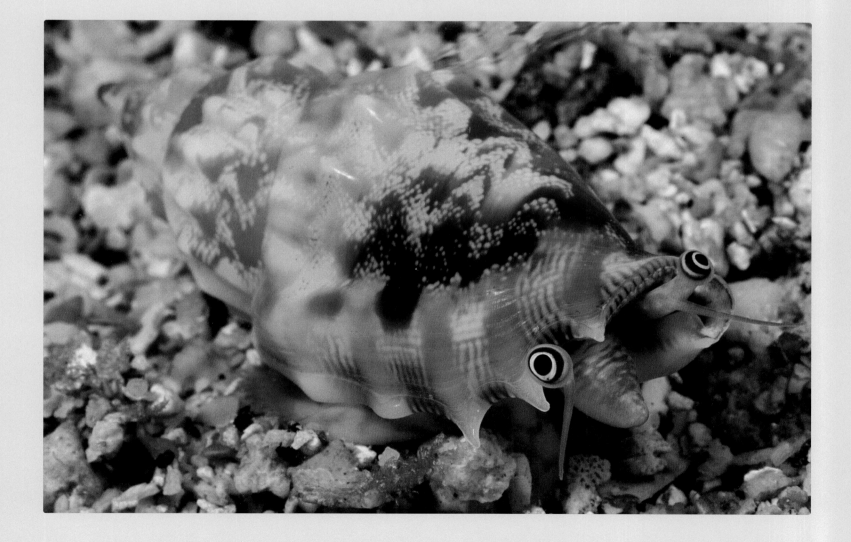

*Strombus Shell*

177

Now the consequences of startling this fifty foot animal were all the more sobering.
If the whale suddenly became frightened,
the gigantic impact of these flukes crashing down on me would surely be disastrous.
Contained in this tail now spread above me like some massive canopy
was a power so stunning
that with a few quick thrusts
it could instantly propel forty-five tons of animal
straight out of the water and through the air
in one of nature's grandest spectacles–a breaching humpback whale.
Hanging at arm's reach beneath this force,
that vivid image came back to me in a dizzying rush.
Out of nowhere and without warning, a humpback erupts from the waves.
At first it seems as though what you are seeing is happening in slow motion.
Then you realize that there is just so much animal rising out of the sea,
it takes some moments for the breach to completely unfold.
As the whale reaches its full body length above the surface,
it often begins an axial rotation with centrifugal force,
flinging its fifteen foot pectoral fins wide from its sides,
transforming the whale into a strange and giant propeller spinning through the air.
All the while,
hundreds upon hundreds of gallons of foaming water
cascade off its body in frothing, flowing sheets, flying wildly in every direction.

Then all too quickly gravity reclaims the truant whale for the sea.
The ninety thousand pound animal slams violently back into the waves
in a huge explosion of white water,
sending geysers of spray twenty-five feet into the air.
Within moments,
all becomes calm once again, the ocean quickly hiding all evidence of the trespass.

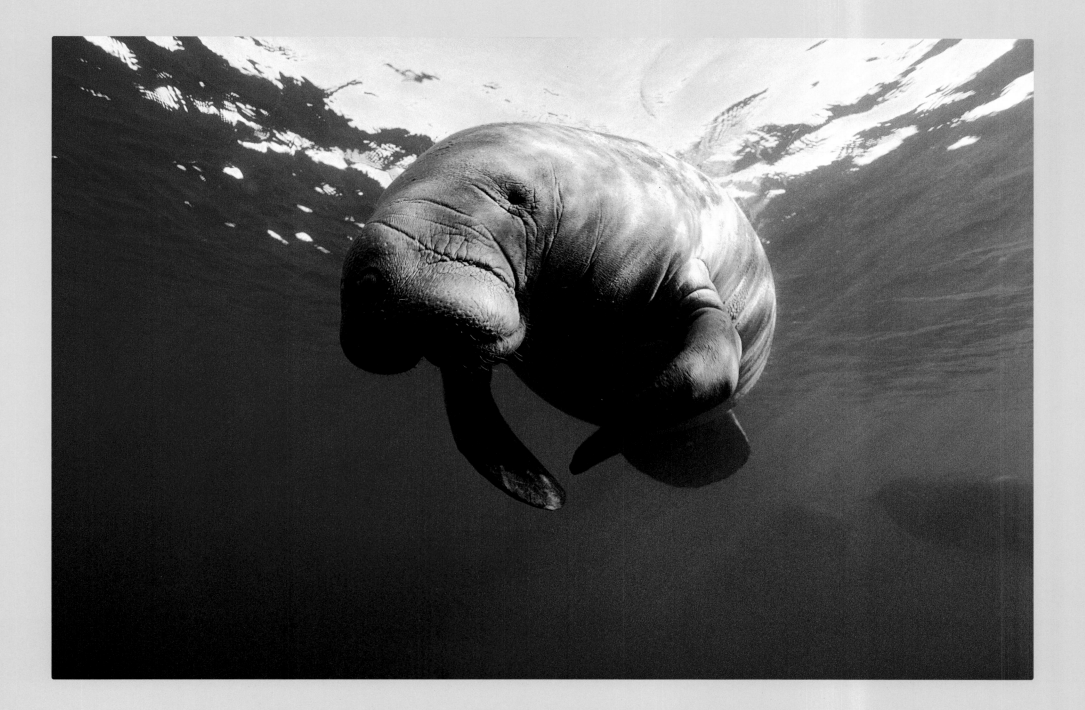

*West Indian Manatee*

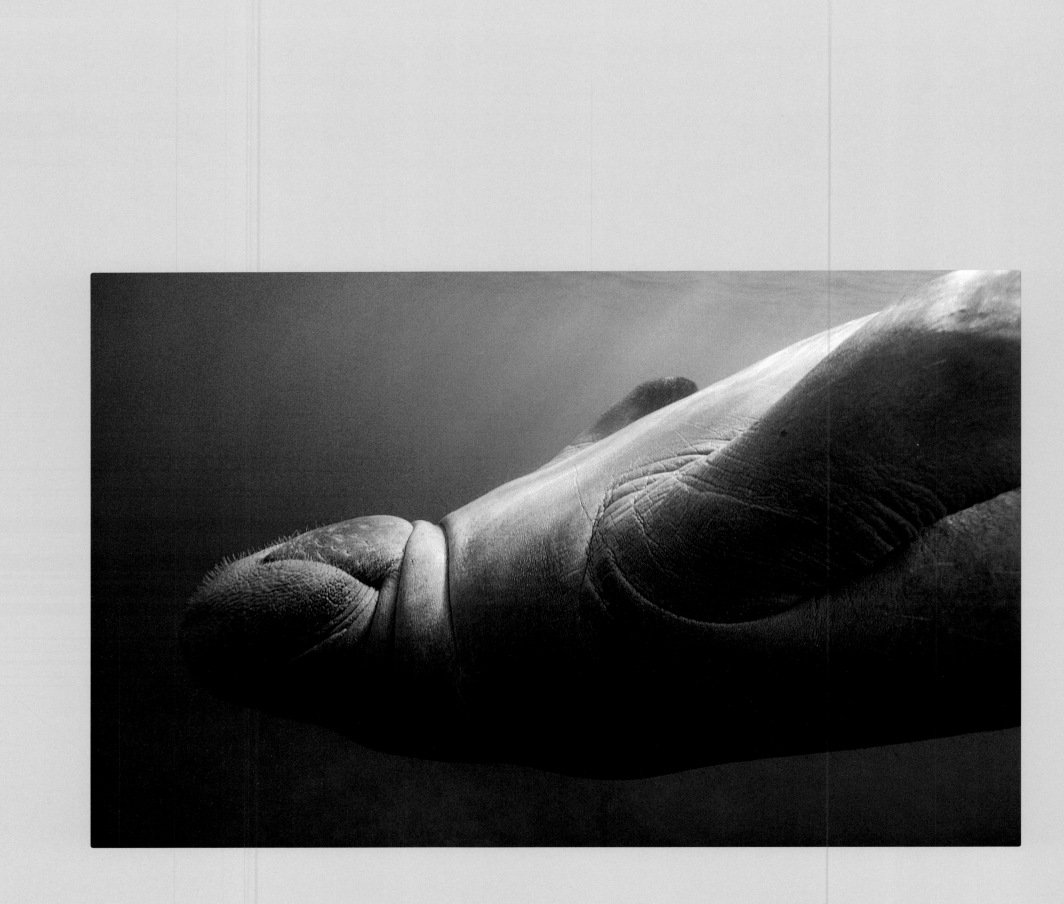

*West Indian Manatee*

*West Indian Manatee*

Looking up at these silhouetted flukes so near me,
my mind graphically replayed this ageless spectacle,
a brief daydream in my deep reverie.
Completely engrossed in its song, however,
the whale was oblivious to my alien intrusion.
More relaxed in the knowledge that my strategy was now working,
I was able to take my time as I photographed.
As with previous experiences with singers, I was struck by the realization
that whales emit no bubbles as they sing.
The sounds are entirely internal, yet seem to radiate from everywhere.
Because the sound seems to lack a single source,
and because a whale directly in front of you
seems encompassed in the music and not its origin,
the experience has an other-worldly,
disconnected sensation.

Usually,
encounters with humpback whales are very short-lived and elusive.
In the harsh contrast of surface light,
one is often too absorbed in the frenzy of trying to get photographs
to appreciate fully the experience of the whale itself.
As this humpback hung suspended above me
like some giant blimp adrift in a hazy sky,
I was suspended as well, slightly behind and below,
hidden by the whale itself,
wrapped in its song,
spellbound by its mystery.
For the first time ever, I had the luxury of time while this near to a whale,
time to ponder more fully this most profound of all animals.
I was dumbfounded by the sheer size of this whale, and I smiled at the absurdity of this simple revelation.
The fact that these animals are huge is the *most* obvious thing about them.
How many dozens of times had I been next to such whales?
But suddenly the reality of the enormous mass of this living, breathing animal really struck me.
For the first time I felt truly close to a whale,
not in distance so much,
but in total awareness of the essence of life contained within.
I was so close to this life force at that moment that I was sure I could sense its heartbeat,
feel the blood rushing through its veins.

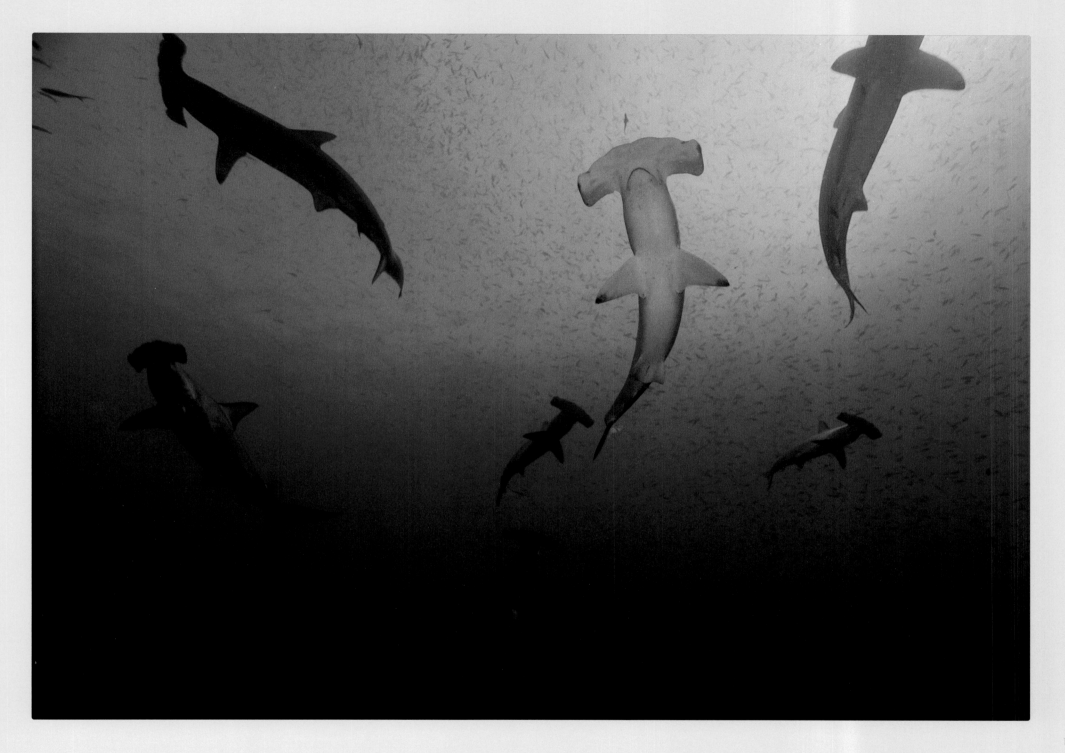

*Scalloped Hammerhead Sharks*

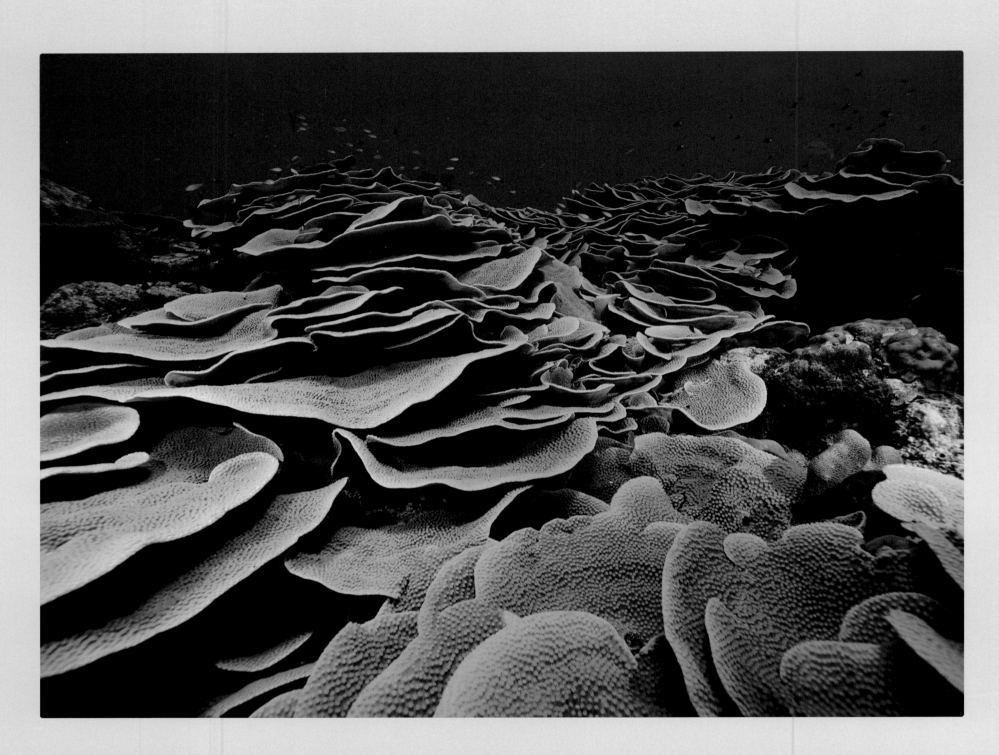

*Plate Corals*

The diffused light around us had that entrancing, rich, deep blue glow one only experiences at greater depths.
I was in a place of dreams,
where even the most surreal events
seemed somehow so fitting, so perfectly correct.

And yet I realized that once back on the surface, as when one awakes from a dream,
I would be straining to retain every precious detail, every sight and sound,
every emotional shading which the experience offered.
I knew that later the sky, the sun, the air–
these primary moorings of my life above water–
would struggle to draw me back from this splendid reverie.

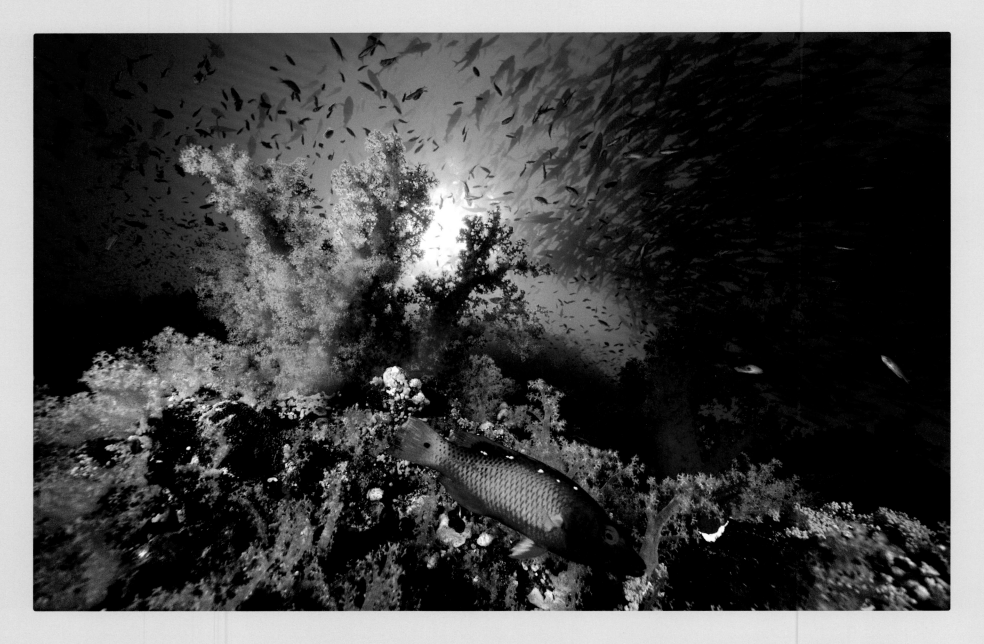

*Schooling Snapper and Diana's Wrasse*

Finishing my roll of film under this tail,
spread as it was like great wings above me,
I rose reluctantly toward the surface,
leaving the whale undisturbed yet filling the ocean forever with its song.
Smaller and smaller the whale now became, soon just a tiny speck in the vast body of the ocean.
The protective layers of the sea gradually enfolded her most musical child,
leaving only that haunting rhapsody to search the depths.
Carried on these eerie notes was a mysterious and beautiful message
finding its way to realms we can only dream of,
concealed places in our world harboring souls we can never know.
And the song had now come full cycle once again.

As I kicked idly toward a brightening sun,
the fading echos of lonely cries hung like a vanishing mist
in the blue emptiness around me.

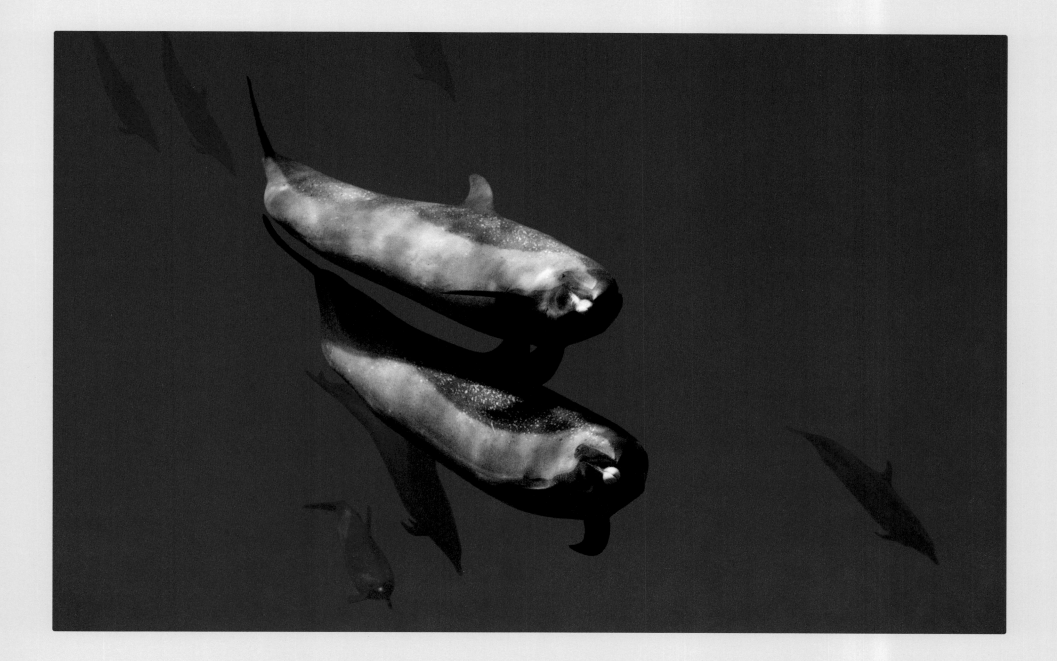

*Pacific Spotted Dolphins*

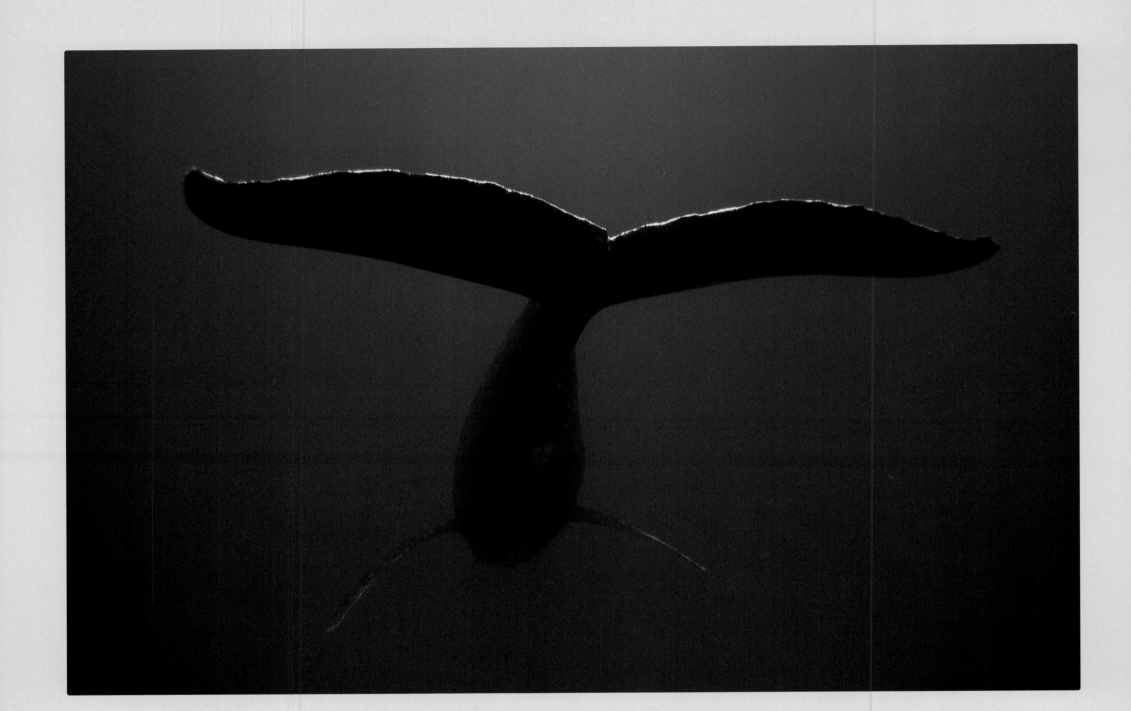

*Singing Humpback Whale*

And still nobody knows why the whales cry.
Perhaps they cry for the sea itself.

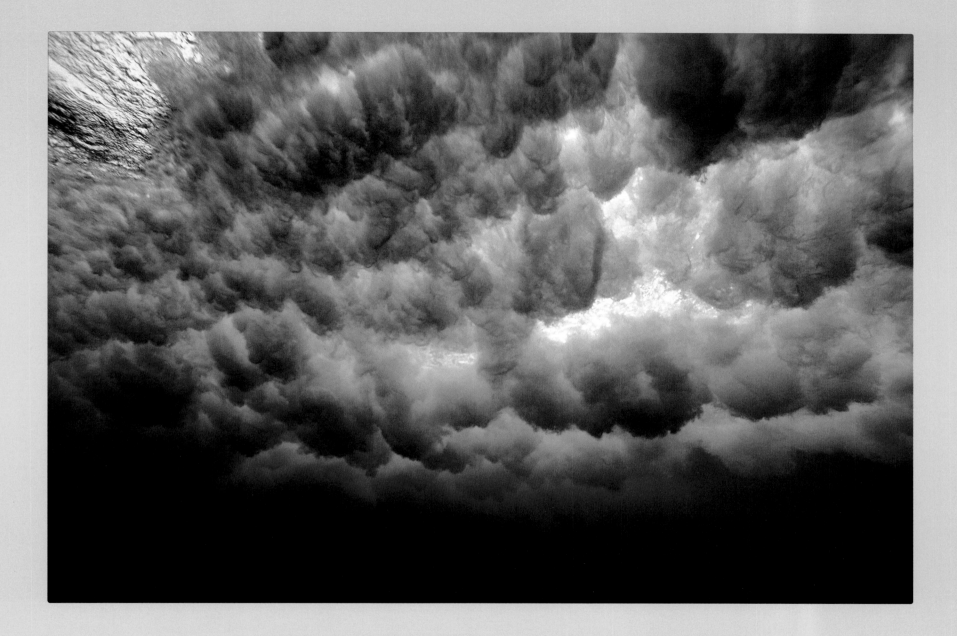

# PHOTOGRAPHERS' PLATE NOTES

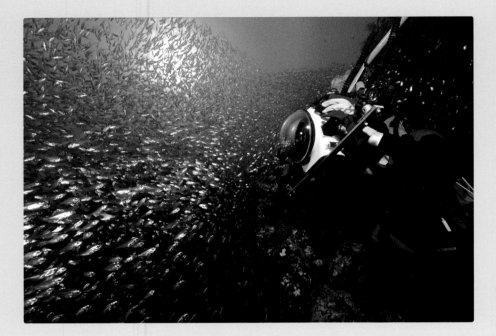

Although experienced divers and marine scientists have developed a good scientific basis for identifying marine creatures, most will acknowledge that the mysteries of the sea sometimes make exact identifications an ongoing puzzle. The notes which follow match the images by page number, and they offer popularly accepted common names where one or two main subjects can be identified in the photograph. Where a reasonable identification could be made by scientists from a single photograph, we have added scientific names. Often, however, a single photo was not adequate for our dedicated scientists to make an accurate, definitive judgment, especially when the nature of the image was abstract or the subject so obscure as to leave identification information unavailable through normal research channels. As a result, some of the plate notes omit the Latin name. Finally, the genus of many subjects could be identified, but the photos did not contain enough information to determine the precise species. In these cases, the genus name is simply followed by *sp.* to indicate that the creature is some species of that genus. If any inaccuracies have occurred, the fault may lie with our style of photography. In the general underwater scenics, photographed for the sheer beauty of the reef, we have made no attempt to identify flora or fauna.

Frontispiece
**Soft Coral Tree**
*Dendronephthya sp.*
SOLOMON ISLANDS
Nearly one hundred and forty feet deep in a reef pass connecting the Solomon Sea to an inner lagoon, soft corals bloom luxuriously in the food-rich current. Such reef passes are like arteries in a massive circulatory system, bringing open sea water and nutrients into the lagoon with the incoming tide, and carrying out fresh water river run-off, vegetation, and warmer, algae-rich water on the outgoing tide. Visibility is generally better as clean sea water pours in, but the action can be great either way as long as the tide is flowing swiftly. CN
*14mm lens  Velvia 50*

6. **Barracuda School**
*Sphyraena jello*
SOLOMON ISLANDS
One of the great underwater experiences, truly one of the great experiences in all of nature, has to be finding oneself as the nucleus in a giant spiraling vortex of barracuda. By the hundreds, sometimes by the thousands, they will surround you, spinning around and around, closing within feet of your touch. In spite of their mouthful of rather fearsome teeth, they represent no threat to a diver. Rather, such an experience leaves you speechless with awe, thankful for the moment. CN
*14mm lens  Kodachrome 64*

7. **Tridacna Clam Mantle Detail**
*Tridacna maxima*
SOLOMON ISLANDS
The giant clam constantly draws water in and out of its siphons, to and from its body cavity, filtering out plankton and organic debris for food while carrying oxygen to its gills. Unlike their portrayal in old grade-B movies, these huge clams will not trap the unsuspecting young maiden's foot as she swims by, closing violently and unexpectedly. The bigger they get, the fuller becomes their mantle, and the more slowly and less completely they can close. The hero will have to find another opportunity to rescue her and win her love. BW
*100mm macro lens  Velvia 50*

8. **Galapagos Shark**
*Carcharhinus galapagensis*
GALAPAGOS ISLANDS
Big, bold, muscular, and beautiful, the Galapagos shark is always a special privilege to see. Unlike terrestrial wildlife photographers, who have the luxury of working in blinds with telephoto lenses to obtain animal photographs, underwater wildlife photographers always work at close range because of the special properties of light in water. To photograph this majestic, ten foot Galapagos shark, I had to be just three feet away. Such intimacy with the subject fosters a great respect and admiration. CN
*24mm lens  Kodachrome 64*

9. **Reef Scenic**
*Dendronephthya sp.*
RED SEA
With anthias fluttering about like little butterflies, the current sweeps across a Red Sea reef richly adorned with blooming soft corals. Typical of these lush reefs, such scenic extravaganzas are why this location is still considered one of the most beautiful in the world. Extreme overdevelopment of the shoreline areas now threatens these irreplaceable natural treasures. CN
*14mm lens  Velvia 50*

10. **Soft Coral and Sea Fan**
*Melithaea sp.*
SOLOMON ISLANDS
Dazzling color, form, and texture characterize the visual properties of this Solomon Islands reef, but intense competition is the defining element shaping its structure. The sea fans, soft corals, sponges, and crinoids compete not only for food, but for living space. While it appears like a benign flower garden, virtually everything in this photo is a living, active animal, using all possible strategies to dominate its neighbors. CN
*14mm lens  Velvia 50*

11. **Leather Coral with Glassfish**
*Sarcophyton trocheliophorum* with *Parapriacanthus guentheri*
RED SEA
A leather coral colony with its polyps retracted is surrounded by schooling glassfish, sponge, and soft corals. The late afternoon sun peeks through a gap in the reef before setting over the ancient Sinai Desert sands. CN
*14mm lens  Velvia 50*

12. **Humpback Whale**
*Megaptera novaeangliae*
HAWAIIAN ISLANDS
Totally absorbed in its song, this fifty foot humpback whale was unaware of my presence as I approached from beneath and behind. The soft, misty light one hundred twenty feet deep lent an other-worldly quality to the moment. I was so close I vibrated with the immensity of the sound produced by this magnificent animal. CN
*14mm lens  Kodachrome 64*

14. **Sea Fans**
*Melithaea sp.*
SOLOMON ISLANDS
What northern California is to redwoods, the Solomon Islands are to sea fans. No place surpasses the Solomons for the sheer size and profusion of these massive gorgonian coral structures. They adorn many continuous acres of reef, row upon row, oriented perpendicular to the prevailing current. Although they are garbed in a wide variety of colors, red and orange blends seem to be the predominant fashion. CN
*14mm lens  Velvia 50*

**15. Crinoid on Soft Coral**
SOLOMON ISLANDS
Soft corals, like gorgonian sea fans, are frequently host to an amazing variety of commensal organisms living on the coral structure itself. Crinoids will often climb upon the coral tree, using it as a kind of stepladder by which they reach further into the passing current where the flow of organic matter will be more bountiful. This coral was found hanging under a ledge at a depth of one hundred feet. CN
*14mm lens  Kodachrome 25*

**16. Rosy-lipped Batfish**
*Ogcocephalus porrectus*
COCOS ISLAND
The bizarre batfish is quite shy but will let you get close if approached slowly and carefully. If frightened, they can escape by jet propulsion, forcefully expelling water through vents on their sides. When not jetting about, they walk or perch on modified fins resembling arms and legs. Compared with a similar species living in the Galapagos Islands, this one is bigger and has more decorative whiskers, brighter lips, and a bigger "nose." The whiskers contain many nerve endings and serve as electrical field sensors, detecting movement around it. The "nose" is an adaptation of the first dorsal spine, used by the batfish as a fishing lure and waved hypnotically to attract prey. BW
*100mm macro lens  Velvia 50*

**17. Marbled Shrimp**
*Saron marmoratus*
SOLOMON ISLANDS
I found this nocturnal creature venturing out at dusk. I had never seen this shrimp before, nor did I expect to find such a dazzling animal on the last dive of the day. The males and females are easy to tell apart, as the males have very long pincers, while females have more hair along their backs and bellies. They feed at night, searching for food with their long feelers. Not bothered by my presence, the shrimp allowed me a long look. With enough light still available, I didn't have to use my focusing light, which surely would have frightened it away. BW
*100mm macro lens  Velvia 50*

**18. Dragonet and Nudibranchs**
*Synchiropus sp.* and
*Chromodoris annae*
SOLOMON ISLANDS
The two colorful nudibranchs caught my eye. They appeared to be courting, and I thought they might begin to mate. Only as I focused to a higher and higher magnification was I able to see this marvelous little dragonet in the foreground. Its camouflage is outstanding, demonstrating two opposite effects of coloration: the dragonet matches the background, becoming invisible to predators. The bright colors of the nudibranchs, on the other hand, may serve to warn predators of the sea slug's bad tasting, toxic flesh. CN
*100mm macro lens  Velvia 50*

**20. School of Fusiliers**
SOLOMON ISLANDS
A school of fusiliers stretches across the reef crest, demonstrating what is known as the "wall of mouths," a curtain of zooplanktivorous fishes hanging over the up welling current side of a reef face. The fusiliers are an excellent indication of where the best activity on the reef can be found. The current carries their food supply, and wherever these fish gather to eat, the predators will soon follow. CN
*14mm lens  Kodachrome 64*

**21. Sea Cave**
SOLOMON ISLANDS
A labyrinth of underwater tunnels and caves braids the shorelines of numerous islands in the Solomons. Many times the caves will open to the surface interior of the shoreline where the ceiling has eroded through, providing an unusual perspective of the sky, jungle, and limestone cliffs above water, and the inside of the cave below water. CN
*14mm lens  Velvia 50*

**22. Beaded Sea Anemone**
*Heteractis aurora*
SOLOMON ISLANDS
While this species would usually host a family of anemonefish, I found this individual deserted. But looking ever closer through my macro lens, I discovered a tiny shrimp hidden behind one of the tentacles and was pleased the anemone wasn't alone after all. For the sheer strength of its graphic patterns, no other anemone species compares with this one. Notable are their long tentacles, lined with small, ball-shaped bladders. BW
*100mm macro lens  Velvia 50*

**23. Cuttlefish**
*Sepia*
SOLOMON ISLANDS
I watched the cuttlefish approach a small, hovering fish. It maneuvered slowly by gently fluttering the thin, transparent fin skirting its body. Its tentacles were arrayed in a manner which seemed to herd the fish into a dead-end coral canyon. Almost faster than my eye could detect, another pair of specialized feeding tentacles shot out, and the fish disappeared in its suction cup grasp. Waves of vibrant colors pulsed through the cuttlefish's body, doubtless the cuttlefish version of "umm, ummm, good." CN
*50mm macro lens  Velvia 50*

**24. Reef Scenic**
RED SEA
The prolific reef-building stony corals of a shallow Red Sea reef are mirrored on the underside of the glass-smooth afternoon surface. Strong north winds funnel down either side of the Sinai peninsula on a regular basis during the early part of the day, but they often drop to nothing as evening approaches. CN
*14mm lens  Velvia 50*

**25. Stony Corals**
RED SEA
Few reefs in the world can match the profusion of color found off the southern tip of the Sinai Desert in Egypt. Massive sea fans, lush soft corals, and richly hued sponges are interlaced with shimmering silver schools of glassfish. This photograph was taken at a depth of just sixty feet. CN
*14mm lens  Velvia 50*

**27. Lionfish**
*Pterois volitans*
RED SEA
Soaring regally above me on a color-splashed Red Sea reef, a lionfish fans its elegant fins into the current. During slack water periods, the lionfish can be found resting docilely among the corals. The sharp dorsal spines can inject a powerful venom which may cause profound pain, though it is unlikely human death has ever resulted from such stings. The non-aggressive nature of these fish makes them a delight to observe and photograph, without any threat of harm. CN
*14mm lens  Velvia 50*

**28. Cleaner Shrimp on Sleeping Goatfish**
*Palaemonid sp.* on *Parupeneus sp.*
RED SEA
While asleep at night and resting stationary amongst the coral, many fish, such as this goatfish, receive free grooming by several species of cleaner shrimp. These shrimp will scurry up and down the length of their slumbering host, picking off parasites, algae, fungal growths, or any other tasty tidbits they encounter. CN
*100mm macro lens  Velvia 50*

**29. Juvenile Brittle Starfish on Sea Star**
*Ophiothrix sp.* on *Linckia laevigata*
SOLOMON ISLANDS
Why is this starfish smiling? I can only speculate: other members of the *Linckia* genus multiply by autonomous asexual reproduction. Incredibly, one of their arms will soften near its base, then, powered by dozens of little tube feet along the underside, the arm will simply walk away from the rest of the starfish. This detached arm segment, called a "comet," will then generate an entire new body. Interesting, but lonely. *Linckia laevigata*, on the other hand, reproduces sexually. Individual starfish of this species release eggs or sperm to mix randomly in the sea water, producing planktonic larvae. Sure, it's a far cry from candlelight and Sinatra, but it's better than a step in the wrong direction. BW
*100mm macro lens  Kodachrome 64*

**30. Hot Lips Daisy Coral**
*Goniopora lobata*
SOLOMON ISLANDS
Of course I made that name up. Like many of the hundreds of species of coral found on the prolific reefs of the Solomon Islands, dozens do not have common names. The fleshy stalks and polyps cover a stony coral base. The polyps will retract if touched. They will also withdraw when feeding conditions are less than optimum. The polyps' mouths, hot pink in color, receive their food from the surrounding tentacles. *CN*
*100mm macro lens  Velvia 50*

**31. Hermit Crab**
*Pagurites sp.*
SOLOMON ISLANDS
Peering out from a field of red encrusting sponge, this tiny hermit crab occupies a vacated serpulid worm hole in the reef instead of the empty, mobile sea shells preferred by most species of hermit crab. In order to feed from this stationary site, it raises its feathery antennae to collect small organisms and particulate organic matter drifting in the current. *CN*
*100mm macro lens  Velvia 50*

**32. Sergeant Major**
*Abudefduf saxatilis*
RED SEA
One of the many members of the damselfish family, this species gets its common name from the vertical stripes on its sides. Typically, the sergeant majors will groom a mat of closely trimmed algae on the underside of rocks, upon which they will lay their eggs. They will then defend this field of eggs vigorously against surgeonfish, goatfish, and other species which attempt to graze on the algae and egg pasture. No creature is too large for the damsel fish to attack and harass. *CN*
*100mm macro lens  Velvia 50*

**33. Sleeping Anemonefish**
*Amphiprion bicinctus* and *Heteractis crispa*
RED SEA
By day, the highly active, aggressive anemonefish dart madly about. They dive in and out of the anemone's tentacles, they chase other fish away, or bob up and down grabbing bits of food. Alternately, they savagely attack photographers attempting to photograph them. At night, however, they can be found quietly nestled within the anemone's tentacles, protected by the stinging nematocysts that discourage predatory fish. *CN*
*100mm macro lens  Velvia 50*

**34. Sea Lion**
*Zalophus californianus wollebaeki*
GALAPAGOS ISLANDS
Leaping through the surface, a sea lion dives back underwater. The cavitation of its pectoral flipper drags a silvery bubble of air along as well. Divers would appear to offer a degree of relief from the day to day boredom of sea lion life. These playful mammals will streak towards you from all directions and commence a dizzying display of underwater acrobatics quite unequalled anywhere else in nature. Supple, fast, and inventive, they captivate you with their antics but are challenging to photograph. *CN*
*14mm lens  Kodachrome 64*

**35. Pacific Spotted Dolphins**
*Stenella attenuata*
HAWAIIAN ISLANDS
Often encountered in schools numbering in the thousands, these dolphins roam the open seas miles off Hawaiian coastlines, where the water is thousands of feet deep. They actively feed during the day, and rest quietly on the surface at night. During the night, an unusual shark arises from the depths, of one thousand feet or more. This Cookie Cutter shark, while only a few feet long, has a circular mouth ringed with sharp, flesh-cutting teeth. It attaches to the sides of dolphins and other marine mammals, extracting a core of flesh, but leaving the animal otherwise unharmed. Such an old Cookie Cutter wound can be seen on the flanks of the uppermost dolphin in this photograph. *CN*
*24mm lens  Kodachrome 64*

**37. Corallimorpharid Detail**
SOLOMON ISLANDS
After thirty years of exploring the oceans of the world, I continue to be entranced by the stunning designs nature has created beneath the sea. When the patterns from this tiny anemone-like creature emerged in my viewfinder, I felt a sense of something fundamental, something molecular. Photographed at a depth of ninety feet. *CN*
*100mm macro lens  Velvia 50*

**38. Parrotfish Pectoral Fin**
*Hipposcarus harid*
RED SEA
Parrotfish quite literally fly through the water on gossamer wings. Their pectoral fins, so delicate and sheer, are their primary means of locomotion. Only when frightened will they use their more powerful tail fins to propel themselves. This sleeping parrotfish was unaware it was being photographed as I worked at very close range while night diving off the Sinai Desert. *CN*
*100mm macro lens  Kodachrome 25*

**39. Parrotfish Mouth**
*Scarus sp.*
RED SEA
Its name suits it well. The teeth of the parrotfish have been fused into a parrot-like beak. The rich green and blue coloration of many members of the species are reminiscent of a parrot's feathers. The function of the teeth is clear: parrotfish bite and scrape off chunks of hard coral rock, grinding it up in their mouths to feed primarily off the algae within the coral cells. The ground coral is excreted as fine sand, which means that beaches, hotels, condos, and oil-covered tourists are by-products of parrotfish feeding. The function of the coloration appears to be to confuse ichthyologists, as colors change from juveniles to adults, from sexual variations, and as females transform into males. *CN*
*200mm macro lens  Kodachrome 25*

**40. Triggerfish Fin Detail**
RED SEA
The macro lens is a wonderful tool for altering human perspectives. As the lens zooms closer and closer to the chosen subject, the entire viewfinder can become filled with the tiniest detail of marine life. The imagination runs free with the colors and forms which materialize before your eyes. I thought of reeds in a pond, summer, and hot, humid days as I focused ever closer on the dorsal fin of this triggerfish. *CN*
*100mm macro lens  Velvia 50*

**41. Needlefish**
*Tylosurus choram*
RED SEA
So named because of their needle-like shape, they can reach five to six feet in length. They are easily excitable and have been known to leap through the surface, accidentally killing people standing out of the water by striking the victim in the head or neck. They swim with a rhythmic serpentine motion, always just below the surface. Their dark blue dorsal coloring can be noted in their reflections under the surface, while the underside is very light and silver. This protective coloration is known as counter-shading and is common in various forms with a great many marine species. *CN*
*50mm macro lens  Velvia 50*

**42. Shrimp on Daisy Coral**
*Periclemenes sp.* on *Goniopora lobata*
SOLOMON ISLANDS
A tiny shrimp, so very delicate and transparent, flits from branch to branch, polyp to polyp in a thick forest of supple daisy coral. A cluster of purple-pink eggs can be seen in the abdomen of the shrimp. I found this lovely specimen approximately seventy feet deep. *CN*
*100mm macro lens  Velvia 50*

**43. Leather Coral**
*Sarcophyton trocheliophorum*
SOLOMON ISLANDS
In my excitement to head for deeper water, I often overlook the quiet beauty which can be found right below the surface. Just three feet deep along the shoreline in the Solomon Islands, I looked up to find a solitary leather coral colony. The reflections of the reef on the underside of the surface framing the overhanging jungle above completed this pleasing still life. *CN*
*14mm lens  Velvia 50*

**44. Tridacna Clam Siphon**
SOLOMON ISLANDS
A feeling of something cosmic came over me as I composed this image of a tridacna clam siphon. Many astronomers say there may be a black hole in the center of all galaxies. Responding to the collosal gravitational pull of a black hole, gasses from surrounding stars spiral into it at astonishing speed, giving off tremendous heat and light before they disappear forever. As I composed this photograph in my viewfinder, I felt my macro lens had been transformed into a telescope, and that I was peering at just such a celestial phenomenon. *CN*
*100mm macro lens  Velvia 50*

**45. School of Barracuda**
*Sphyraena jello*
SOLOMON ISLANDS
They poured from the surface like a waterfall. The barracuda numbered in the hundreds, and I watched them descend until my eyes couldn't follow them any longer. These barracuda probably school to help camouflage themselves. With so many bodies looking alike, it is hard for a predator to single out just one. When they are on their own hunt for food, more eyes and more sensors make prey easier to catch. *BW*
*20mm lens  Kodachrome 64*

**46. Leather Coral and Glassfish**
*Sarcophyton trocheliophorum* and *Parapriacanthus guentheri*
RED SEA
A shimmering whirlpool of glassfish encircles a flourishing leather coral colony. Enormous schools of glassfish are one of the hallmarks of Red Sea reefs. It is not uncommon to witness wild feeding frenzies, as dozens of jacks shatter silver veils of glassfish, while lionfish circle the perimeter, gulping down large mouthfuls of panicked strays. *CN*
*14mm lens  Velvia 50*

**48. Sea Whips and Pseudanthias**
RED SEA
Gorgonian whip coral, blossoming soft corals, hard plate coral, and schools of pseudanthias all intermingle in this marvelous tangled collage of life I found flourishing on a deep water Red Sea reef. All of these different species of animals thrive on the same food source, the abundant supply of plankton carried by the swift currents flowing past the tip of the Sinai Desert. *CN*
*14mm lens  Velvia 50*

**49. Stargazer**
*Uranoscopus sp.*
RED SEA
The eyes and mouth of this fascinating fish are located on top of its head. The stargazer will then bury itself completely in the sand with only these parts exposed. Should an unsuspecting morsel wander too close, the stargazer can explode out of hiding to catch its meal. What appear to be teeth are only flaps of tissue to keep sand out of its mouth. *CN*
*100mm macro lens  Kodachrome 25*

**50. Grey Moray Eel**
*Siderea grisea*
RED SEA
The spots on the head of this eel are more than attractive decoration. They mark the location of open sensory pores capable of detecting light pressure waves and weak electrical fields against their bodies. Because they are nocturnal feeders, the light coloration is not detrimental to their hunting ability or their protection. Most often found in shallow depths, this small eel can be seen during the day poking its head out from holes or crevices in the rocks. *CN*
*100mm macro lens  Velvia 50*

**51. Pelagic Squid**
*Loligo sp.*
HAWAIIAN ISLANDS
Adrift in water two miles deep, one hundred feet beneath the surface ten miles off the Kona Coast of Hawaii alone at night, I could imagine the fearsome spectacle this squid would present to its intended prey. Those long, grasping tentacles surrounding a sharp beaked mouth would be the last sight such a victim would have before succumbing to this cunning predator. *CN*
*50mm macro lens  Kodachrome 25*

**52. Oscellated Lionfish**
*Dendrochirus biocellatus*
SOLOMON ISLANDS
Also dubbed the Fu-Manchu fish, this nocturnal beauty is a great challenge to photograph. They will retreat immediately to the inner maze of the coral thicket when a light is shined on them, venturing cautiously back out to the open reef after the light has been turned off or pointed away. They are a classic example of a "predator mimic" with the two eye-spots on their fins. A single eye-spot confuses the differentiation between the head and tail of the prey. The double eye-spot pattern mimics the eyes of creatures which might prey on the predator itself. *CN*
*100mm macro lens  Velvia 50*

**53. Hermit Crabs**
*Pagurites sp.*
SOLOMON ISLANDS
Observing these two tiny reef-dwelling hermit crabs through the magnifying lens of my camera, I felt drawn into their world, part of their lives. I imagined I was watching two neighbors gossiping, possibly complaining about those noisy shrimp down the reef. *CN*
*100mm macro lens  Velvia 50*

**54. Juvenile Tomato Anemonefish**
*Amphiprion frenatus* in *Entacmaea quadricolor*
SOLOMON ISLANDS
Inflated with water, the tips of the tentacles of this anemone form an almost ethereal setting for this anemonefish. Like all anemones, these tentacles are coated with microscopic nematocysts. Each one is like a tiny toxic harpoon, firing when stimulated by touch or chemical reaction. The anemonefish develops a temporary immunity to its host anemone by progressively touching different parts of its body to the stinging tentacles and stimulating production of protective agents in the mucus coating of its scales. When removed from its particular host for a period of time, the anemonefish loses its immunity and would have to re-adapt to its host once again. *CN*
*100mm macro lens  Velvia 50*

**55. Coral Polyps**
*Alveopora gigas*
PAPUA NEW GUINEA
Tentacles of hungry polyps wave from the ends of long slender stalks. Daisy corals such as these prefer quiet water, out of the strong current and surge. Undisturbed, the delicate polyps are free to extend and distribute themselves fully in their efforts to capture passing plankton. In strong current, the soft, flexible stalks would be forced flat against the reef, all bunched together, and their feeding efficiency would be minimized. *CN*
*100mm macro lens  Kodachrome 25*

**56. Sea Whips**
*Ellisella sp.*
SOLOMON ISLANDS
Preferring the deeper, cooler water with reduced sunlight, sea whips are a gorgonian coral common to the Solomon Islands and many other parts of the Western Pacific and the Indian Ocean. While beautiful in their own right, each strand of this flexible, polyp-lined coral is often home to tiny gobies and various species of shrimp. These tenants typically adopt the color of the whip coral they inhabit. *CN*
*14mm lens  Velvia 50*

57. **Sea Fan**
*Subergorgia hicksoni*
RED SEA
This enormous sea fan has truly become an old friend, for I admire it when I visit Yolanda Reef in Ras Mohammed National Park every summer. The anthias dance around the sea fans when the current brings food to them and they dare to leave the protection of the reef. The flowing current also brings the polyps to full bloom on the sea fan's branches so the coral, too, can feed. When the current slackens, the polyps retract and the sea fans look barren, like a tree in autumn after all the leaves have fallen to the ground. *BW*
*20mm lens  Velvia 50*

58. **Decorator Crab on Soft Coral**
*Hophophrys oatesii* on *Dendronephthya sp.*
RED SEA
Here the shallow depth of focus of a macro lens at high magnification combines with the full spectrum of light from an underwater strobe, allowing us to differentiate this fascinating decorator crab from its soft coral habitat. Viewed under natural ambient conditions, this crab is virtually invisible. The cherry red orb near the top of the animal is its left eye. The crab will break off polyps from the coral with its pinchers and carefully attach the stolen decorations on its carapace to further enhance its camouflage. *CN*
*100mm macro lens  Velvia 50*

59. **Sergeant Majors**
*Abudefduf saxatilis*
RED SEA
They swarmed me like a gang of escaped convicts heading for a bordello. A member of the damselfish family, sergeant majors are commonly found in tropical waters throughout the world, and ounce for ounce damsels constitute some of the more aggressive and nasty fish in the sea. It is fortunate for divers and all other sea creatures alike that no damselfish ever gets more than five or six inches long. *CN*
*24mm lens  Kodachrome 64*

60. **Fire Goby**
*Nemateleotris magnifica*
SOLOMON ISLANDS
The fire goby lives over sandy areas from shallow to very deep water. These fish are commonly found in pairs or in larger families, and they use their long dorsal fins to signal one another. They build burrows in the sand into which they can instantly retreat when frightened, moving so quickly they seem to simply disappear. However, if a diver waits patiently, the fire goby will reappear after a few minutes. *CN*
*200mm macro lens  Velvia 50*

61. **Squarespot Basslet**
*Pseudanthias pleurotaenia*
SOLOMON ISLANDS
Typical of the anthias family, the males are both larger and more colorful than the females. But none have more vibrant colors than this species, whose neon hues glow brightly even at the deeper depths where they are normally found. Each male will lord over a harem of females. Should that male be removed for any reason, or should the group become too large for a single male, the dominant female will transform into a male, finally adopting these same striking colors. In this fashion, male competition for harems and the energy expended fighting for their possession is minimized, as the numbers of males are limited to only those needed to service the harems, and male replacement comes from the ranks of females, not rival males. *CN*
*100mm macro lens  Velvia 50*

62. **Shrimp on Corallimorpharid**
*Periclemenes sp.* on *Corallimorpharid*
SOLOMON ISLANDS
I found a common periclemenes shrimp walking across a remarkable landscape of corallimorpharids. Similar to anemones and very closely related to corals, these disc-shaped creatures have no skeleton and are somewhat mysterious. Often we find them associated commensally with crustaceans of varying types. *CN*
*100mm macro lens  Velvia 50*

63. **Scorpionfish**
*Scorpaenopsis cirrhosa*
SOLOMON ISLANDS
These masters of camouflage are undone by the brief flash of my strobe. Illuminated by a full spectrum of light, they suddenly contrast brightly against their surroundings. Under natural light at depth, however, they can be nearly impossible to see. And that, of course, is the whole point. An unaware fish might venture too close, only to find itself instantly inhaled by this creature that it mistook for part of the reef. *CN*
*100mm macro lens  Velvia 50*

65. **Scorpionfish Detail**
SOLOMON ISLANDS
Blending perfectly against the coral and algae-covered rocks, a scorpionfish rests absolutely still, waiting for an incautious fish to pass within lunging distance. The seemingly slow and lethargic scorpionfish will then burst forth with blinding speed, and the unfortunate victim will instantly disappear. A detail of the pectoral fin area on the scorpionfish reveals the elaborate decoration adorning its body. *CN*
*100mm macro lens  Velvia 50*

66. **Feather Duster Worm**
SOLOMON ISLANDS
I was attracted to the similarity of the image formed in my viewfinder and the patterns found on woven Indian blankets, artifacts created by people whose cultures traditionally took their artistic and philosophic inspiration from nature. I was reminded how nature's designs are repeated in such widely diverse environments around the world, both above water and below. *CN*
*100mm macro lens  Velvia 50*

67. **Tube Anemone**
*Cerianthus membranaceus*
GALAPAGOS ISLANDS
On the dark sandy, bottom where they are found, these anemones actually seem to glow. They sit like undersea jewels, quietly waving their tentacles in the current, feeding on the rich nutrients that the Galapagos waters provide. Each anemone resides in its own tube, formed of sand cemented by the mucous which it secretes. *BW*
*100mm macro lens  Velvia 50*

68. **Parrotfish Patterns**
*Scarus longiceps.*
SOLOMON ISLANDS
When parrotfish sleep, they frequently secrete a mucous cocoon around their bodies. Scientists have suggested this mucous sac might confine the parrotfish's scent, providing some protection from predators which hunt by smell. Needless to say, when I hope to make some images of the endlessly interesting patterns found on the parrotfish, it is necessary to find one which has no distracting cocoon. *BW*
*100mm macro lens  Velvia 50*

69. **Parrotfish Pectoral Fin**
*Scarus oviceps*
SOLOMON ISLANDS
Photographing the patterns found on fish is for me a little like photographing sunsets. Every new one seems more beautiful than the last, so I keep on shooting. The camera has a great power to isolate detail and manipulate perception, and the results always remind me of the parable of the blind men and the elephant. Individually, the sightless old men touch different parts of the animal. They each describe from their separate experiences what the whole elephant must be like, and of course each forms a radically different understanding of what an elephant is. In making such photographs, I am visually feeling selected areas of my subjects, the details of these small parts holding a larger experience of their own. *CN*
*100mm macro lens  Velvia 50*

70. **Eye of Conch**
*Lambis sp.*
RED SEA
They lie mostly buried in the sand by day, but at night they emerge to hunt for food. The eyes, sitting on the end of the eye stalks, can do little more than sense light and shadow. This is generally sufficient to warn them of an approaching predator, giving them time to withdraw into their hard, protective shell. Like most molluscs, this conch breathes by means of a gill. They also have a simple heart and something of a circulatory system connected to their gill. Though they lack the efficient circulatory system of vertebrates, molluscs are far less active and the demands on such a system are far less great. *CN*
*200mm macro lens  Kodachrome 25*

**71. Sea Fan with Glassfish**
*Subergorgia hicksoni* with
*Parapriacanthus guentheri*
RED SEA
The sea fans were concentrated along the reef point, where the current flowed most swiftly. Beautifully formed soft corals were growing between the towering gorgonia. Glassfish drifted like a silver cloud around the fans, forever moving and changing shape. Glassfish have a slight luminescent green hue on their underside. At night when they feed, the dim glow serves as camouflage, balancing evenly against the soft moonlight. *BW*
*20mm lens  Velvia 50*

**73. Coral Reef Scenic**
*Acropora sp.* and *Dendronephthya sp.*
RED SEA
Two major types of coral are contrasted in this image. Like all hard corals, the polyps of the table coral on the left secrete minerals forming the rigid skeleton. The soft corals on the right are far more colorful, faster growing, but shorter lived. They use hydraulic pressure to inflate their branches during periods of prime feeding opportunity. *CN*
*14mm lens  Velvia 50*

**74. Serpulid Worm and
Hermit Crab Colony**
*Spirobranchia gigantea* and
*Paguritta harmsi*
SOLOMON ISLANDS
A spiraling serpulid worm towers above a colony of hermit crabs at a depth of fifty feet in the Solomon Islands. The serpulid worms do not bore into the coral like many of their cousins. Rather, the juvenile secretes a small tube on the surface of the coral, and the coral grows around the worm tube. The worm will build the tube at a rate consistent with the coral growth to avoid being buried by the coral. These hermit crabs eventually colonize the tubes of dead serpulid worms. *CN*
*100mm macro lens  Velvia 50*

**75. Chromodoris Nudibranch**
*Chromodoris kuniei*
SOLOMON ISLANDS
Mother nature works a special magic in the sea, transforming even the most mundane terrestrial creatures into objects of extraordinary delicacy and beauty. Crawling over the reef at a depth of sixty-five feet is an elegant cousin of the terrestrial slug. Its exposed, external gills are the source of the name nudibranch, meaning "naked gills." *CN*
*100mm macro lens  Velvia 50*

**76. Mushroom Coral**
*Fungia sp.*
RED SEA
Mushroom coral, distributed generously in various incarnations throughout the Indo-Pacific region, is notable because the entire organism is a single, lone polyp. Radiating out from the center of the disc are grooves from which extend the food-gathering tentacles. In their early stages of life, they grow on stalks attached to the reef. As they grow larger and mature, they break free of the stalks, lying around loose on the bottom. *CN*
*50mm macro lens  Velvia 50*

**77. Napoleon Wrasse**
*Cheilinus undulatus*
RED SEA
Napoleon Wrasse can weigh over four hundred pounds, measuring in excess of six feet in length. My guess is the strange lump on its head is home to the curiosity center of its brain, for this rather bizarre fish seems to have an excessive interest in the activities of divers. Focusing closely on some tiny nudibranch, coral polyp, or shrimp, I have many times had the sense of being watched. Turning quickly, I have often been greeted by what seems to be nothing but a huge, rotating eyeball with a fish attached. Great fat lips and scales the size of saucers at last come into background focus, as that strange, staring eyeball keeps swinging from side to side like a metronome, as if watching an undersea tennis match. The curious lump is formed of fatty, connective tissue and is a common secondary sexual characteristic of terminal males of many large fish species. *CN*
*14mm lens  Velvia 50*

**78. Sea Anemone and Leather Coral**
*Heteractis magnifica* and
*Sarcophyton sp.*
PAPUA NEW GUINEA
A small school of fusiliers arcs over a quiet composition of anemone fish in a sea anemone and a leather coral. One of numerous species of soft coral found in these rich waters, leather coral grows in isolated colonies as pictured here, or in vast fields covering an acre or more. *CN*
*14mm lens  Kodachrome 64*

**79. Manta Ray**
*Manta birostris*
PAPUA NEW GUINEA
Their giant wings lifting gracefully, then thrusting powerfully downward, manta rays swim constantly, filtering enormous quantities of water through their cavernous open mouths. While they are absolutely harmless to humans, their sheer size can be intimidating, as they may attain wingspans exceeding fifteen feet. Remoras are often found hitchhiking on manta rays, but other than creating some extra drag, they do no harm. *CN*
*14mm lens  Kodachrome 64*

**80. Goby on Gorgonian Coral**
*Bryaninops loki* on *Solenocaulon sp.*
SOLOMON ISLANDS
Commonly found on wire coral and gorgonian coral, these inch long gobies will be color-matched to the coral they inhabit. Scurrying up and down the coral branches, they forage among the coral polyps, taking advantage of food captured in the coral branches. When frightened, they will dart to the opposite side of the coral branch, their slender bodies hidden from view. *CN*
*100mm macro lens  Velvia 50*

**81. Orange Spotted Prawn Goby**
*Amblyeleotris guttata*
SOLOMON ISLANDS
The sandy, rubble areas found between stretches of glorious coral architecture are often overlooked by divers. Just beyond these patches a more magnificent reef waits, and divers are tempted to move quickly past such nondescript habitat to the more visually stunning areas. But living in and around the sand, silt, and broken, dead coral is a menagerie of wonderful life forms. Prawn gobies are found here in large numbers, each one sharing a burrow in the sand with a blind, or nearly blind, shrimp. The shrimp spends its life cleaning and building the burrow, while the goby stands guard at the entrance. *CN*
*200mm macro lens  Velvia 50*

**82. Table Coral and Glassfish**
RED SEA
We had crossed the Straits of Gubal to visit a tiny reef, little known and infrequently visited. The currents were steady, and the water was clear. Rising in the distance like a mountain peak was a sharp pinnacle sheathed in luscious soft corals. Around this undersea mountain thick clouds of baitfish and glassfish gathered, swirling in and out among the table corals as if blown by strong winds. Lightning would strike and thunder would roll when the large predators would smash through this waiting feast. *CN*
*14mm lens  Velvia 50*

**83. Diana's Wrasse and Soft Coral**
*Bodianus diana* and
*Dendronephthya sp.*
RED SEA
The festive colors of soft corals and the swirl of orange anthias make the reef appear like a country fair. With no fresh water run-off from the parched desert shore, the water is extremely clear throughout most of the year. As the soft corals grow right to the surface, where the sun's rays easily reach them, these reefs can be as vivid in real life as in the strobe-illuminated photographs. *BW*
*100mm macro lens  Velvia 50*

195

**84. Ascidians and Hydroids**
*Pycnoclavella detorta*
SOLOMON ISLANDS
While appearing like a colorful bouquet of flowers, this cluster is comprised of individual animals, formed of numerous ascidian species. Sharing many characteristics of the sponge, ascidians represent perhaps the next evolutionary step beyond the sponge. They contain blood vessels and a limited range of movement. The incurrent and excurrent siphons are often arranged in a precise orientation so that the waste products are not mixed with incoming sea water. *CN*
*100mm macro lens  Velvia 50*

**85. Frogfish**
*Antennarius sanguineus*
GALAPAGOS ISLANDS
This frogfish was pointed out to me by my dive buddy; otherwise, I probably would have passed it by. Though bright red in the photograph because of the light from my strobes, it blended perfectly with its algae-covered, sponge-encrusted surroundings. They are also called anglerfish for the fishing lure that they dangle in front of their mouths, which is actually a special adaptation of their front dorsal spine. This frogfish is in a bit of a shock, as evidenced by the fact its angler is erected with no prey in sight. *BW*
*100mm macro lens  Velvia 50*

**86. Soft Coral**
*Dendronephthya sp.*
SOLOMON ISLANDS
While the shallow water reefs in the Solomons are carpeted with rich clusters of soft corals in a multitude of colors, venturing into the deeper water reveals a species almost shocking in hue. At one hundred forty feet I encountered an extensive field in full bloom, feeding off the up welling current sweeping up the reef face. *CN*
*14mm lens  Velvia 50*

**88. Two Nudibranchs**
*Risbecia pulchella*
RED SEA
These elegant nudibranchs are commonly found in pairs, typically traveling over the reef nose to tail, so to speak. One can only speculate as to the purpose of their striking coloration, but many scientists believe that their frequently bright colors make them very obvious, serving notice to predators that they are bad eating. Lacking eyes, they cannot see each other, or themselves. So attractiveness to mates or personal vanity can be ruled out. *CN*
*100mm macro lens  Velvia 50*

**89. Soft Coral Polyps**
*Dendronephtya sp.*
SOLOMON ISLANDS
Canopies of coral polyps unfold like flowered parasols along the branch of a soft coral tree. While soft corals contribute nothing to the structure of the reef, these colorful colonial animals provide an enchanting habitat for shrimps and crabs, slugs and crinoids, fish and seashells, plus a host of other creatures. *CN*
*100mm macro lens  Velvia 50*

**90. Reef Scenic**
SOLOMON ISLANDS
The Solomons may be the Garden of Eden above water, but nothing seen on land can compare with the profound abundance and variety of flora and fauna found on her undersea reefs. This beauty can be deceptive, for the reef's surface is actually a place of violent competition and warfare, as invertebrate species employ a wide range of chemical and mechanical weapons in their endless fight for space. *CN*
*14mm lens  Velvia 50*

**91. Crimson Sea Fan**
*Melithaea sp.*
SOLOMON ISLANDS
Its apparent color muted by the absorption of sunlight through one hundred feet of sea water, this gorgonian sea fan explodes in vivid red hues ignited by my powerful strobe lights. The Solomon Islands are host to perhaps the world's most magnificent sea fans, their dimensions approaching twenty feet across. *CN*
*14mm lens  Velvia 50*

**92. Anemonefish in Sea Anemone**
*Amphiprion perideraion* in *Heteractis magnifica*
PAPUA NEW GUINEA
This species of sea anemone is normally extended widely across the reef, a large tentacle-covered disc attached to the bottom at the center on its underside. Periodically, the resident anemonefish will circle the perimeter of the host anemone, nipping at the edges and so irritating the anemone that it folds up in a bowl-shaped fashion, exposing the richly colored red underside. The anemonefish will then lay their eggs on the reef around the base of the anemone. When the anemone relaxes and spreads out once again, it will cover and protect the eggs. *CN*
*50mm macro lens  Kodachrome 25*

**93. Cuttlefish**
*Sepia*
SOLOMON ISLANDS
Possessing eyes almost human in structure, the cuttlefish is also a camouflage artist. The ability of this mollusc to instantly change both the color and texture of its skin is but one of its impressive survival skills. When stalked by a predator, the cuttlefish might switch suddenly to a dark color, then expel a thick cloud of blackish ink in the size and shape of itself. The cuttlefish will then go immediately light in shade while escaping backwards at great speed with its jet propulsion system, unseen. *CN*
*50mm macro lens  Kodachrome 64*

**94. Tridacna Clam Siphon**
*Tridacna maxima*
SOLOMON ISLANDS
Photosynthetic algae growing symbiotically in the flesh of the giant clam mantle give it the vibrant colors. The algae produce oxygen while consuming waste ammonia, benefitting the clam. The mantles of these clams have "windows" to let extra light into the mantle flesh to enhance the photosynthesis. Tridacna clams, growing over four feet long and weighing hundreds of pounds, are harmless creatures, but over-fishing has nearly eliminated them from many reefs in the world where once they thrived. *CN*
*100mm macro lens  Velvia 50*

**96. Soft Coral Polyps**
*Dendronephthya sp.*
PAPUA NEW GUINEA
Like cherry blossoms in spring, the white polyps of the soft coral are in full bloom in response to the rising current. Since the supply of nutrients is greater during these periods, the soft corals expand to full size. During stretches of slack current, they will deflate and shrink to a fraction of their extended size, conserving energy. As a consequence, the reef changes appearance and character dramatically as the currents rise and fall during the day. *CN*
*200mm macro lens  Kodachrome 25*

**97. Coral Polyps**
*Goniopra sp.*
SOLOMON ISLANDS
Almost dreamlike in their delicacy, a colony of daisy coral polyps was found about ninety feet deep in a protected undersea crevasse. A single tentacle in the center polyp can be seen reaching into its mouth, transferring a particle of food it has just captured. *CN*
*100mm macro lens  Velvia 50*

**98. Parrotfish Tail**
*Scarus ghobban*
RED SEA
Beyond being a visual recording device, a camera can become a vehicle of discovery. The macro lens, producing a magnified image at its closest focusing ranges, transforms into a window to another world. Though somewhat clumsy-looking when viewed as a complete animal, parrotfish have wonderful details that can be isolated by such a lens, transforming the subject into dynamic studies of contrasting texture and form. *CN*
*100mm macro lens  Velvia 50*

**99. Parrotfish Detail**
*Hipposcarus harid*
RED SEA
Flowing from the corner of its mouth like watercolors, lovely hues wash across the side of this male parrotfish's face. Fast asleep at night, the parrotfish was unaware of my presence, allowing me to work at very close range with my magnifying macro lens. Photographed at a depth of forty-five feet. *CN*
*100mm macro lens  Velvia 50*

**100. Feather Duster Worm**
*Protula magnifica*
SOLOMON ISLANDS
The feather duster worm cements together fine particles of sand with a secreted mucus-like substance, building the long tube in which it lives. The feathered crown is extended from the tube to gather food, passing captured bits of plankton down the spiral grooves in the filaments toward the mouth. Highly sensitive to shadow and motion, the feathers can be quickly retracted to avoid being bitten off by hungry fish. *CN*
*100mm macro lens  Velvia 50*

**101. Lionfish**
*Pterois volitans*
RED SEA
Found throughout the Indo-Pacific, the lionfish is particularly abundant in the Red Sea. Often seen elsewhere alone or in pairs, here they may school by the dozen. While they appear slow and graceful, they are deceptive. When hunting, they will spread their webbed pectoral fins wide to the sides, slowly herding their prey. Then with lightning speed they will whip these fins back while lunging forward, swallowing their victims whole. *CN*
*50mm macro lens  Velvia 50*

**102. Freckle Face Blenny**
*Istiblennius chrysospilos*
SOLOMON ISLANDS
This colorful blenny inhabits vacated invertebrate holes in the surge-washed reef slab in the shallows, where the water is highly oxygenated from the turbulent wave action. Their habitat makes them a challenge to photograph, as there is nothing to hold on to, and the photographer is constantly getting pushed back and forth by the surge. It doesn't help that these fish are quite shy, disappearing into their holes when frightened. The fleshy antlers help them identify members of their own species, as well as the sex of that member, males having larger antlers than the female. *CN*
*100mm macro lens  Velvia 50*

**103. Nudibranch with Ascidians**
*Godiva sp.*
SOLOMON ISLANDS
One member of a large group of nudibranchs called *aeolids*, is characterized by the tubular projections along their backs called *cerata*. At the tip of each cerata is a small sac containing the concentrated stinging cells the nudibranch ingests by eating various coelenterates. If molested by a predator, the nudibranch will fire this purloined arsenal in retaliation. *CN*
*100mm macro lens  Velvia 50*

**104. Nudibranch**
*Glossodoris cincta*
RED SEA
Protruding from the front of this nudibranch are its rhinophores. These sensory organs can detect extraordinarily minute concentrations of chemical scents in the ocean, often leading them to food sources or to another nudibranch to satisfy a mating urge. *CN*
*100mm macro lens  Velvia 50*

**105. Gilded Pipefish**
*Corythoichthys schultzi*
RED SEA
Though it may appear primitive, the pipefish is a very advanced animal, using its elongated snout to gather food from the recesses of coral polyps. Its scales have fused to become like an armor casing. The pipefish is a relative of the sea horse, and as with the seahorse, it is the males which become pregnant. The female will lay her eggs inside a special brood pouch, and the male then fertilizes, carries, and cares for them. This is advanced? *CN*
*100mm macro lens  Velvia 50*

**106. Crinoid**
*Comatula sp.*
SOLOMON ISLANDS
Modern crinoids exist today practically unchanged from their ancestors hundreds of millions of years ago. In a sense, they are living dinosaurs. While they may appear to be flower-like plants, they are active animals in the same family as starfish, capable of walking, swimming, and most particularly, climbing up to the highest part of sea fans, whip coral, or any other object on the reef which will allow them better access to the stronger, food-rich current. *CN*
*50mm macro lens  Velvia 50*

**107. Tridacna Clam Mantle**
*Tridacna maxima*
SOLOMON ISLANDS
Nature's designs continue to dazzle me. The undersea world is a rich gallery of abstract form, color, and pattern. In areas like the Solomon Islands, which offer such extraordinarily rich reefs, a photographer can spend an entire dive examining just a few square feet of reef. The photographic opportunities are endless. The electric colors on the mantle of this giant clam attracted my attention, but it was the elegant curves of the clam's flesh, formed on one end where the shells hinge, which attracted my lens. *CN*
*100mm macro lens  Velvia 50*

**108. Stonefish**
*Synanceia horrida*
SOLOMON ISLANDS
The most difficult part of any fish's body to camouflage is the eye, but the stonefish has done an exceptional job, for warty protrusions can be seen growing even on the surface of their eyes. The result is a fish virtually impossible to see, so well does it blend with its rocky surroundings. However, it is an animal worth knowing about, for at the base of each of its thirteen dorsal spines are two poison glands, packing enough toxin to kill a person. Thankfully, however, stonefish are not in any way aggressive and will only use their weapons for protection. *BW*
*100mm macro lens  Velvia 50*

**109. Sea Squirt**
*Polycarpa aurita*
SOLOMON ISLANDS
Exploring the reef through the magnified image of a lens can produce some interesting surprises. As I focused on a common sea squirt, I noticed this individual had two excurrent openings instead of the usual single one. A mutant. As I framed the subject, a startling image emerged when a macabre face suddenly gazed back at me. The incurrent siphon is typically pointed down and away so that sediment cannot fall in, and waste material expelled from the excurrent siphon does not get mixed with the incoming seawater. *CN*
*50mm macro lens  Kodachrome 25*

**111. School of Batfish**
*Platax orbicularis*
RED SEA
Batfish flutter along in schools of hundreds, lustrous silver bronze in the clear sunny waters of the Red Sea. They remind me of aspen leaves shimmering in the wind in late fall, while sunlight streams through the forest. The juvenile stage is even more spectacular, as the fins are extremely elongated. During this growth cycle they live in the mangroves and estuaries, often lying on their sides, floating near the surface to mimic a floating broken mangrove leaf. *CN*
*14mm lens  Kodachrome 64*

**112. Reef Scenic**
*Dendronephthya sp.*
RED SEA
Like a living robe cloaking the stalks of a long dead gorgonian sea fan, soft corals thrive in a dazzling array of colors ninety-five feet deep in the Red Sea. *Dendronephthya,* along with certain related species, are a uniquely Indo-Pacific phenomenon. In the Caribbean they are replaced largely by gorgonian corals. *CN*
*14mm lens  Velvia 50*

**113. Elephant Ear Sponge**
*Phakellia sp.*
SOLOMON ISLANDS
Found in deeper water, where they are less likely to be damaged by wave action, the elephant ear sponges maximize their water filtering efficiency by increasing their surface area via their undulating shapes, and by growing perpendicular to the current, enhancing the flow of water into their pores. *CN*
*14mm lens  Velvia 50*

**114. Sailfin Leaffish**
*Taenianotus triacanthus*
SOLOMON ISLANDS
Slowly rocking back and forth in the current, the thin-bodied leaffish resembles exactly what its name implies. Though capable of swimming, it more often uses its pectoral fins to walk across the reef, then hold itself in place when it finds an appropriate location. Unsuspecting prey might swim too close and suddenly be inhaled as the leaffish dramatically distends its small looking mouth, engulfing its meal instantly. *CN*
*100mm macro lens  Velvia 50*

**115. Decorator Crab**
SOLOMON ISLANDS
I was thrilled when I found this amazing little crab at night sitting out in the open, in plain view, on top of a coral head. So confident was it with its wonderful camouflage, that it paid no attention to me as I moved closer with my powerful night light. I had never seen one like this before, and I was impressed with its decorative attire–an exquisite combination of sponge, corallimorpharids, and coral polyps which it carefully had placed all over its shell. As these adornments eventually die, the crab will gather new garments to keep itself hidden from hungry, dangerous predators. *BW*
*100mm macro lens  Velvia 50*

**116. Slipper Lobster Eye**
SOLOMON ISLANDS
The eye of a slipper lobster protrudes from its colorful armor-plated shell. At depth, however, these bright hues are muted, becoming effective camouflage. By day, the slipper lobster takes advantage of its wide, flat body shape to hide within rocky crevices, usually under ledges or in caves where it is dark. At night, this ten inch long crustacean will scavenge the open reef for dead or decaying food. *CN*
*100mm macro lens  Velvia 50*

**117. Bravo Blenny**
*Labrisomus dendriticus*
GALAPAGOS ISLANDS
To draw female attention to itself better during mating season, the male Bravo Blenny will turn its gills bright yellow, and its body will become white with vertical black bars. The black spot on its gill plate, while normally a false-eye spot as seen here, also turns bright yellow as an additional signal to potential mates. *BW*
*100mm macro lens  Velvia 50*

**118. Imperial Shrimp on Spanish Dancer**
*Periclimenes imperator* on
*Hexabranchus sanguineus*
RED SEA
One of the largest nudibranchs, the nocturnal Spanish Dancer is impressive by itself. Not content simply to slither along the bottom like most of its cousins, this seductive sea slug can fly off the reef with a graceful, undulating swimming motion. But on one night dive I was most excited to discover, peering out from the clustered gills on the Spanish Dancer's back, a tiny imperial shrimp. As it was momentarily bewildered by my powerful light, I managed to get a shot or two before it scurried back into hiding among the gills. *CN*
*100mm macro lens  Velvia 50*

**119. Field of Leather Coral**
*Lobophyton sp.*
SOLOMON ISLANDS
What is commonly referred to as leather coral comes in a wide variety of species. Some exist as distinctly individual colonial stalks. Other varieties, such as these, form extensive lush carpets covering the reef. The low profile and leathery flexibility of these corals mean they are resilient to strong current and heavy surge from storm waves. Thus they are commonly found thriving in areas subject to these conditions such as reef passes or shallow water reef tops. If an environmental niche exists, nature has created something that will succeed in it. *CN*
*14mm lens  Velvia 50*

**120. Plate Coral**
*Leptoseris explanata*
SOLOMON ISLANDS
The ridges on the plate coral help create turbulence as the current passes over them. This disturbance of the water flow retards the current, giving the coral polyps greater opportunity to reach out and collect nutrients. The coral plates will grow in positions that optimize both exposure to the prevailing currents for food, and exposure to the sun to benefit the photosynthetic algae growing symbiotically in them. *CN*
*50mm macro lens  Velvia 50*

**121. Soft Coral Spicules**
*Dendronephthya sp.*
SOLOMON ISLANDS
In place of the lime-calcium skeletal cells constructed by hard, reef-building corals, the soft corals form small, fibrous spicules in their flesh. These spicules, also called sclerites, act like the fibers in fiberglass, giving the soft coral structural strength when inflated. *CN*
*100mm macro lens  Velvia 50*

**122. Sailfin Leaffish**
*Taemoamptis troacamtjis*
SOLOMON ISLANDS
While they come in a wide range of colors, the pink leaffish is by far the most striking. As they rely on camouflage to a large extent to capture prey and for their own protection, one might wonder why one variety is so brightly colored. But since the longer, warm-colored wavelengths of light are progressively filtered out the farther it travels in water, this leaffish has a very muted coloration at depth, allowing it to blend in well with its surroundings. *CN*
*100mm macro lens  Velvia 50*

**124. Ribbon Eel**
*Rhinomuraena quaesita*
SOLOMON ISLANDS
Bobbing and weaving, pulling back, then ducking, lunging forward, feigning right then pulling left... this comical looking ribbon eel reminded me of a prize fighter in a gold and blue silk robe, shadow boxing while preparing for the title fight. Only the males are found in these striking colors. Reversing the pattern of most fish, these males may mature into females, growing larger and turning completely yellow with a black dorsal fin. All the juveniles are black with a yellow dorsal fin. *CN*
*100mm macro lens  Velvia 50*

**125. Stonefish Portrait**
*Synanceia verrucosa*
RED SEA
They often are found in pairs, and true to form, this pink stonefish had a partner sitting only a few feet away. For an animal that moves very little, they are deceptively fast when necessary. The hunting of the stonefish has been documented on film. From the moment they leap out of hiding, catch their victim fish, and return to their original position, the elapsed time might be no longer than one-sixteenth of a second. To accomplish this, they possess among the fastest jaws in the world, capable of protruding in less than two milliseconds. *BW*
*100mm macro lens  Velvia 50*

**126. Mating Nudibranchs**
*Nembrotha sp.*
RED SEA
At one hundred and ten feet on a Red Sea reef, I discovered this engaging pair of nudibranchs. Being hermaphroditic, each will fertilize the other during these pairings. Then each individual will subsequently lay a delicate spiraled ribbon of eggs, seen dotting the reef like lovely flowers. *CN*
*100mm macro lens  Velvia 50*

**127. Decorator Crab in Corallimorpharid**
SOLOMON ISLANDS
This crab is most often seen along the periphery of bubble coral colonies, where it imitates the red-brown algae commonly found growing around the edges of these clusters. This particular crab I discovered living in a blue anemone-like creature called a corallimorpharid. As it is not quite an anemone, lacks a skeleton, but is closely related to coral, I guess it might be called an "uncoral." My subject was not only covered in algae, but had also adorned itself with bits of sponge. *BW*
*100mm macro lens  Velvia 50*

128. **Frogfish**
*Antennarius sanguineus*
COCOS ISLAND
Slow, lumpy, covered with growths, warts, and other fleshy protuberances... well, you gotta love 'em. But nature is purposeful as always, even when it may appear she has been simply disdainful, for the survival strategy of this brightly colored fish is to resemble an innocuous blob of sponge. It has a specialized dorsal fin spine between its eyes that can extend a bulbous, succulent tip to dangle seductively in front of its mouth. An unsuspecting, hungry little fish, seeing nothing but a floating bit of food next to a lump of sponge, attempts a bite to eat, only to be quickly inhaled by the large, gulping mouth of the frogfish. *CN*
*100mm macro lens  Velvia 50*

129. **Nudibranch Laying Eggs on Sea Squirt**
*Nembrotha lineolata* on
*Polycarpa aurata*
SOLOMON ISLANDS
Nudibranchs of many species often choose to lay their eggs on the surface of these common sea squirts. This nudibranch has nearly completed its delicate egg ribbon. Each spiral cluster may contain thousands of eggs, but only a few of the eggs will survive and mature into colorful sea slugs. Curiously, sea squirts are our closest invertebrate cousins, a point many might consider less than flattering. *BW*
*100mm macro lens  Velvia 50*

130. **Parasitic Anemones**
RED SEA
Seeking a suitable place to live, these anemones attach themselves to the branches of sea fans, smothering and killing the polyps beneath them in the process. Some sea fans become completely overrun, and the entire coral colony eventually dies. These same anemones will also grow on soft corals, but typically in minimal numbers, so the soft coral tree is not greatly affected. Feeding activity is particularly apparent at night, as the diver's light aimed at these anemones attracts large numbers of larval creatures to the beam, and the anemones have a feast. *BW*
*100mm macro lens  Velvia 50*

131. **Thorny Oyster Mantle**
*Spondylus sp.*
SOLOMON ISLANDS
The beautiful mantles of the thorny oyster beckon the underwater photographer, but these creatures are so extraordinarily sensitive to light and motion, they are quite difficult to approach. When disturbed in the slightest way, the two halves of the shell will quickly slam shut. The upper and lower edges of the mantle are lined with dozens and dozens of "eyes," detecting only light or shadow. Such animals are filter feeders, and must remain open for extended periods of time for nourishment and respiration. *CN*
*100mm macro lens  Kodachrome 25*

132. **Shrimp on Crown of Thorns Starfish**
*Periclimenes soror* on
*Acanthaster planci*
RED SEA
Well protected among the sharp, toxic spines of the coral-eating crown of thorns starfish, an inch long periclemenes shrimp will feed off the excreted material ejected through the anal opening at the center on the surface of the starfish. Similar shrimp are commonly associated with various species of starfish and sea urchins world-wide. They often have color and form to match their hosts. *CN*
*200mm macro lens  Kodachrome 25*

133. **Goby on Coral**
*Coruphopterus personatus*
SOLOMON ISLANDS
Quite often it is not necessarily the main subject of a photograph which makes it interesting, but rather the situation the subject is found in. The goby pictured is very common throughout the Solomons, and I have photographed it numerous times in many different habitats. However, the beautiful coral background I found this subject resting on reminded me of a male peacock's feathers, and that is what set the photograph apart. *BW*
*100mm macro lens  Velvia 50*

135. **Cleaner Shrimp on Yellowmargin Moray Eel**
*Periclemens sp.* on
*Gymnothorax flavimarginatus*
RED SEA
Cleaner shrimp forage over the body of a moray eel forty five feet deep on a Red Sea reef. The hungry little shrimp remove parasites from the eel. While the shrimp get fed, the eel gets cleaned. It is unlikely that the receptive host eel understands it is getting cleaned, but it probably does enjoy the tactile sensation of the shrimp tickling its face and body. *CN*
*100mm macro lens  Velvia 50*

136. **Soft Coral Tree**
*Dendronephthya sp.*
SOLOMON ISLANDS
The extraordinary richness and variety of the Solomon Islands reefs can be only glimpsed in this photograph. Regrettably, no single picture can truly do justice to the grandeur of these undersea gardens. The enormity of the biomass is astounding, the diversity of life inspiring. The fact that in many cases we have been the first human eyes to embrace these marine vistas is humbling. *CN*
*14mm lens  Velvia 50*

137. **Barrel Sponge**
PAPUA NEW GUINEA
A giant barrel sponge dominates a reef slope as a school of fusiliers passes overhead. Toxins in the flesh of mature sponges combined with their rough texture make them unattractive as food. But in their larval stage, over ninety-nine percent are consumed by plankton-eating animals such as fusiliers. *CN*
*14mm lens  Kodachrome 64*

138. **Decorator Crab on Sea Fan**
SOLOMON ISLANDS
Taking advantage of the sea fan's highly efficient ability to capture drifting plankton, a decorator crab forages among the snowflake polyps and crimson branches of this large gorgonia. The crab itself is covered with a tangle of white fibers which aid in its camouflage. *CN*
*100mm macro lens  Velvia 50*

139. **Caledonian Stinger**
*Inimicus caledonicus*
SOLOMON ISLANDS
Clawing along the bottom, this bizarre creature left a distinctive trail in the sand. It looked like a chicken had just walked past underwater. Indeed, the Caledonian Stinger has evolved a chicken-like claw from the two first spines on its pectoral fins which grow unwebbed and separate from the rest. It actually uses these claws to walk. These Stingers can be hard to find, as they bury themselves completely in the sand. Even when exposed, they look more like a skeleton than a healthy, living fish. Their fully fanned pectoral fins, displaying a palette of bright colors, are a final warning to possible predators, for the Caledonian Stinger boasts a powerful venom in its dorsal spines. *BW*
*100mm macro lens  Velvia 50*

140. **Reef Scenic**
SOLOMON ISLANDS
One hundred twenty feet deep in this undersea wonderland, soft corals unfurl their thick polyped branches and sea fans wear lush capes of crinoids. Leather corals, sea whips, and sponges occupy whatever gaps remain. Here the proliferation of life leads to vigorous competition for space, creating limits for invertebrate populations. *CN*
*14mm lens  Velvia 50*

142. **Parrotfish Tail**
*Scarus sp.*
SOLOMON ISLANDS
The tail fin of a sleeping parrotfish displays rich color and bold patterns not often seen during the day when the parrotfish is busily biting off chunks of hard corals as it feeds. During its life a large adult parrotfish can create as much as one ton of fine white sand from the crushed and excreted coral. *CN*
*100mm macro lens  Velvia 50*

**143. Lyre-tailed Sea Slug**
*Chelidonura varians*
SOLOMON ISLANDS
This species of sea slug differs from the nudibranchs in two important areas: while it has no external shell (similar to nudibranchs), it does have a small internal shell which nudibranchs do not possess. Also, this sea slug does not possess the exposed gills from whence the nudibranch derives its name. The electric blue rim lines contrasted with its jet black body make this species the most striking member of its family. *CN*
*100mm macro lens  Velvia 50*

**144. Clownfish in Anemone**
*Amphiprion percula* in
*Heteractis magnifica*
SOLOMON ISLANDS
One of the more beautiful members of a family of fishes distinguished by their striking appearances, the percula clownfish are also probably the most energetic. Dipping and diving, wiggling, flitting about, charging forward, then making a hasty retreat, they are a study in perpetual motion and an exercise in photographic frustration. *CN*
*100mm macro lens  Velvia 50*

**145. Fluorescent Nudibranch**
*Nembrotha kubanara*
SOLOMON ISLANDS
Though it was merely two inches long, I was able to spot this spectacular nudibranch from thirty feet away at a depth of sixty feet. Eyes like a hawk? Hardly. But amazingly, on this particular species the orange markings actually fluoresce. The intensity of the flash from my strobes overwhelms the weak emission of light from the fluorescence, which will not record on slow speed films on its own. *CN*
*100mm macro lens  Velvia 50*

**146. Porcelain Crab and Sea Anemone**
*Neopetrolisthes maculata* and
*Stichodactyla haddoni*
SOLOMON ISLANDS
Porcelain crabs are generally found living along the edge of sea anemones. In this way they can gather food while on top of the anemone, but should danger come their way, they can quickly retreat to the underside of the stinging anemone. Their hard shells protect them from the sting of the anemone's tentacles. When feeding, they extend feather-like nets from specialized arms to trap food particles. *CN*
*100mm macro lens  Velvia 50*

**147. Invertebrate Tableaux**
*Clavularia sp.*
SOLOMON ISLANDS
Slinking through a forest of coral polyps, a nudibranch passes under the siphon of a sea squirt. All three are invertebrate animals representing a tiny fraction of diverse invertebrate species found in the Solomons. Every square foot of reef here is another page in an endless catalog of fascinating life forms. *CN*
*100mm macro lens  Velvia 50*

**149. Thimble Jellyfish**
SOLOMON ISLANDS
Massing in enormous numbers, the jellyfish completely covered the surface everywhere I looked, extending to depths past fifty feet. Because they are less than a quarter of an inch in diameter and there were tens of thousands of them all around me moving quickly, I found it difficult to decide which one to focus on. They aren't strong enough swimmers to fight a current, so they are carried through the sea by wind and tide. *BW*
*100mm macro lens  Velvia 50*

**150. Glassfish in Cave**
*Parariacanthus guentheri*
RED SEA
Underwater caverns lining the shores of the ancient Sinai Desert afford excellent protection for great swarms of glassfish. The hungry jacks and tuna are unlikely to venture into the recesses of such caves. However, lionfish and snapper happily lurk in these dark recesses, enjoying daily feasts of these small, prolific fish. *CN*
*14mm lens  Velvia 50*

**151. Spotted Moray Eel**
*Gymnothorax meleagris*
HAWAIIAN ISLANDS
The compressed perspective afforded by a telephoto macro lens creates the unusual appearance in this photograph. Moray eels are extremely common on Hawaiian reefs. They are typically nocturnal feeders, using their sharply pointed teeth for grabbing and holding fish. The captured victims are generally swallowed whole, the outlines of which can be clearly seen protruding through the eel's body hours after being eaten. *CN*
*200mm macro lens  Kodachrome 25*

**152. Shrimp in Anemone**
GALAPAGOS ISLANDS
Dancing among the tentacles of the host anemone, this shrimp is constantly well protected from predators by the stinging nematocysts coating the anemone's tentacles. Knowing this, hungry fish are unlikely to venture within touching distance of these lethal, waving arms, and the shrimp is free to forage for food in safety. *BW*
*100mm macro lens  Kodachrome 64*

**153. Scorpionfish**
*Scorpaena sp.*
GALAPAGOS ISLANDS
The Galapagos Islands have what I feel are the most decorative and largest scorpionfish found anywhere. This striking beauty was probably young, with its colors and patterns clearly defined and no algae yet attached to its scales. The protruding tabs around its mouth and body help break its outline and reduce shadows, enhancing its camouflage. Scorpionfish don't have swim bladders; thus they are always found resting on the bottom. They will move only when necessary, often solely to feed. *BW*
*100mm macro lens  Velvia 50*

**154. Marbled Ray**
*Taeniura meyeri*
COCOS ISLAND
On my way back to the surface, this graceful ray swam right beneath me, so I decided to follow along. It wasn't bothered by my presence, and we swam side by side for a long time. Other than the rippling along the periphery of its wings, there was no movement of its body, yet it seemed to glide forward effortlessly. The white underbelly contrasts with the mottled camouflage on its top. They are often found resting on the bottom and will for the most part ignore divers if approached gently. At the top of their tail, they have a venomous spine which is used for self-protection should they feel threatened. *BW*
*20mm lens  Kodachrome 64*

**155. Sea Lion**
*Zalophus californianus wollebaeki*
GALAPAGOS ISLANDS
We prefer to dive the Galapagos Islands in April and May, directly following the sea lion mating season. Satiated from months of amorous activity, the males are less territorial and less protective, allowing the females in their harems to play with divers. Even so, it is advisable to keep a fair distance from the bulls, as they can be aggressive any time of the year. This young female came right up and blew bubbles in my face, somersaulted several times, then raced away to rejoin her kin. *BW*
*20mm lens  Kodachrome 64.*

**156. Scalloped Hammerhead Sharks**
*Sphyrna lewini*
GALAPAGOS ISLANDS
The Galapagos Islands are the finest place on earth for viewing at very close range the schooling of hammerhead sharks. While the hammerhead certainly has the physical equipment to cause harm to humans, the fact is that they are by nature quite shy. The best technique to experience very close encounters with these ten to twelve foot carnivores is to stay very quiet on the reef, slow your breathing rate to reduce the amount of bubbles, and stay largely hidden from view. With your visual and audible impact thus minimized, it is quite possible to have schools of hammerheads numbering in the hundreds pass sometimes within touching distance. *CN*
*14mm lens  Kodachrome 64*

157. **Barnacle Blenny in Sponge**
*Acanthemblemaria castroi*
GALAPAGOS ISLANDS
I am constantly amused at the sight of these blennies. I think it must be their teeth. They almost seem to have human dentures. In combination with the bright red eye rings and wild-looking protrusions above their eyes, they remind me somehow of old men with bushy eyebrows. They typically live in dead barnacles, popping in and out to grab passing food particles. They are common throughout the Galapagos Islands and are found in abundance between twenty to forty feet deep. *BW*
*100mm macro lens Velvia 50*

158. **School of Barracuda**
*Sphyraena idiastes*
GALAPAGOS ISLANDS
This magnificent school of barracuda was the biggest aggregation of fish of any kind I have ever seen. Only a small portion of them could be captured by my wide angle lens... barracuda seemed to fill the entire ocean! While their sheer numbers could be intimidating, the barracuda do not measure up to their aggressive reputation and are considered quite safe to mingle with. *BW*
*20mm lens Kodachrome 64*

159. **Galapagos Shark**
*Carcharhinus galapagensis*
GALAPAGOS ISLANDS
Between house-sized boulders washed by turbulent foam from crashing waves, a parade of brawny Galapagos sharks wove in and out of the shallow water, as if playing hide and seek. They seem to avoid eye contact, often approaching divers from behind. Every once in a while they become curious or bold, moving in for a closer look. Galapagos sharks can be found in large schools, but they are most often seen alone or in small groups. *BW*
*20mm lens Kodachrome 64*

160. **Scalloped Hammerhead Shark**
*Sphyrna lewini*
GALAPAGOS ISLANDS
The wide, flattened head of the hammerhead shark features an array of sensory organs permitting the shark to detect the existence and direction of very weak bio-electrical fields, such as those given off by potential prey. The head is flattened simply for hydrodynamic efficiency. With its eyes perched on the very ends of each lobe, the hammerhead is also afforded an excellent three dimensional view as it sweeps along inches over sandy bottoms seeking food such as rays or lobster. *CN*
*14mm lens Kodachrome 64*

161. **Mustard Rays**
*Rhinoptera steindachneri*
GALAPAGOS ISLANDS
Chris and I were lucky to encounter this school as soon as we entered the water. Mustard rays are often found close to the surface in shallow lagoons surrounded by mangroves, so to find them in the open sea was a treat. They have light bellies and golden dorsal sides. Not a particularly large ray, they typically have wingspans of one and a half to two and a half feet. Their swimming was slow for rays, but we were out of breath trying to keep pace with them before we ran out of film. They were kind enough to make several passes, and as they swam over us, they left me with an unforgettable image of ten smiling faces. *BW*
*20mm lens Kodachrome 64*

162. **Sea Lion**
*Zalophus californianus wollebaeki*
GALAPAGOS ISLANDS
They are the class clowns of the sea, constantly playing, getting into mischief, harassing passing sharks, chasing each other, or entertaining divers. At times their exuberance can simply be irritating. I was focusing on a brilliantly colored frogfish nestled at the base of a flourishing black coral tree. The water surrounding me was a swarm with activity, and I was having considerable difficulty in the current trying to hold still. Peering over my shoulder, a curious turtle watched my efforts momentarily, appearing careful not to disturb me and make matters worse. After a prolonged struggle, I had the rare fish sharp and nearly composed to my liking when, from out of nowhere, a sea lion exploded past me, right through the branches of the coral. When the dust settled, the turtle was gone, the frogfish was gone, the coral was in disarray, and only the sea lion remained, dancing in front of me, still jealous for attention. *CN*
*14mm lens Kodachrome 64*

163. **Pacific Spotted Dolphins**
*Stenella attenuata*
HAWAIIAN ISLANDS
Using their highly developed sense of echolocation, dolphins "read" objects with sound. A diver in their midst causes great agitation and excitement. The increased speed of sound underwater makes it impossible for a human to determine the source of the sound. Many times I have been swept up in the cacophony of clicks, whistles, pings, and racheting noises created by the dolphins surveying me, then chattering among themselves. When you find yourself among several hundred of these animals, their discordant racket makes the ocean seem like it may erupt. *CN*
*24mm lens Kodachrome 64*

165. **Leather Coral**
*Sarcophyton sp.*
RED SEA
Looking across the miniature landscape formed on the surface of a leather coral colony in the Red Sea, I was reminded of an oasis in a wadi, somewhere in the Sinai Desert. Leather corals are fleshy soft corals, and individual stalks can often grow together in tight clusters to form large, downy fields, undulating across the reef. When disturbed, the polyps will retract, leaving the surface of the coral shiny and smooth. *CN*
*100mm macro lens Velvia 50*

166. **Parrotfish Detail**
RED SEA
During the day, a parrotfish would be far too shy to allow a photographer to make a very close approach. But at night, parrotfishes seek refuge under coral ledges, overhangs, or any place which offers similar protection from predators. Even the bright flash of strobes used by underwater photographers generally will not wake them. The photographer can explore the intricate landscapes formed by the color and texture of their bold scales. *CN*
*100mm macro lens Velvia 50*

167. **Crocodilefish Pectoral Fin**
*Cociella crocodila*
RED SEA
When viewed from a short distance away, the Crocodilefish appears perfectly camouflaged for its life among its chosen habitat: sandy rubble, dead coral, and rock-strewn bottom. When examined closely, however, the patterns on its body are elegantly beautiful, both subtle and delicate, like designs in dyed silk. This photograph is of a small part of its extended pectoral fin. *CN*
*100mm macro lens Velvia 50*

**168. Anemone Tentacles**
RED SEA
Anemones are members of the same class as corals and jellyfish. Unlike corals, the anemone's lack skeletons, and they are solitary rather than growing attached to other polyps. They are primitive animals with a single body cavity which functions as the stomach, lung, circulatory system, and intestine. The anemone's mouth is the only opening into this cavity, and through it all food and waste pass in and out. The mouth is always surrounded by tentacles covered with stinging nematocysts. CN
*100mm macro lens  Velvia 50*

**169. Sea Urchin Spines**
*Asthenosoma varium*
RED SEA
Like miniature minarets, the satiny globes on the end of each urchin spine are crowned with a short, sharp spike. These spines contain a painful venom, causing a severe burning sensation at the site of a puncture. This urchin is nocturnal and reacts quickly to a diver's light by "running" away. Care must be taken never to touch this creature, for its defenses are formidable and automatically deploy when contact is made. CN
*100mm macro lens  Velvia 50*

**170. Octocoral Polyps**
*Xenia sp.*
SOLOMON ISLANDS
I was struck by the delicacy of these coral polyps which I found growing about one hundred feet deep. Viewing them through the high magnification of my lens, the soft, subtle colors and the gentle grasping action of each polyp as it repeatedly opened and closed were hypnotic. As beautiful as it appeared to me, this colony would present a terrifying jungle for small planktonic creatures helplessly carried by the current within range of the polyps' hungry grasp. CN
*100mm macro lens  Velvia 50*

**171. Half-spotted Grouper Pectoral Fin**
*Cephalopholis hemistiktos*
RED SEA
Beautifully colored by day, this grouper becomes even more lovely when it adopts its sleeping coloration at night. Like all fish, the grouper sleeps with its eyes open, having no eyelids nor any means of covering its eyes. Even so, they are unaffected by brief exposure to a dive light or the powerful, instant flash of an electronic strobe. CN
*100mm macro lens  Velvia 50*

**172. Soft Corals**
*Dendronephthya sp.*
RED SEA
In full bloom, these stunning bouquets of soft coral can reach over four feet in height. Because they secrete only minimal skeletal elements, this variety of soft coral plays no role in building the reef. Nor do such soft corals host the tiny symbiotic plants in their polyps called zooxanthellae, which, through photosynthesis, produce food which other polyps can then eat. Carnivorous soft corals rely entirely on their ability to snag drifting micro-organisms on their polyp-lined arms. To conserve energy, soft corals only expand when the flow of currents is optimum, shrinking into compact balls during slack water. CN
*14mm lens  Velvia 50*

**173. Lionfish**
*Pterois volitans* and
*Parapriacanthus guentheri*
RED SEA
Working the fringes of a thick cluster of glassfish, this prowling lionfish remains patient in pursuit of its next meal. The glassfish schools will not move away from their home coral head or cave, so the lionfish is assured of a never-ending supply of food. CN
*14mm lens  Kodachrome 64*

**174. Two-spot Gobies**
*Signigobius biocellatus*
SOLOMON ISLANDS
They are typically found in pairs, and always live in sandy, silty areas. They dig burrows into sand and, if disturbed, they will quickly dive into their holes. The two large spots on their fins, when presented sideways, are another example of the "predator mimic" coloration pattern. CN
*100mm macro lens  Velvia 50*

**175. Irish Setter Pipefish**
*Solenostomus sp.*
SOLOMON ISLANDS
As I worked my way along the base of an undersea wall at a depth of sixty feet, my eye momentarily lingered on two pieces of drifting red-brown algae, suspended a few inches off the sandy bottom and swaying easily in the nearly imperceptible surge. But the rhythm was just a bit off, enough to arouse my curiosity and cause me to take a closer look. Much to my astonishment, I discovered not one, but two fish, seemingly members of the rare and exotic ghost pipefish family, and these individuals were covered from nose to tail with a coat of reddish-orange, hair-like growth. This species, currently new to science, is yet unnamed, and this is likely the first photograph ever made of them. The common name I made up. I was tempted to call them the Cheap Motel Ghost Pipefish, covered as they are with an orange shag rug. Birgitte wouldn't let me, and they probably deserve something better. But she thinks this name, too, is a dog. CN
*100mm macro lens  Velvia 50*

**176. Nudibranch on Sponge**
*Thecacera picta*
SOLOMON ISLANDS
The Solomon Islands are host to a magnificent variety of nudibranchs, and every dive becomes a treasure hunt. I am often confounded by the enchanting shapes, colors, and designs of these shell-less molluscs scattered all over the reef like jewels. One marvels at the whimsy of evolution, producing as it does such an astounding diversity of creatures which basically do the same thing. As long as an adaptation works, it is there. CN
*100mm macro lens  Velvia 50*

**177. Strombus Shell**
*Strombus sp.*
SOLOMON ISLANDS
Finding active shells in the day would be quite unusual. One of the highlights of night diving is the opportunity to observe these molluscs as they engage in their natural pursuits such as feeding and mating. Like many other shells, this species lies hidden under the sand for protection during the day, but this specimen, emerging after dark, was surprisingly unaffected by my bright dive light and photographic strobes, never bothering to hide its shell. Its eyes, however, would momentarily retract every time my flashes fired. BW
*100mm macro lens  Velvia 50*

**179. West Indian Manatee**
*Trichechus manatus*
FLORIDA
The endearing nature of the homely yet lovable manatee has not helped their survival prospects appreciably. A tourist industry unto themselves in parts of Florida, the remaining population of manatees hangs preciously low at less than two thousand. While they were once hunted mercilessly for food, now the churning of boat propellers threatens to carve them from the body of nature's species. Confined to shallow inland waterways where they can dine on abundant *Hydrilla* plants, these slow sea cows have little chance of escaping oncoming high powered boats operated at excessive speed. CN
*14mm lens  Kodachrome 64*

**180. West Indian Manatee**
*Trichechus manatus*
FLORIDA
Sunlight shines on a thirteen hundred pound manatee. Fate, however, has cast a shadow on their future, for the Amazon and West African manatees join their West Indian cousins on the endangered list. Affectionate manatees will commonly approach and hug divers with their flippers, apparently holding no malice for those responsible for their near extinction. But in the embrace of this gentle mammal, I could only wonder if their small eyes were asking me why we threaten them, or if my eyes revealed my shame. CN
*14mm lens  Kodachrome 64*

**181. West Indian Manatee**
*Trichechus manatus*
FLORIDA
Before sunrise we went out in our boat to have a few precious moments alone with these amicable mammals and photograph them in the first light. Because they have been reduced to such a frighteningly small population, we may be the last generation to enjoy their touching interactions. They are peaceful vegetarians and can live in both salt and fresh water. Though they have ample blubber, they have a poor tolerance for cold. During the winter months they seek the warmth of Florida's fresh water inland springs as well as power plant effluent canals. *BW*
*20mm lens Kodachrome 64*

**183. Scalloped Hammerhead Sharks**
*Sphyrna lewini*
GALAPAGOS ISLANDS
One of the more fascinating features of hammerhead schooling in the Galapagos is the cleaning behavior given the sharks by the King Angelfish; it apparently occurs around certain reefs. The hammerhead schools are comprised largely of females, many of whom are heavily scarred from recent mating. A hammerhead may drop out of the school, and exhibit an unusual, listing attitude as it swims, shaking its head uncharacteristically, as if in a trance. Invariably, the hammerhead will be approached by one or more King Angelfish, which proceed to groom the hammerhead's body, cleaning it of parasites or dead skin, particularly from the wounded areas. *CN*
*14mm lens Kodachrome 64*

**184. Plate Corals**
*Turbinaria sp.*
PAPUA NEW GUINEA
A great parallel can be drawn between the coral reef and a terrestrial forest, as in both cases it is critical that every possible bit of energy from the sun be captured in order that the maximum amount of photosynthesis can occur. In hard coral, the sun's energy fuels the photosynthesis of symbiotic algae which provide the oxygen and the little bit of sugar that the coral depends upon. The plate corals are more fragile than the stocky, dense corals which might be found in the shallows on the wave-battered outer reef. Predictably, such corals as these are found in deeper or more protected water where they are less subject to wave damage. *CN*
*14mm lens Kodachrome 64*

**185. Goatfish Patterns**
SOLOMON ISLANDS
At night the sleeping goatfish wears its most vibrant hues, but its colors quickly fade to an undistinguished palette if it is awakened. Specialized pigment cells in the skin called "chromatophores" can contract or expand, concentrating the color intensity or dispersing it. The chemical content of each chromataphore determines its hue. The layering of the chromataphores allows not only changes in color and intensity, but pattern as well. *CN*
*100mm macro lens Velvia 50*

**186. Schooling Snapper and Diana's Wrasse**
*Lutjanus bohar* and *Bodianus diana.*
RED SEA
A giant storm cloud of snapper dominates the blue water, while a colorful Diana's Wrasse passes before a soft coral garden in the foreground. Powerful teeth allow the wrasse to break apart shells and sea urchins for food. The juvenile stage is dramatically different in coloration, being nearly black-bodied and punctuated with large white spots. *CN*
*14mm lens Velvia 50*

**187. Pacific Spotted Dolphins**
*Stenella attenuata*
HAWAIIAN ISLANDS
Wary but curious, the Pacific Spotted Dolphin always seem torn between investigating me and taking flight. A human skin diver is very alien to the wild dolphins. Everything about us is foreign to their world. To try to reduce the impact of my presence, I will wear a counter-shaded wetsuit–dark on the dorsal side, light colored on the ventral side, to better mimic the coloration of pelagic animals. I will also use a dolphin-style kick in the water, instead of the traditional scissors kick, as that too will reduce the visual impact of my presence. Bubbles from scuba frighten these dolphins, so photographing them requires free diving skills. *CN*
*24mm lens Kodachrome 64*

**188. Singing Humpback Whale**
*Megaptera novaeangliae*
HAWAIIAN ISLANDS
The singing whale was suspended motionless, one hundred twenty feet below the surface. I approached from behind to remain outside its view, for in spite of their enormous size, they are extremely timid of divers. I was hopeful that the intensity of its singing would mask the noise of my bubbles. Undetected, I was able to venture directly under its massive tail for the shot. *CN*
*14mm lens Kodachrome 64*

**189. Breaking Waves**
PAPUA NEW GUINEA
Like gathering storm clouds, a breaking wave crashes above me. Looking at this photograph, I am reminded of the dramatic spring thunderstorms which roll toward our mountain valley home in the Colorado Rockies. The richly oxygenated water and strong surge produced by the waves in shallow water give rise to a specialized ecosystem which thrives in these conditions. *CN*
*14mm lens Kodachrome 64*

## From The Authors

Making marine life photographs underwater, in the wild, is ultimately a solo pursuit. A single diver can move somewhat unobtrusively along a reef, minimizing the commotion a human presence creates. Exhaled bubbles are noisy and foreign to underwater animals, quite often frightening creatures away. Alone one can breathe quietly and slowly, and marine life is far more likely to allow a close approach. Very often a solitary diver will become the focus of attention, with fish swarming in dense schools at very close range. But as the number of divers and bubbles increases in a given area, dramatic underwater wildlife encounters usually decline. Intimidated, the animals keep a wary distance.

Perhaps this is the way it should be. Alone, deep in the sea, self-reliant by necessity in a foreign, sometimes hostile environment, an underwater photographer develops an intimate connection with those creatures which materialize in the camera's viewfinder. The situation invites introspection, and introspection lies at the core of good photography.

But making photographs underwater, and bringing the beauty of this hidden world to life on the pages of a picture book are seahorses of a different color. While the former may well be better accomplished alone, creating a book is by necessity a group effort in which each participant plays a vital role, like creatures in a well developed ecosystem. To the great many individuals who have contributed their energy, expertise, and love to this project, we have no adequate words to express fully our thanks. But so vital to the realization of our dream were their efforts, we are compelled to try.

We met them several years ago at a book signing event. They came to us a bit shy and somewhat nervous, two gals from Texas with the unlikely story that they had just purchased what was even then, before they brought to it their polished vision, the world's most elegant magazine devoted to the sea: *Ocean Realm*. They wanted to know if we might consider contributing material to their publication. From that initial introduction has blossomed a rewarding and wonderful friendship, one which has given us great joy and has led to their publishing of *In a Sea of Dreams*. Cheryl Schorp and Charlene deJori, our publishers, we thank you from deep within our hearts. Our gratitude is immense. Your faith and encouragement in our work continue to inspire us. We both hope this book will, in some way, help you realize your dreams as well.

The success of my first publication, *Within a Rainbowed Sea*, can be attributed in no small part to the patience, dedication, and expertise of those unsung artisans performing the vital first step in the printing process, the creation of the "color separations." Dwight and Karen Cummings, with their staff at Wy'east Color, Inc., in Seattle, Washington, and Portland, Oregon, spared no effort ten years ago when they brought out the best qualities my photographs had to offer. We were thrilled with the opportunity to work with them again a decade later, and once more they have proved they stand alone and proud at the pinnacle of their field. Though a great many of their staff are involved in a project of such magnitude, and we thank them all, we are especially grateful to Chris Adams, Craig Brasch, Dan Bulstrode, You are masters of your craft, all of you. You bring to our work the very best in photographic color separation.

The final and most tangible step in the image reproduction process is printing. It is the quality of the printing which greets the viewer's eye, and therefore the skills of the printer are of ultimate importance. Given the difficulties and risks involved in making underwater photographs, given the painstaking effort and high expense of the color separation process, clearly the selection of any less than the best printer in the business would make little sense. We didn't have to look any farther than Dynagraphics, Inc., in Portland, Oregon to entrust with this important job. They printed *Within a Rainbowed Sea* and won numerous awards for their extraordinary effort. To our delight, many of the same skilled artisans are still operating these mammoth presses ten years later, and once again they have proven invaluable. To owners Byron and Char Liske, we are truly indebted. You have shepherded this project through with the finest personal care and loving attention, as you did before. To supervisor Greg Smith, congratulations and thanks. Now that you don't actually run the press anymore, you are less covered with ink, but your experience has once again proved invaluable. Finally, to pressmen Robert Gallup, Jim Foland, Aaron Davis, and Geoff Pierce, proof of your commitment to excellence is on these pages. We thank you.

While a painter can retouch a detail again and again until it is just right, or a sculptor can work clay over and over until it is satisfying, a photographer often has but a single shot at perfection. On the other hand, we can simply throw the bad photos away, showing only what came out right, and everyone then believes we actually know what we are doing. Writing, on the other hand, is a far more uncertain and tortuous process, filled with self-doubt and the terror of the empty page . . . in modern times, the blank computer screen. The process would be impossible for me were it not for the guidance, prodding, reassurance, and tenacity of my text editor. Once more we drew upon a member of the team assembled for *Within a Rainbowed Sea*, as he proved himself not only professionally, but as a steadfast friend. Paul "Doc" Berry again came to my aid. Instead of sitting side-by-side in my little house in Kona, working together on an archaic computer as we did ten years ago, we linked by modem, Doc in Santa Barbara, we in Colorado, and beamed signals into space, bouncing digital pulses back and forth off satellites which carried on them dreams of the sea. Lost in the technology was the tennis and beer, but Doc's knees are shot now anyhow. Assuming his elbow is fine, we'll catch up on the beer. Doc, we thank you for your invaluable help. If our stories bring dreams to others in an articulate way, we share the credit with you.

The opportunity to work with a genius is always exciting. Literally a man and master of letters, Tim Girvin outdid himself with the calligraphy for our cover. Expanding upon the fluid grace and mystery of the cover calligraphy for *Within a Rainbowed Sea*, Tim has employed a freer stroke, one manifesting the unencumbered spirit of the dream experience of our theme. You amaze us, Tim. The rhythms of the sea flow from your hand.

Birgitte and I wouldn't be publishing *In a Sea of Dreams* together, indeed, we probably would never have met, had not *Within a Rainbowed Sea* become a reality. To Richard and Cindy Cohn, and to Bob Goodman, for your belief in my work, for your indefatigable efforts in publishing my first book, the depth of my gratitude to you is truly Beyond Words.

I once thought I might like to become a marine biologist, but found I couldn't manage the scholastic regimen. I also concluded that marine biologists and other ocean scientists spend all their time in labs, and very little time underwater, giving me all the excuse I needed for flunking out. Therefore, I have particular admiration for those marine scientists who have not only achieved prominence in their field and contributed greatly to our body of knowledge concerning the sea, but who still have managed to spend great amounts of time underwater, studying first-hand this mysterious and marvelous realm. Their expertise proved invaluable in the preparation of this book, as we were able to tap the considerable data bases in their minds for the scientific names and natural history anecdotes that comprise our plate notes. John McCosker, Director of the Steinhart Aquarium in San Francisco, and his associates Gary Williams and Terry Gosliner unselfishly gave of their time and energy. Across the country, Paul Erickson and Les Kaufman with the New England Aquarium likewise provided much appreciated assistance, asking in return only millions of dollars and our first-born child. We're hoping our sincere thanks will suffice.

Unlike Birgitte, who is relatively new to this profession, I've been around so long at this point that I am starting to feel a bit like an aging, algae-encrusted stonefish. One satisfying aspect of this is that I have been able to observe through the years the growth and prosperity of colleagues in the field, many of whom have started modestly but achieved great success and respect internationally. I look with particular admiration upon Bob Hollis, President of Oceanic USA. Twenty years ago I bought my first camera housing from Bob, along with my first underwater strobe. The ocean is a severe arbiter of excellence in underwater equipment. Nothing less than the best is acceptable, nor will it survive. From a small line of camera gear and accessories, Bob has built a company offering a full line of innovative diving equipment. In the intervening years, we have relied upon underwater camera gear and diving gear developed and manufactured by Oceanic. We still use the original Oceanic 2003 model strobes, and they still perform brilliantly for us. To date we have found no finer regulator than the Oceanic Delta to deliver smooth, effortless air, regardless of depth or exertion. This is no small consideration when dragging bulky camera systems through a heavy current at depth. And over the years we have found no more loyal supporter and friend in the industry than Bob. Bob, you are an original. Thanks for your considerable contributions to our sport and profession.

While many employees at Oceanic have helped us with our equipment needs or assisted us in a variety of ways, George Brandt has never failed to provide fast and friendly responses to our requests. George has pulled us out of many jams, and we are indebted to George for his efficiency and enduring good cheer.

Though specialized underwater cameras are on the market, we have found that nothing combines the qualities of broad lens selection, light weight underwater, optical excellence, and overall versatility as well as placing a quality single lens reflex camera in specially designed underwater housings. While most any housing should adequately perform its most basic function of keeping air in and the little fishes out, it is the more subtle features such as balance, neutral buoyancy, control placement, and port selection which mark the leaders in the field. For all of our photography employing wide angle lenses, used for reef scenics, whales, fish schools, and other large subjects, we use Aquatica housings with spherical dome ports manufactured by Aqua Vision of Canada. These precision cases have served us admirably, proving to be rugged, reliable, and easy to use. Our thanks to Stanley Hopmeyer and John Paul at Aqua Vision for all their gracious help.

For close-up photography we favor very compact, lightweight housings which offer a wide range of extended flat ports. Such ports are capable of accommodating the long macro lenses used to capture the fine details of a parrotfish fin or the intimacy of mating nudibranchs. For this specialized application, our choice has long been Ikelite housings made in Indianapolis. Dave Combs and founder Ike Brigham have been most cooperative always, and we are grateful to them for making our images possible with their fine equipment.

The feeling of weightlessness is one of the most engaging sensations experienced while diving. The ability to soar over a towering coral head or to glide in slow motion down a two hundred foot deep crevasse has no terrestrial equivalent. Gravity is a relentless force in air, and, as divers, we revel in our temporary refuge underwater. But when it comes to photography, gravity is a welcome friend, giving the land photographer stability. Gravity permits the photographer to anchor equipment with tripods, monopods, bipeds, you name it. On land we can hold still. Not so underwater. We float, we drift, we move with every little ebb and flow of the passing current. It is necessary that our myriad photographic gear, our housings, light meters, focusing lights, and strobes be somehow attached to each other. A fully rigged underwater camera system looks only slightly less ungainly than a moon landing pod. Our undersea photo studio has to be a single, integrated unit, so that it can be maneuvered, held, aimed, and operated with a single hand. One's other hand is often used to grasp a rock or some dead, unbreakable outcropping to attempt to maintain stability, as we often work in macro ranges with a depth of focus that can be as shallow as an eighth of an inch.

If you hope to have any chance at success, you will find that the unsung strobe arm is an essential component of your photographic system. Many have tried to build the perfect arm, and many have failed. Tom Campbell of Santa Barbara succeeded with his system, dubbed TLC for Technical Lighting Control. Since their introduction we have used them exclusively. We thank Tom not only for his craftsmanship, but for his generosity to us personally. We also wish to thank Lee Sams at TLC, who manages TLC with courtesy and professionalism.

Since we aim, literally, to produce sharp, crisp images of marine life, it is obvious that uncontrollable shivering is not a preferable condition. Forget the photos; hypothermia takes the fun out of diving and can be dangerous as well. The density and thermal conductivity of water is so great that all but the very warmest waters can produce excessive cold in a short time when fully submerged. Photographers, endeavoring as we do to move slowly and breathe quietly, burn off fewer calories than a more active diver, so we get colder still. Thus, a high performance wetsuit is more than a luxury. For the serious diver and underwater photographer, it is as essential to our comfort, well being, and quality results as any piece of equipment we use. Henderson wetsuits have been our perennial choice. Well-cut, rugged, and warm, they stand up admirably to the abuse we subject them to. And they look jazzy as well. Bonnie Biggs at Henderson deserves our special recognition for all of her great service.

Robbie Robertson was one of my earliest friends and supporters in this business. Robbie went on to build his company, Deep See Products, Inc., into one of the most highly successful diving accessory companies around, a testimony to Robbie's hard work and business acumen. We thank you, Robbie, for your help and enthusiasm which happily continue to this day.

Eric Peterson of Eric Peterson Sales in San Marcos, Texas has, in addition to getting me into all kinds of trouble best forgotten, arranged and promoted innumerable book signing events throughout the South and West regions of the country. Many are the miles we have spent together during our traveling road shows, and many are the laughs we have shared. We are looking forward to round two. Eric, representing Seaquest diving equipment and Deep See Products, has generously provided us with high quality gear whenever we have needed it.

Tony Farmer, founder of Sport Suits of Australia, helped change the look of diving with his line of flashy, skin-tight lycra suits. But they are primarily functional, increasing warmth, easing the struggle when donning wetsuits, or preventing stings from certain water-borne nasties. Our thanks to Tony, who has provided us with many fine suits, keeping us always high on the best-dressed diver list.

The diving world was revolutionized several years ago by the introduction of compact diving computers. These digital devices monitor a diver's time and depth, and provide the user with vital information on safe remaining dive times, or any critical decompression information as required. Such computers have proved a special boon to underwater photographers, freeing our minds to concentrate on the technical and aesthetic challenge of creating photographs. To our friends at Orca, originators of the digital diving computer, we thank you for your innovation and valuable contributions to our sport, as well as for your personal assistance to us.

The great reefs of the world are found in remote places, untouched by the devastating pressures of civilization. To dive and photograph these areas typically requires the services of fully equipped, self-contained, live-aboard dive boats. The popularity of international dive travel has spawned a population explosion of such vessels, and they are generally of reasonable quality. However, two such boats that we have used repeatedly stand out in our minds as exemplary operations, in the quality of the vessel, but more importantly, for the integrity of those who run them. The *Lammer Law* in the Galapagos Islands is superb. She is co-owned by Annie and Duncan Muirhead in the British Virgin Islands and their Ecuadorian partner company, Quasar Nautica, operated by Dolores and Eduardo de Diez. There are no finer people to be found in the business. Aboard *Lammer Law* and guided by her wonderful crew, we have traveled through the magical Galapagos Islands, experiencing the most exciting diving to be found on earth.

Half a world away another vessel plies the astonishingly rich waters surrounding the Solomon Islands. The *Bilikiki* and her dedicated crew are in a class by themselves. Owners Rick and Jane Belmare, and Roger and Janita Radsford have literally created one of the world's premier dive boats from a once rusted, sinking hulk. Their vision and dedication are remarkable, their friendship greatly valued.

Traveling to such locations has been made fairly easy with jet service to all but the most obscure destinations. Were we simply a writing team, this exercise in flying might even prove enjoyable. A couple of pads of paper, a few extra pens, and away we would go. In our dreams! Photography adds a new factor to the equation, equal to about six hundred pounds of luggage, even for a short trip. These logistics have been made easier for us through the cooperation and support of a number of airlines and airline personnel. In particular, everyone with Air Pacific, serving the Solomon Islands, has been wonderful always. Our friends at Air New Zealand have made our expeditions to the South Pacific virtually hassle free. We would also like to thank the good people at Qantas Airways for the many enjoyable flights we have made with them to our favorite Pacific dive destinations such as Papua New Guinea. Our travels to Egypt to dive the Red Sea have been facilitated by Lufthansa Airlines, and to them we are thankful for their consistently excellent service. Closer to home, in the underwater photography business, where ironically half our time is spent in the air, we are appreciative of the good care provided us by United Airlines.

We have a small, family-style dive travel business, cleverly called Rainbowed Sea Tours, Inc., and we specialize in conducting personally hosted dive expeditions around the world to our favorite and most exciting locales. But with us away for half the year, such an operation would be impossible were it not for the tireless efforts and dedicated support of our Travel Coordinator and all-around stalwart office manager, Phyllis Dresie. While we have all the fun taking photos, Phyllis handles the grist of the business with expertise and dedication. Phyllis, we thank you from the bottom of our hearts, as we couldn't do it without you. And to Dick Dresie as well, our appreciation for the many airport shuttles and general errand- running duties you have performed to assist Phyllis on our behalf. These numerous little favors have added up to a great big helping hand.

Rainbowed Sea Tours, Inc. would never have gotten its start in 1988 were it not for the cooperation and assistance of Lars Sahl, then owner of Momentum Travel in Kona. Insofar as our company has been instrumental in making this book possible, Lars, your belief in us is greatly appreciated. We can't thank you enough.

Our home away from home while attending our many book promotions in the San Francisco area has been the Eisenhardt Inn. To our special friends Roy, Betsy, Jesse, and Sarah, for your always gracious hospitality and generosity, our warmest thanks.

We might never have known about Texas Champagne were it not for the ever-bubbly Carol Boone, nor would we have the fine photo of us gracing this book jacket were it not for Carol's expertise with a lens. We extend an affectionate thanks to you, Carol, for your contributions and the countless good times we have shared.

Finally, we would like to thank all our many guests who travel with us on our diving excursions. You are too numerous to mention by name, but please know that your support, friendship, and loyalty have made this book a reality. We hope these photos will remind you all of our many great undersea adventures together around the world.

*Chris Newbert and Birgitte Wilms*
*Sopris Mountain Ranch, Colorado*
*June 1994*

PUBLISHER:
Fourth Day Publishing, Inc.
San Antonio, Texas

EXECUTIVE EDITOR:
Cheryl Schorp
San Antonio, Texas

EDITOR:
Paul Berry
Honolulu, Hawaii

DESIGN:
Charlene deJori
San Antonio, Texas

COLOR:
Wy'east Color, Inc.
Bellevue, Washington

PRINTING:
Dynagraphics, Inc.
Portland, Oregon